MW01088723

ANATOMY OF
A PREMISE LINE

If a story is going to fail, it will do so first at the premise level. *Anatomy of a Premise Line: How to Master Premise and Story Development for Writing Success* is the only book of its kind to identify a 7-step development process that can be repeated and applied to any story idea. This process will save you time, money, and potentially months of wasted writing. Whether you are trying to write feature screenplay, a novel, develop a television pilot, or just trying to figure out your next story move as a writer, this book gives you the tools you need to know which ideas are worth pursuing. In addition to the 7-step premise development tool, *Anatomy of a Premise Line* also presents a premise and idea testing methodology that can be used to test any developed premise line. Customized exercises and worksheets are included to facilitate knowledge transfer, so that by the end of the book, you will have a fully developed premise line, log line, tagline, and a completed premise-testing checklist.

Here is some of what you will learn inside:

- Ways to determine whether or not your story is a good fit for print or screen
- Case studies and hands-on worksheets to help you learn by participating in the process
- Tips on how to effectively work through writer's block
- A companion website (*www.focalpress.com/cw/lyons*) with additional worksheets, videos, and interactive tools to help you learn the basics of perfecting a killer premise line

Jeff Lyons is a working writer, story editor, script and book doctor, and has worked in the film, television, and publishing industries for more than two decades, helping thousands of screenwriters and novelists tell better stories. He is an instructor through Stanford University's Online Writer's Studio, and is a regular guest lecturer through the UCLA Extension Writers Program. Jeff's writings on the craft of storytelling can be found in leading industry trade magazines such as *Writer's Digest Magazine*, *Script Magazine*, and *The Writer*.

"Story structure changed my writing life, and the magician who taught it to me was Jeff Lyons. Every writer on the planet needs coffee, chocolate, and this book!"

Caroline Leavitt—*New York Times* and *USA Today* bestselling author, *Is This Tomorrow* and *Pictures of You*

"This is a book for which many of us have been waiting, and if you are at all like me, incorporating Jeff's ideas and guidance into your work can make all the difference."

Barnet Bain—Producer, *What Dreams May Come*; Writer/Producer, *The Celestine Prophecy*

"There is no book like this in the marketplace. It will help writers, producers, and directors, and save everyone from wasted time writing drafts to find a story. I wish I had this book when I was in film school."

David Jeffery—Producer, *Bones*; *American Family*; *Lesson Plan*

"Working with Jeff reminds me of a quote from Michelangelo, 'I saw an angel in the marble and carved until I set him free.' Jeff's amazing tools have helped me develop solid premise and log lines, and to chisel my stories free from the stone. This book will help you do the same."

Michael Perri—Staff Writer, NBC's *State of Affairs*

"After reading Jeff's terrific book I felt like rushing to my desk, new tools in hand, and fixing all my unsold screenplays. I highly recommend to anyone writing a screenplay or novel."

Nick Castle—Writer/Director, *Escape From New York, Hook, August Rush, Last Star Fighter, The Boy Who Could Fly, Tap, Dennis the Menace*

Before, I used to write myself into a corner, but thanks to Jeff Lyons' premise tools now I can see my story's structure from the outside, to see what's working and what could be stronger. This book will help you draw a map through the story forest, rather than getting lost in the trees. I've used this material with my students with the same beneficial effect as with my own writing. I highly recommend this book."

Malena Watrous—Author, *If You Follow Me*; Head Instructor Stanford University Online Writers Studio

ANATOMY OF A PREMISE LINE

How to Master Premise and Story Development for Writing Success

Jeff Lyons

Focal Press
Taylor & Francis Group

NEW YORK AND LONDON

Visit the companion website for this book at
www.focalpress.com/cw/lyons

First published 2016
by Focal Press
70 Blanchard Road, Suite 402, Burlington, MA 01803

and by Focal Press
2 Park Square, Milton Park, Abingdon, Oxon OX14 4RN

*Focal Press is an imprint of the Taylor & Francis Group, an
informa business*

© 2016 Taylor & Francis

The right of Jeff Lyons to be identified as author of this work
has been asserted by him in accordance with sections 77 and 78
of the Copyright, Designs and Patents Act 1988.

Notices

Knowledge and best practice in this field are constantly changing.
As new research and experience broaden our understanding,
changes in research methods, professional practices, or medical
treatment may become necessary.

Practitioners and researchers must always rely on their own
experience and knowledge in evaluating and using any information,
methods, compounds, or experiments described herein. In using
such information or methods they should be mindful of their own safety
and the safety of others, including parties for whom they
have a professional responsibility.

Product or corporate names may be trademarks or registered
trademarks, and are used only for identification and explanation without
intent to infringe.

Library of Congress Cataloging-in-Publication Data
Lyons, Jeff.
 Anatomy of a premise line : how to master premise and story
development for writing success / by Jeff Lyons.
 pages cm
 Includes bibliographical references and index.
 1. Motion picture authorship—Vocational guidance. 2. Motion picture
plays—Technique. I. Title.
 PN1996.L845 2015
 808.2'3—dc23
 2015000347

ISBN: 978-1-138-91758-3 (hbk)
ISBN: 978-1-138-83885-7 (pbk)
ISBN: 978-1-315-73376-0 (ebk)

Typeset in Garamond
By Apex CoVantage, LLC

This is for you Kimberley. You know why.

CONTENTS

FOREWORD

Like a lot of writers, I used to believe in the Muse. I would sit at my desk and wait for inspiration, for some idea that might propel me into a story. I'd also eat a whole lot of cookies and drink a whole lot of coffee while I waited. Sometimes ideas did come, like little solar flares, and then I would write and write, until the flares went out and I was left wondering, "What happened?" My novels' first drafts usually turned out to be eight hundred unwieldy pages with the story so convoluted that you'd need a road map just to figure out where it started, never mind where it ended or what it meant. To dig out the story, to refine it, took years, but I told myself that that was how a writer works, that that was just part of the process.

Oh, how wrong I was.

Following the Muse is a bad strategy because you end up with a story that really isn't a story at all, but more like an add-a-pearl necklace of events following events, for no particular deep reason. There's often no cause and effect, and character development becomes unwieldy or nonexistent. Plus, the Muse is fickle, not showing up some days. Inspiration is great, but then there is the hard, satisfying work of craft—and make no mistake, writing is a craft as well as an art.

One day, while I was teaching at UCLA online, a student told me about story structure. I thought it sounded ridiculous. I had read books on story before and they hadn't been helpful at all. Instead, they soothed. They told writers to keep going, to deepen their characters, but they never really showed you how or why. Plus, everyone knew that outlines were for the non-creative. They would box you in, and keep you from discoveries. "No surprises for the writer, no surprises for the reader," was the logic.

Guess what? That logic is wrong, too.

In that class was also Jeff Lyons, who enthusiastically told me he was into story structure and he was working on his own kind of story structure and would I like to be a guinea pig and test it out? I liked his work, and I trusted his judgment, and I began to listen to Jeff; as I did, I felt my mind expanding. What was so terrible about knowing where you were going when you started?

Wasn't that like driving from Boston to Los Angeles, where you might not know the route, or the things you might encounter along the way, but at least you had a destination? To my astonishment, I found that my literary hero, John Irving, never writes a book until he knows his ending.

So I began to work in a new and very different way. Instead of sitting down and writing and "following my pen," I began to think about my premise, to ponder the moral choices and reveals my characters would undergo. And as I worked my way through my novel, I kept badgering Jeff about how I was doing, what I was missing, where I was going wrong. Jeff kept asking me questions I hadn't really pondered before, like why was this book so important to me personally? What question was haunting me that this book might answer? What was the moral component of the story? Those questions made me crazy, but they also made me dig deeper into my work. It made me work smarter, too, because I now had tools that not only worked, but also kept me inspired and saved me valuable time.

With Jeff's help, I wrote *Pictures of You*. It was my ninth novel and the very first to hit the *New York Times* "Bestseller List" and be on the "Best Books of the Year List" from the *San Francisco Chronicle, Kirkus Reviews, Bookmarks Magazine*, and the *Providence Journal*. I used the same story structure principles for the book after that, *Is This Tomorrow*, and that hit the *New York Times* "Bestseller List" too, won an Audiophile Earphones Award, was a Jewish Book Council Pick, was long-listed for the Maine Readers Prize, and was one of the "Best Books of the Year" from *January Magazine*.

Anatomy of a Premise Line is invaluable for screenwriters and novelists alike, because it gives you real and important tools you can't get anywhere else. I use Jeff's methods in my novel writing courses at Stanford University, UCLA, and the University of Toronto (I'm going to make this book a required text). I never write a novel without going over my premise and my synopsis with Jeff, and this book is the next best thing to having him there. It's time we all gave up worshipping the Muse, and instead recognized our own innate creativity. I promise that this book will change your writing life, just the way great stories do.

I know it changed mine.

Caroline Leavitt, November 2014

ACKNOWLEDGMENTS

Writing a book is a gargantuan task, and you never do it alone. I certainly could not have done this without the talented people who stepped up, rolled up their sleeves, and graciously gave of their personal grace and professional skills.

Writers need other writers in their lives who will tell them the truth. I was lucky to have Caroline Leavitt, Mary Barr, Masha Hamilton, Kimberley Heart, Stephen David Brooks, and Frederick Ponzlov. Their trusted advice and keen observations made this a better book. I especially want to thank Caroline Leavitt, who did the technical edit on this book and whose story skills were invaluable in helping me get out of my own way. Likewise, Frederick Ponzlov's and Stephen David Brooks' smart and intuitive "between the lines" insights helped to keep me on a straight line.

This book would not have been possible, in its present form, without my agents Janet Rosen and Sheree Bykovsky (Sheree Bykovsky Associates Inc.). I will always be grateful that Janet took a chance on a first-time book writer, and bulldogged his book proposal through power lunches, book festivals, and book trade conferences for over a year, trying to find the right partner. She finally did find that partner in Focal Press. I want to thank Focal Press editors Emily McCloskey and Elliana Arons for managing the acquisition, pre-production, and production processes with ease and flexibility. They were (are) a pleasure to work with.

And thank you Lazaris.

INTRODUCTION

ABOUT THIS BOOK

Anatomy of a Premise Line: How to Master Premise and Story Development for Writing Success was created in response to the explosion that has taken place in all forms of creative writing over the past five years, including in the realm of screenwriting. Anyone who writes is aware of the sea change that has occurred in the world of self-publishing. Now, more than at any time in human history, people are writing books and distributing them for mass consumption in multiple media platforms. While screenwriting (for the most part) has no market outside of the normal acquisition channels of the traditional business models of the film and television industries, there are, nonetheless, new and exciting windows opening even for screenwriters: webseries, streaming video, independent distribution outside of traditional distribution channels, and more. Consequently, more people are taking the plunge into story development, along with facing all of its ramifications—many of which we will touch on in this book. These are great times to be a writer. But with great opportunity comes great competition.

The film and television industries hold no unique position in the world of "tough to break into" industries. The entertainment industry likes to think of itself as particularly hard to get into (and it is), but there is this "specialness" mind-set that really doesn't ring true. The truth is, it's hard to break into any competitive field; just ask anyone trying to get a job at Google or the latest medical-tech startup. Those who succeed are those who have the raw talent, yes, but it's more that the successful candidate also has the core skill set and craft toolbox needed to get the job done. You don't have a chance of getting a job at Google if, when handed a wet-dry marker and pointed to the nearest whiteboard (and this is what happens), you can't whip out a bubble-sort algorithm in a couple of minutes—on the fly.

It's no different for screenwriters. If you can't break a story properly in a writers room, or handle studio notes from creative executives, or structure a story

1

properly to hit the proper narrative milestones, then success will be elusive, if not impossible. You must learn the basics, which means: story structure, dialogue, character development, pacing, the language of film, the proper formatting of various types of screenplay drafts, and much more. Experienced screenwriters have many of these tools in place; if that is you, then bravo. If that is not you, then get to it. Learn story structure in particular. Go find a story guru, or take class, or find a good book on story structure and learn it. Starting here is a good first step.

This book is not meant to fill all the gaps in all these critical skill sets. Rather, *Anatomy of a Premise Line* is meant to fill a single gap, the one that I have found *every* screenwriter (and novelist) needs filled in their personal skill set, regardless of their level or experience in the entertainment industry. That gap is the one that exists between a writer's raw talent and their basic story knowledge. Specifically, it is the ability to properly develop, validate, and execute a story's premise so that they can know, *before* they start pages, that a script will have legs and a story will work as a story. Why does this gap exist? Because premise development isn't taught anywhere. As of this writing, you can't learn this topic in film school. MFA graduate and extension writing programs don't teach it. There are no books on it (except this one), and producers certainly aren't going to take the time to train you when they have deadlines and a billion other things demanding their attention (and with few exceptions, producers don't know this stuff either).

No, you are on your own, so it is no wonder this particular gap has been festering for as long as it has. And now, with the growth of new outlets and platforms open to screenwriters, the gap is only widening, as more and more writers jump into the screenwriting game from a craft foundation made of sand. So, now is the time to close the gap and master the critical story development skill of premise development.

WHO SHOULD READ THIS BOOK

While this book is skewed to screenwriters, there is a broad range of individuals who work in various capacities in the entertainment business who could benefit from this information. There are many people working at production companies, agencies, in story departments, and in studio executive suites, even though they may not consider themselves "creatives," who would nonetheless find valuable tools in these pages to help them work more effectively with, and better manage, staff writers or freelancers. Some of these include the following:

- *New and Aspiring Screenwriters*: Whether new to creative writing, or just to screenwriting itself, this book will give you a foundation you can use to get productive immediately, and give you clear direction for further study and growth in the craft.

- *Experienced Screenwriters*: Even seasoned professionals can benefit from tailored and productivity-focused processes designed to leverage the keener insight and knowledge that comes with experience. The processes taught in this book can add to the toolbox of even the most professional writer.
- *Producers*: When it comes to evaluating literary acquisitions, hiring writers, liaising with studio or network development departments, or working one-on-one with writers themselves, producers need to have the same basic story skills as screenwriters to effectively mange the development process. They don't have to be writers, but having the same foundational skill set will save time, money, and development time.
- *Script Analysts*: Part of Hollywood's gatekeepers, film and television story analysts read many scripts and can be surprisingly unaware of the story best practices in their own industry. Story analysts, often called "readers," can benefit from all the material herein, as it applies to general narrative and story construction, especially since they read everything and anything that might be adaptable to film or TV (books, short stories, comics, blogs, etc.).
- *Story Editors*: Also part of the Hollywood gatekeepers, story editors responsible for managing production company or literary agency story departments often need to fill in for analysts who drop the ball or fall short in their work. Consequently, the more a story editor can know, the better. This material will definitely help any editor up their story game.
- *Literary Agents and Managers*: Whether at a literary agency or talent agency, those individuals involved in packaging literary properties or acquiring projects for further development as sales opportunities will find that having stronger story development skills will ultimately cut overall development time.
- *Creative Executives (CEs)*: Individuals responsible for shepherding film, television, or new media projects through the production process at a film studio, talent agency, or new media company can benefit from knowing all the same tricks of the trade as the writers they work with every day. They may not be writers themselves, but they have to make creative business decisions on which projects to produce and which to pass, so knowing the basics can help any CE do a better job.
- *Creative Writing Teachers*: Because this material is foundational and not taught in most creative writing programs, at the college or university levels, this book can be a solid addition to a new or established writing class that has heretofore not dealt with story development as a craft component of the creative writing process.
- *Novelists & Creative Nonfiction Writers*: Most of the issues discussed in part one and two of this book also relate to prose fiction and creative nonfiction storytelling. Novelists and creative nonfiction writers, by definition, live all their creative lives in these arenas. All the comments about inexperienced and experienced writers apply here, without question.

In short, this book is for you if you want to:

- move past being a talented amateur, and build on or move into becoming a working professional;
- master the first tool of story development: the premise line;
- improve your craft skill as a screenwriter or novelist;
- build a foundation in story development that can serve you your entire career;
- write screenplays or novels that will get past the gatekeepers and possibly find that elusive green light.

HOW THIS BOOK IS ORGANIZED

This book is organized into three parts. Each part deals with core concepts and processes needed to master the premise development process, as well as basic story theory required to master the material. The table of contents will give you more detailed chapter contents.

PART 1: PREMISE AND STORY—BUILDING THE FOUNDATION

This part of the book introduces the reader to the basic concepts of story premise, the premise line tool, and the essentials of story structure (as related to premise development). It also lays down the six core foundation stones needed to master the "7-Step Premise Development Process" and the "Anatomy of a Premise Line."

PART 2: THE 7-STEP PREMISE DEVELOPMENT PROCESS

This part of the book walks the reader through each of the seven steps of the premise development process, exploring core development issues such as story vs. a situation, what is high concept, and why this is an important idea to understand. It also gives the reader a "7-Step Premise Testing Process" that can be used to test and validate any story idea before you start writing.

PART 3: DEVELOPMENT: A FEW REMAINING NUTS AND BOLTS

This last part of the book addresses next steps in the development process, after mastering the premise line and overall story development. This section discusses how to write a short synopsis, the three stages of development, the broad strokes of character development, and how to develop the discipline of writing in the face of a writer's worst enemy.

APPENDICES

There are substantial appendices at the end of the book that support all the previous material: writer resources, extensive samples and examples of all the exercises used in parts one and two, and numerous templates and forms to help readers create their own tools for use with future projects. Instructions are also given for how to access the book's companion website, where readers can download electronic versions of all the same materials for free.

ICONS USED IN THIS BOOK

To make this book more visual to read and use, I've included some icons to help you quickly find key information and resources.

KEY CONCEPT

This icon highlights key concepts and information fundamental to learning what's in this book.

EXAMPLE

This icon highlights examples that illustrate learning concepts in action.

CASE STUDY

This icon shows where case studies are located in the text for easy access and reference for the future.

REMEMBER

This icon points out information that would be beneficial to remember going forward.

TIP

This icon gives a heads-up on valuable tips and techniques that may come in handy along the way.

WHAT'S NEXT?

There are countless resources in print and online that can give you further direction and help. In the appendices of this book I've put a section on "Writer Resources." Perhaps you are already familiar with the story consulting zoo out in the world, and would prefer to avoid it altogether; no problem. You don't have to get caught up in the endless sales cycle trying to get you to buy the next flavor-of-the-month story technique or cutting-edge, how-to DVD. The information in this book is more than enough to give you a solid foundation for developing any story. If you are moved to keep learning through workshops, books, or webinars, then you might enjoy checking out the few resources I list. I only picked the ones I felt offer true value and not snake oil. But always remember, *caveat emptor*. There are some very smart and effective teachers out there with new ways of saying many of the things you will learn here; sometimes you just need to hear something said a little differently for it to sink in. Not bad or wrong—just a personal preference.

Whatever you choose—to continue exploring the very deep waters of story development and story structure, or just stop right here—my mantra is this: *Listen to everyone. Try everything. Follow no one—you are your own story guru.* Now, go be brilliant!

PREMISE AND STORY—BUILDING THE FOUNDATION

YOUR FIRST BOOK IN STORY DEVELOPMENT

Before writing characters, before writing scenes, before worrying about your act breaks, you have to first know you have a story that will work.

TELL ME YOUR STORY

That is what this book is all about: you working through your story with me, as I guide you through a seven-step process that will transform your story from an idea into a story premise, a premise line, and then into a synopsis that can be used to develop a full-fledged screenplay worthy of any serious producer or production company. Even if you don't know what terms like *story premise, premise line*, and *synopsis* mean, that's okay, because it will all be explained along the way.

It is probably a safe assumption to make that at this point in your growth as a writer this is not your first book on "how to write." You have no doubt been exposed to various story gurus, writing teachers, and how-to books and have learned terms like premise line, log line, inciting incident, midpoint complication, story beat, opponent, hero's journey, story structure, and many more. The story zoo is crowded and noisy, with many competing voices, systems, and methodologies, such as Blake Snyder's *Save the Cat* series, Christopher Vogler's *Hero's Journey*, Syd Field's three-act structure, or Michael Hague's six-stage plot—to name just a few.

What you are going to learn in this book is different. It is a foundational process, "The 7-Step Premise Development Process," that comes before all of these other systems and methodologies. You will be learning the most basic and fundamental story development process that every screenwriter (or novelist) needs to learn, i.e., how to discover whether or not you have a story that will work before you write a page of script or prose, and then how to develop that story idea into a tool (premise line) that can support the entire writing process. Once you master this process, then any other development tools or systems you use—which I encourage you to do—will work all the more powerfully in support of your story. But, first things first: *tell me your story*.

EXERCISE 1: WRITE OUT YOUR STORY PREMISE

Take some time and put your story idea down on paper. This is not a test! This is not meant to be anything other than you getting your story idea down in as concise a way as you can, so that you feel you have told your story at a very high level. This is not about giving details and minutiae; instead, keep it short, sweet, and to the point. But, do the work in a way that makes you feel like you have told the story as best you can in as few words as possible. So, imagine I'm your dream producer or publisher and you have me trapped in an elevator for ten floors. I turn to you and see you have a manuscript or screenplay strategically placed under your arm. I smile and say, "I see you're a writer. So, what are you working on?" (Remember, I said I was your *dream* producer/publisher.) Pitch me; wow me; tell me your idea. This exercise will be used as your benchmark for later comparison to the final premise line near the end of part two of the book. *You can't do this wrong*, so don't worry. I guarantee you that you will see a dramatic difference between what you do here and what you end up with in your final premise line after you've been through the process.

STORY COMES FIRST—WRITING COMES SECOND

For many, story development sounds like part of the writing process; it is not. I have found this one mistaken belief to be at the core of almost every failed script or novel—screenwriters who write scripts that fall short all have one thing in common: they began writing pages before they really knew their story. Believing that developing the story is equivalent to developing the script implies that the writing of pages as early as possible is not only logical, but that it is natural, good, and sensible. Especially if the screenwriter is under a deadline, who has time to hold back? Get to work!

Fighting this tendency to forge ahead and write, write, write is at the heart of this book and at the heart of the "7-Step Premise Development Process." If you learn nothing else from this experience, at least take away the new belief that you will increase your chances of writing a good story if, after coming up with your killer idea, you just take a deep breath and resist the urge to write pages. A writer's instinct to write first and develop as they go is an impulse responsible for leading more writers into the story woods than any other behavior. The impulse is fueled from the misconception that story development is scriptwriting. This fallacy originates from the sad reality that story development is not a skill most writers are taught: not in film school, not in MFA programs, and not even in the midst of the story consulting zoo that has sprung up around the entertainment industry as a whole. Yes, there are talented and dedicated writers who teach, and who have a natural ability in the area of story development, but as a basic skill set supported by the industry itself, and by the educational institutions that feed the creative pool of writing talent that will create product for the entertainment industry in the future—no, story development is a woefully lacking craft skill.

This is why I say that this book is your first book in story development: because almost everything you've been exposed to at this point has not been about story development so much as about the nuts and bolts of how to physically write a screenplay, or "beat" out a story, or structure a scene, or write great dialogue, or create a story world, or the myriad other writing-related functions required to write a solid screenplay. Even if you are a seasoned screenwriter, chances are pretty good that separating the storytelling function from the writing function is not an activity you would consider worthwhile, or advisable.

But until you as a screenwriter, or novelist, can approach your work story-first, rather than writing-first, real story development will be elusive and the script development process will be fraught with false starts, missteps, and frustrating excursions into the writing wilderness. Executing proper story development *before* you start writing pages is an essential first step to producing a screenplay that will survive the rigors of the overall development gauntlet that is sure to come. And successful development begins with the screenwriter knowing why the job of storytelling is not the same as the job of writing. Understanding the distinction between storytelling and writing is critical for understanding why story development is not synonymous with screenwriting (or novel writing, or playwriting, etc.). If you approach one as an expression of the other then you will always get caught up in the details of writing at the expense of story. I will illustrate how this happens in the next chapter, but this is the key: *you should not begin writing your script or novel until you have the story premise solidly in hand in the form of a premise line.*

STORYTELLING AND WRITING ARE NOT THE SAME THING

Stories have *nothing* to do with writing. When I say this to participants in a workshop or to a room full of producers, the reaction is either blank stares, rolling of eyes and snickers, or cocked heads and perked up ears (like when dogs hear something they can't recognize). I hope for the last one, because this at least demonstrates some humility and curiosity on the parts of the listeners. But the point is still the point: stories don't need writers. Stories can be danced, painted, sculpted, mimed, spoken, sung, and none of these vehicles for conveying a story have to be anywhere near a pencil, pen, paper, or word processor to work the magic of storytelling.

Think about it: stories predate written language and constitute the primordial method we humans used to communicate. Oral history and the handing down of oral tradition is the first form of how we told our stories. The painting of stories, as magnificently illustrated in the El Castillo Cave along Spain's Cantabrian Sea coast, dates back more than 48,800 years—the oldest examples of human storytelling in Europe—besting the previous title-holder, France's Chauvet cave paintings, by more than four thousand years. But, we don't have to go back forty millennia to prove the point. Even today, there are many ethnic minorities throughout the world who possess stronger spoken versus written traditions,

preferring to use oral histories, myths, epics, songs, and visual arts and crafts to hand down their cultural memes and stories. Stories don't need writers; they only need storytellers. Stories can be written, but they don't have to be.

REMEMBER

The function of storytelling is to teach ourselves about what it means to be human.

Contrast this to writing. Writing is all about language. It is about how you use syntax, grammar, rhetoric, and the tools of language to convey emotion, thought, and the experience of a moment or idea. Writing is one of the vehicles that can carry a story, and it does so using the rhythms and musicality of words, clauses, and phrases in the form of prose or poetry. Writing has its own forms, none of which directly relate to the need or requirement of telling a story. It just so happens that writing is second only to the power of oral storytelling, but writing is not storytelling; it is only one way to tell a story.

Writing and storytelling require two different talents and two different craft skill sets. Most creative people who use the writing form to tell stories are good with the writing function, but weak with the story function. We see this even in famous writers: Charles Dickens was strong with both, Marcel Proust was mesmerizing as a writer and weak as a storyteller, Hemingway was strong with both, Stephen King is impressive with both, Flannery O'Conner was unsurpassed in both, William Faulkner was magical as a writer and middling as a storyteller, Cormac McCarthy is masterful with both, and this list can go on and on. Whether you agree with my literary assessments or not, the phenomenon of having writing and storytelling being concurrently present in the same writer is a rare occurrence, relatively speaking. And of the two talents or craft skills (writing vs. storytelling), it is almost always the story skill that is out of balance. Writing a screenplay needs to be as engaging and as "literate" as any novel. Script readers are the first line of defense in the entertainment industry. Newbie screenwriters often make the mistake of writing their first-draft script to be "seen," rather than to be read. If you want to get a script in the pipeline toward development, you have to get past the gatekeepers, and that means wowing them with a great read.

THE 7-STEP PREMISE DEVELOPMENT PROCESS

Producing a great read means first creating a great story. That is what premise development is all about, and that is what this book has as its focus. "The 7-Step Premise Development Process" is designed to give you a repeatable, reliable, and validated methodology for consistently producing stories that will have narrative legs and survive the overall development process. I cannot promise that

every story idea you have will survive the process, once you master it. Indeed, I have worked with many writers and producers who have worked through this practice and come out the other end realizing their story was not able to stand on its own. Initially upset, perhaps, but every one of them was grateful for learning sooner than later that they were running after the wrong story bauble.

So to that end, the "The 7-Step Premise Development Process" contains the following steps:

Step 1: Determine if you have a story or a situation.
Step 2: Map the Invisible Structure to the "Anatomy of a Premise Line" template.
Step 3: Develop the first pass of the premise line.
Step 4: Determine if the premise is soft or high concept.
Step 5: Develop the log line.
Step 6: Finalize premise line.
Step 7: Test the premise and log lines.

In part two of this book, you will walk through all of these steps in detail using one of your story ideas—perhaps the one you used for the first exercise—guided by the supplied worksheets and case studies. But, before you dive into this work, we have to build a common ground, a solid foundation from which we can leap into the hard work of breaking out a working story premise and uncovering the story you want to tell. This means that we have to define some basic concepts, set up some agreed-upon terminology and development jargon, and build a conceptual framework that can act as an armature to support the premise development process as a whole. We will lay the following groundwork in this first part of the book:

- Premise
- Invisible Structure
- Visible Structure
- Premise Line
- Story / Character / Plot
- Moral Premise

The following chapters will build on these six foundation stones, and challenge many common assumptions and consensus viewpoints about the screenwriting process. Try to keep a balanced frame of mind so that any preconceived judgments and beliefs you may hold don't rob you of an experience that might otherwise open your mind and give you a new creative perspective to explore in your own artistic process.

2

WHAT IS A STORY PREMISE AND WHY SHOULD YOU CARE?

STOP
REMEMBER

If a story is going to fail, it will first do so at the premise level, i.e., at the level of the idea itself.

The "7-Step Premise Development Process" is all about developing your story's premise. This is what you are going to learn how to do, step by step in part two of this book. But, do you even know what a story premise is? Is it the same as a log line? Is a story premise all about your characters, or should it focus on plot? Or is story premise a pitch tool that you only use when you're pitching your movie idea to a potential producer at the annual pitchfest?

COMMON DEFINITIONS OF STORY PREMISE

Certainly the above questions are common ones asked in today's screenwriting world, because all of them have been used to define a story premise. Could they all be right? If I've learned anything in my years of working with screenwriters, producers, and novelists, I have learned that just because people use the same words doesn't mean they are speaking the same language. Nothing illustrates this vocabulary-language disconnect better then when I ask a room full of screenwriters to define a story premise. Invariably, I get as many definitions as there are writers in the room. Consider some of the more popular definitions screenwriters use for defining story premise:

- It's a log line.
- It's your story's hook.
- It's the theme of your story.
- It's a pitch line.

- It's the underlying idea of your story.
- It's the concept that drives the plot.
- It's the story of your main character's journey.

None of these really define the term "story premise," or clarify the true nature of a story premise. They are more akin to clichés than useful definitions. They hold no practical information or utility that a screenwriter can rely on in developing a story, and that is because none of the common definitions of story premise allow for its use as a story development tool. A premise might help you sell your idea to someone, or define some discrete aspect of your story (character, theme, or plot), but story premise is never considered an all-around tool for actual story development. This is why none of the "default" answers to the question "What is a story premise?" can be taken seriously and why this is something you should care about as a writer. You should care because as long as you buy into the consensus responses, you deny yourself one of the most powerful tools in the screenwriter's toolbox: the *premise line*.

It is ironic that much of today's screenwriting trade (not all) has developed such a disconnect between what a story premise really is and how the consensus defines it. This is ironic because historically even the ancients were closer to understanding story premise than most contemporary scriptwriters.

HISTORICAL DEFINITIONS OF STORY PREMISE

Story premise, as a concept and as a literal thing, was not an invention of the 18th, 19th, 20th, or even the 21st centuries. Indeed, the beginnings of story premise go back much further into our collective narrative past. The Greeks first sowed the seeds of story premise more than 3,500 years ago, with Aristotle's (384 BC–322 BC) seminal work *The Poetics*,[1] in which he addressed the idea of "unity of action," recognizing that:

> . . . they [plots] should be concerned with a unified action, complete and whole, possessing a beginning, middle parts and an end, so that (like a living organism) the unified whole can effect it[s] characteristic pleasure (p. 38, *The Poetics*).

For more than 35 centuries, the principal truth underlying Aristotle's idea of "organic unity" has been examined, theorized, and refined by many narrative theorists. After all, if the essence of this idea could be harnessed, then all story-tellers would have an invaluable tool that could help them decide what narrative elements should, or should not, constitute any story.

The search for clarity would take a giant's step with Gustav Freytag, the renowned 19th century German novelist and playwright. Freytag, famous for his five-stage (act) theory of dramatic structure, presented an intuitive proposition

called the "Idea of the Drama," which came tantalizingly close to a workable proposition for the principle of "organic unity":[2]

> ... the drama gradually takes shape out of the crude material furnished by the account of some striking event. First appear single movements; internal conflicts and personal resolution, a deed fraught with consequence, the collision of two characters, the opposition of a hero to his surroundings, rise so prominently above their connection with other incidents, that they become the occasion for the transformation of other material ... The new unit which thus arises is the Idea of the Drama ... This idea works with a power similar to the secret power of crystallization. Through this are unity of action, significance of characters, and at last, the whole [structure] of the drama produced (pp. 9–10, *Freytag's Technique of the Drama*).

As we will see, the structure produced is not generated from the "crystallization" Freytag describes, but rather it's the other way around; it is the structure of the story itself that makes possible all of what he describes. The "Idea of the Drama" may be the first cohesive and grounded proposition in modern dramatic theory that gives a basis for any contemporary definition of story premise.

It would be Lajos Egri, the Hungarian-born playwright and creative writing instructor, who in his influential work *The Art of Dramatic Writing* (originally published in 1946) put forth the idea that well-motivated and defined characters gave rise to plot, and not the other way around. Egri's building upon Freytag's "Idea of the Drama" was a significant stepping-stone for the further evolution of our modern concept of a story premise, and he became even so bold as to define the pieces of dramatic structure needed to form a functioning premise idea:

> ... every good premise—is composed of three parts, each of which is essential to a good play. Let us examine [the premise] *'Frugality leads to waste.'* The first part of this premise suggests character—a frugal character. The second part, *'leads to,'* suggests conflict, and the third part, *'waste,'* suggests the end of the play (p. 8, *The Art of Dramatic Writing*).

Almost everyone who teaches screenwriting today identifies these same three "parts" in any premise construction. They may change the terminology a bit, but any current premise construct, by knowledgeable teachers or screenwriters, sources from Egri's writings. The concept is the same: a premise has three parts: *character, conflict*, and an *ending*. If you can convey the sense of a character in conflict that is working toward some conclusion, then you have the basis for a premise to a story.

Following Egri's lead, we are certainly better off than following the creative writing consensus mentioned earlier. With Egri, at least, we're not talking in sound bites and clichés. But we still don't have a functional explanation for story premise that captures the full utility and power of the concept.

A WORKING DEFINITION OF STORY PREMISE

Think of a story premise as being like the banks of a river. When there are no banks to form the flow of water, what does water do? It does what comes naturally: it takes the form of its container—this is one of the defining characteristics of any fluid. Without banks, the container is space itself, so the water fills the space. We recognize this as a flood. Now, make the water your writing process. Without guides, without form, without direction, your process will flood and act just like any fluid thing; it will fill the space. And before you know it, you will be lost in the flood plain wondering how to get back to solid ground. Story premise, and its tool the premise line, acts like the banks of a river to guide, not control; to harness, not to contain your writing process. But more, together (story premise and premise line) they constitute your canary in the coal mine warning you when you are about to go off into the story flood plain. They can keep you going in a solid direction, allowing you to safely run off in "crazy" story tangents when the muse hits, but always giving you a clear path back to dry land.

KEY CONCEPT

A story premise is a container that holds your story's right, true, and natural structure.

So, if a story premise is a container (river banks) that holds your story (the river), what exactly does that mean? What is really being "held"? A story premise holds the very structure of your story and thus acts as a guide and conduit to support the entire storytelling process. Rather than just three parts (character, conflict, and ending), story premise is made up of seven parts: *character, constriction, desire, relationship, resistance, adventure,* and *change.*

Those seven parts constitute one of the most important and mysterious creatures in the storytelling universe: the *Invisible Structure.* Important because every story has an Invisible Structure; mysterious because while crafted by you the writer, it is more akin to a force of nature than a human invention. And like a force of nature, it can overpower us in our writing process, or it can work with us co-creatively to reveal the marvel of a fully formed story.

Consider how every writer writes a story. As we write, we all make choices to include one thing at the exclusion of something else. As soon as one thing is chosen, countless other things will not be chosen by default, thus eliminating thousands of other potential story lines from coming into existence. We narrow, constrict, limit the story window with every choice we make. And yet, creativity is not stifled, ingenuity flourishes, and invention cannot be stopped. Choice frees us; it does not imprison us. And why do we make the choices we make? You could have a character walk through the door or not walk through the door.

Which one will you choose? You will choose the one that "works." You will be attracted to one or the other choice: door, or no door. Why? Because, while you are the architect, the structure is already there embedded in the choices you choose to pay attention to. You as a writer have unlimited possibilities when you start a story, you cannot entertain them all—you will never get anything done if you do. So, you listen, you focus, you follow your instincts to make one story choice over another. The structure that guides this process is the Invisible Structure—there, but unseen—until you choose. The seven components of the Invisible Structure are the seven common springs that feed the story river upon which we all sail our boats. They are the headwaters that help you, me, every writer make the story choices that "work."

Watery metaphors aside, helping to make the "right choice," and revealing the embedded structure every story possesses, are two of the central tasks of the "7-Step Premise Development Process." But to fully understand how this works, and the role you play as the creating force, a deeper understanding must be had of the Invisible Structure. And for that to happen, we need a separate chapter.

3

THE INVISIBLE STRUCTURE

STOP

REMEMBER

Every story has a structure. Every story must have a structure. If it doesn't, then it's not a story—it's something else.

The Invisible Structure is the structure we can't see. Okay, "invisible" kind of gave that away. But this is not just a play on words—it is literally true. And it is true because of the nature of the Invisible Structure; it is an intuition, a feeling, a tangible intangibility. As I mentioned in the previous chapter, the Invisible Structure feeds the creative process by revealing the embedded structure present in any story as we make choices along the story development path: when one story idea resonates with us more than another idea, and we get that unmistakable feeling that "this is it," that is the Invisible Structure talking to us. We create with it, and it creates with us. This co-creative relationship is at the heart of the imaginative process and fundamental to all great storytelling.

The Invisible Structure is an archetypal structure, and as such our job as writers is to discover it, not presuppose it or take it for granted. Archetype means "primal stamp," or "original pattern," sourced from the original Greek *arkhe*, "first," and *typos*, "model." What this means is that when something is archetypal, we are working with a pattern of nature that is accessible to all human beings because all human beings use archetypal structures as part of living life. The famous analyst Carl Jung made famous the idea of the collective unconscious, that part of human nature that is shared by all human beings, and through which the Archetypes (Magician, Trickster, Animus, Anima, etc.) are accessible by every man, woman, and child. For example, Christopher Vogler's story system called the "Hero's Journey" is based on Jungian archetypes and the research of the celebrated mythologist Joseph Campbell, who described the universal mythic structure of storytelling in his famous work *The Hero with a Thousand Faces*. The Invisible Structure is another of those archetypal patterns, and as such is available to any story—in fact, it is required for a story to be a story.

"Stories are not about things, stories are things."[1] This quote from Bret Johnston at Harvard University, sums up concisely this idea: that stories are

tangible and objective and not whimsical human inventions or flights of fancy. "Stories are things" means that they have substance, form, and structure, and this substance exists not because we give stories those qualities; it exists because stories bring the substance with them as part of their very existence as stories.

When you as a screenwriter have an idea for a new script the following happens: you get the idea, you stop what you're doing and have an "ah-ha" moment, you begin to get emotionally excited about the idea, you then decide that this is something that you will spend the next 8, 12, 18, or more weeks developing and writing. An idea "drops into you" and you get so excited that you commit to the writing process.

Really—based on what? Because you got excited about an idea? How many ideas do you have in a day, and how many do you get excited about? I would bet more than one. So, something special happened with that one idea that made you decide to commit time, energy, and money toward writing it out as a screenplay. Something separated that idea from the twenty other ideas you had that day, to make its voice heard amongst all the competing voices in your creative subconscious. That "something" was the Invisible Structure. When you have a story, then the Invisible Structure is palpable. We know instinctively when a story is present because over the eons human beings have become "hard wired" to storytelling and this archetypal Invisible Structure.

THE BLINDING BALL OF INFORMATION

These are the components of the Invisible Structure:

- Character
- Constriction
- Desire
- Relationship
- Resistance
- Adventure
- Change

These are what "drop" into your conscious awareness when you get inspired to write a new story. The problem is that they don't present themselves in a nice, neat, and orderly fashion, like the bulleted list above. No, the Invisible Structure drops in as one, big, ball of information. The ball is like a blinding, bright light. You know you have something, but you can't see the pieces making the whole. This is why the individual components are invisible—you can only see the big picture, not the pieces that make up the picture. What you get is a massive gestalt, i.e., ". . . a structure, configuration, or pattern . . . so integrated as to constitute a functional unit with properties not derivable by summation of its parts."[2] Consequently, each of the seven components is more of an impression,

an intuition, not a fully formed thing. This is why it is so challenging to wrap your head around the concept of the Invisible Structure. It is abstract, beyond words, but not unknowable. In this "invisible" state, all seven components work together to create the feeling of a story and the sensation that there is something of substance present. The sensation is literally physical; many writers talk about how they feel it in their bodies when a new idea kicks into their consciousness. The final form of the story may be unknown, but the writer knows they have a story, because all seven of these components make themselves felt. The presence of the Invisible Structure, or its absence, is the reason why some ideas inspire you and others leave you flat.

KEY CONCEPT

Every story has a structure, every story must have a structure, and that structure is the Invisible Structure.

THE INVISIBLE STRUCTURE

Let's look at each component individually to appreciate the role each plays in creating this "feeling" of a story.

Character

When the Invisible Structure drops in, you get the impression that a human being is at its core: not a sport, not a chocolate cake, but a person. Why do I give such silly examples like a sport? Because this actually happened to me after a talk I gave to a writers group in California. After the talk a man walked up to me and was all excited because he loved the information about premise development and wanted to tell me all about his novel. The main character was golf. When he told me this, I thought for a moment and asked, "So your protagonist is Mr. Golf?" assuming he was talking about a human being. "No," he replied, "The sport of golf. I am a golf nut and wanted to write a novel about the sport. Golf is the main character." I told him he could not have a sport as a main character in his story, because inanimate objects are not characters, they are things. The man was not happy and summarily dismissed the entire experience of the evening's lecture, which just a moment before had him excited and enthused.

The point here is that he did not have a story because the idea that dropped into him did not give him a real sense of a human focus, i.e., a human character. If he proceeded with pages on his "golf" novel, he would quickly land in the story flood plain because there was no substance to his structure.

So, when you get an idea and the Invisible Structure is present, you get a sense of person, or an anthropomorphized representation (Harvey the Rabbit, Jiminy

Cricket, etc.) for a human being. You don't know if it is a man, or a woman, or a child, but you know this impression feels central, essential, and the center of attention of the idea. There is also a sense that this person has a forward or backward motion in the space of the idea. You don't know what that means yet, but there is a sense of motion and a centrality of this person to the fullness of the idea. If you are thinking that this character is probably your protagonist, you would be correct. But more on this later.

Constriction

Along with a sense of a central person, you get a feeling of constriction. Something breaks the inertia of the idea; something disturbs the peace of the idea. There is a tightness, a pressure that is undefined, you know it's there and it is not random, it belongs to the character. You don't know how it belongs, but you know it would not be there unless it was part of this idea. This constriction is impactful to and dependent upon this character. This moment of constriction results in the character moving from one line of action to another. You may not know exactly what happens, but you sense that they will be squeezed or pushed by something off their current line to a new line or action. This is what is meant by the inertia of the idea being broken; the character is moving along some dramatic line and then, as with all objects moving in a line of action, they are acted on by some force and moved to new action. It's basic physics, and basic story structure.

In theater, this constriction is called the point of attack; in literature and film/TV, it is called the inciting incident. There are also other terms used for the same moment, but the function is the same: the character is forced by events to change dramatic direction.

Let's use Joe the bank robber as our example. (He will be our test dummy throughout this book to illustrate points.) Joe is happily living his life, poor as a church mouse, but wanting more. His ne'er-do-well cousin Vinnie knocks on his door and says, "Hey, let's go rob a bank!" Sounds good to Joe, who's fed up with sitting around watching TV. Joe was following a specific line of action (being poor and watching TV all day), until that fateful knock on the door. Events constrict Joe into making the fateful decision—it is not an expansive moment, it is a constrictive one. If Joe did not answer the door, he would not have become a bank robber. Answering the door marked the beginning of the adventure.

Now, when the constriction drops into you, around your idea, you will not have all this specificity. I'm just using Joe to illustrate structurally what this constriction represents in a story. How it plays out and what it looks like on the page is the creative writing part of your job. But, if you have a story, then this constriction will be there and you will sense it strongly. This constriction is also connected to another key element we will talk about at the end of this part of the book: the moral component, which we will look at in chapter seven.

Desire

Along with a constriction, there is also a sense of want. The character has a desire. It's not clear what specifically that want may be, but he-she wants something. It is the wanting that you sense here, not the thing they want, just the function of wanting. Wherever you have a human being there will be desire, and you sense that desire in its generality, not in its specifics. I say that you may not know the specifics, but this is not wholly true. Often this is so strong a component in a story that it makes itself known even at this stage. But, it is not necessary at this point to know specifically what the character wants, just that they want something.

This may seem obvious, but you would be surprised how many scripts and novels I've read where the protagonist had no desire whatsoever. They just moved from scene to scene, buffeted by episodic events with no direction and no dramatic compass of any kind. This leads to a specific problem called episodic storytelling, which is a kind of storytelling where scenes or groups of scenes can come off as standalone episodes, almost as little stories within stories with their own beginnings, middles, and ends. Episodic writing can be jolting to viewers or readers, leads to uneven development, and can even alienate audiences. But, here at the Invisible Structure level, the story will give you a sense that there is desire present and it is human desire.

Relationship

Wherever you have a human being you also have relationship, and you sense that here as well. You don't know the nature of the relationship; all you sense is relatedness. There is a sense of interdependence; the character cannot exist in a void. Stories are not monologues, they are dialogues, even if you can't tell who is having the conversation. The best stories always involve a protagonist in relation to one or more other characters—they never exist in a vacuum. At this level of the story, you sense your character and you know he or she is going to be in relationship with someone else, or a group of people. You don't know their names yet, or who they are, or what that relationship is based on, but you know it's there.

Resistance

More than a constriction, there is also a sense of serious pushback. Something opposes the forward movement of the character, and this force—unknown—creates a sense of friction. You don't know yet how this will play out in action at the scene level; all you sense is the feeling of opposition. And it will lead to chaos, not order. You know that this is not going to be a neat and tidy affair. You don't know how messy it will be, or what that will look like in action, but you know bedlam, confusion, and turmoil are on the way. This opposition may have a face, but more likely it will just be a sense of antagonism, and that is enough.

Adventure

Entropy is defined as the tendency of all things to move toward disorder and chaos. Along with resistance, relationship, desire, and constriction, you sense there is disorderliness to it all. Even while the movement of the character may be forward or backward (all characters don't move forward in their journeys), the tendency is chaotic and unruly. This is the heart of the adventure, you don't know what that adventure is exactly, but you know it is there and it will be rowdy. This also feels like the middle of your story, not just a moment or a few scenes. This adventure/chaos is going to take some story time.

Change

As in life, there is order in your idea's chaos. You may not see the endpoint, but you sense this character will not end where he-she began. There is a direction in all the mess and disorder. While the middle may be a blur, there is a sense of beginning and end. If there is such a sense, then there must be something present that allows for these two points. That "something" is the phenomenon of change. You may not have a clue what change is possible, but you have a gut feeling that this idea of yours will not end up in the same emotional space as it began. Change is essential for a story to be a story, and if you have a story, then change will be present—even if all you sense is that it is there in the abstract.

TIP

Einstein's Cows and the Invisible Structure

Sit back and let me tell you some stories.

Albert Einstein had two dreams as a teenager; one was a literal dream and the other was what he called a "thought experiment," a kind of waking dream. The latter he had in 1896 at the age of 16, where he pondered what it would be like to chase after a beam of light. Already a student working on the problem of special relativity, this "dream" posed some paradoxical issues that disturbed him greatly, with him ultimately admitting 46 years later in his *Autobiographical Notes*:[3]

> From the very beginning it appeared to me intuitively clear that, judged from the standpoint of such an observer, everything would have to happen according to the same laws as for an observer who, relative to the earth, was at rest.... One sees in this paradox *the germ of the special relativity theory is already contained* [author emphasis].

Some years later, still a teenager, he had a literal dream—about cows. He was walking near a meadow and saw a group of cows huddled against an electric fence. Obviously, the current was not on. Down the way, he saw the farmer who also saw the lazy cows leaning against the fence. Being the

kind of guy he was, the farmer flipped the switch and electrified the fence. Einstein then saw all the cows jump away at the same time, in unison.

He remarked to the farmer in the dream that his cows were well coordinated to move in such a way. The farmer, still being a jerk, argued back that Einstein was crazy, they didn't all move together. What the farmer saw was each cow moving one at a time, jumping back from the fence: first one, then two, etc. Einstein argued back and forth with the farmer to no avail. They saw the same event, but saw completely different things.

Einstein awoke from this dream perplexed and confounded. How could he and the farmer have seen the same event so differently? Both the light beam "dream," and the literal dream about cows, haunted him throughout the nine years he took to construct the famous theory that would rock the world, and that we all recognize as $E=mc^2$.

Another little story: Friedrich August Kekulé von Stradonitz was a remarkable figure in the history of organic chemistry. One night in 1865, he had a dream that helped him discover that the Benzene molecule, unlike other known organic compounds, had a circular structure rather than a linear one, solving a problem that had been confounding other chemists:

> I was sitting writing on my textbook, but the work did not progress.... I turned my chair to the fire and dozed. . . . My mental eye, rendered more acute by the repeated visions of the kind, could now distinguish ... long rows sometimes more closely fitted together all twining and twisting in snake-like motion. But look! What was that? One of the snakes had seized hold of its own tail, and the form whirled mockingly before my eyes. As if by a flash of lightning I awoke ...[4]

The snake seizing its own tail (an archetypal image known as an *ouroborus*) gave Kekulé the circular structure he needed to solve the Benzene problem!

And one final story (though there are many others):[5] Elias Howe, the inventor of the Singer Sewing Machine in 1845, long held the idea of a machine with a needle that could go through a piece of cloth, but he couldn't imagine how it might work. One night he dreamt he was taken prisoner by a group of natives. They were dancing around him with spears. As he saw them moving, he noticed that their spears all had holes near their tips. When he woke up he realized that the dream had brought the solution to his problem. By locating a hole at the tip of the needle, the thread could be caught after it went through cloth, thus making his machine operable. He changed his design to incorporate the dream idea and found that it worked!

What does any of this have to do with story structure? *Everything!*

It is not news to anyone who creates that dreams are important for the creative process. There are myriad books, classes, teachers, and gurus who make very nice livings leveraging this basic and well-known truth: dreams are central to creative output. What is not well known, however, is why this is true. And this is what Einstein's cows, and Kekulé's ouroborus, and Howe's spears with the holes at the wrong end all teach us. When we

dream the solution to a problem, be it a night dream or a day dream, we are tapping into the Invisible Structure, and it is working with us to create our vision of whatever it is we are trying to create: a new motorcycle, a better toothpaste, a new light bulb—and yes, even a new story. The Invisible Structure is everywhere; it is part of how we create.

To quote Kekulé to his colleagues, "Let us learn to dream!"

BACKING INTO THE STORY

These are the seven parts that constitute any story's structure, and consequently are the building blocks of any story premise, because a *story premise is a container for the structure of your story*. So, they drop in all at once, blindingly bright, but leave the writer with an unmistakable excitement and sense of hope for a new project. But most writers don't have the story skills necessary to deconstruct that bright light into its constituent parts to build a coherent premise. Excitement turns to anxiety, and anxiety turns to panic, "What do I do now? I have to do something, or I might lose the moment," and writers do what writers do: they start writing. And here is where the trouble begins. Rather than sitting with the discomfort of the moment, we try to control it to relieve the anxiety. The only way writers can relieve that kind of anxiety is by writing, so pages commence, or voluminous character studies, backstories, and all manner of index cards on cork boards follow. In time, you will uncover the Invisible Structure components, because if you have a story they will be there (they must be there). But, jumping into writing to relieve anxiety will only lead you into the story flood plains, and most writers will find themselves lost and drowning after weeks of writing. This, in turn, will lead you to the moment when you realize you are lost and that you must backtrack, i.e., *back into your story* to find where it went off the rails. You will retrace your steps, trying to find where—in the dialogue, or the middle, or perhaps deep in the ending, or maybe all the way back in the opening pages—everything lost its form. You will keep backtracking, looking for breadcrumbs and hints on where to pick up the right storyline once again, but ultimately not finding it. In the end, you will end up back where you started, at the beginning—at the premise idea itself. This process I call backing into the story.

This is the most natural recovery strategy a writer has—and everyone does it—everyone—when they get lost in the story flood plain. If you can't find the Invisible Structure of your story idea, if you stay blinded by that "big ball of information," then backing into the story is waiting for you and your script. It is unavoidable, it is inevitable, and it is what happens—every time you get lost— unless you know how to make the invisible visible and the abstract concrete. If, however, you are armed with the most powerful tool available to any writer (the premise line), then you can bridge the crevasse between the right, true, and natural structure of your idea and a tangible story form that you can use to write a screenplay. But, before you can bridge that crevasse, you have to understand what making the "invisible visible" means; what "concrete" refers to. In this context, what we're talking about is the Visible Structure.

---*4*---

THE VISIBLE
STRUCTURE

The Visible Structure is the structure you see; it is the concrete expression of your story that plays out on the page or on the screen.

You should have noticed something subtle and important in our discussion of the Invisible Structure in chapter three. We began that discussion in the abstract, and then we slowly moved *toward* the concrete. All seven of the component elements of the Invisible Structure were introduced as almost impressions and feelings—not literal or fully formed things. As we moved through them, however, the words and the metaphors I used to illustrate and express these impressions became more substantive, i.e., concrete. This was no accident. This was not just a learning technique. This was an unavoidable evolution of the discussion, because any story follows this same path in the development process; every story moves from the abstract to the concrete. It moves from your mind as a mental image, impression, and feeling onto the page as characters, scenes, story beats, and plot. The path from the abstract to the concrete is the journey of building your premise and uncovering the structure of your story. Like you, I have no choice but to follow this same path, as I describe the two structures needed to tell any story: the Invisible and Visible Structures. I have shown you the abstract. Now we move to the next step in the journey; we move to the concrete.

Your story cannot stay in your head; it will pester you to get free and find form, but it will do so in its own sweet time. We've all had this experience with stories, they will not be forced or cajoled, or born prematurely. When left to their own devices, they come in their time, and sometimes that timing takes years. I have stories in my head that have been there for many years, and when they finally decide to emerge into the light, nothing I can do can stop them from finding their outward appearance. This was the case with a boxing story I'd had for almost nine years. I will never forget the day it decided to be born. A story that had only been accessible to me from forty thousand feet suddenly pulled me down to ground level, and I saw it fully formed and whole. That's how it felt; my creative mind literally dropped like a stone and I was staring at this

thing eye-to-eye, and I could see every blemish, every imperfection, and every character wrinkle. I wrote the first draft in five weeks and it needed very little rewriting. There was no struggle, no bouts of writer's block, no temptations to get onto social media and distract myself; no, all my usual ploys to avoid writing fell away, and the story just flowed and didn't stop until it was done. Another writer would have said that the story just wrote itself, because that's how it feels in these magical moments. But that is not what happened—stories don't write themselves. I wrote it; but at the time, there was no question in my mind that it and me were working co-creatively together. That story was the best writing partner I'd ever had. I tell you this personal anecdote to illustrate the point. This is what happens when the Invisible Structure wends its way from your subconscious into the conscious mind.

While there is value in allowing the creative process to work its own schedule, most of us do not have the time or the patience to allow our stories to ferment for years like a good wine. We have deadlines, contract obligations, or rent to pay. Fortunately, using your knowledge of the Invisible Structure, the Visible Structure, and the Anatomy of a Premise Line (chapter five) you can "induce labor" safely and facilitate your story's birth on your calendar.

THE INVISIBLE MADE VISIBLE

It should come as no surprise that the Invisible and Visible Structures are intimately connected. Each has seven components, each conveys the structure of the story, and each is necessary to tell any story. The seven components of each structure form a one-to-one relationship, as shown in Figure 4.1:

Invisible Structure	Visible Structure
• Character	• Protagonist
• Constriction	• Moral Component
• Desire	• Chain of Desire
• Relationship	• Focal Relationship
• Resistance	• Opposition
• Adventure	• Plot & Momentum
• Change	• Evolution-de-Evolution

Figure 4.1 Invisible-Visible Structure Connection

Looking at these two structures side by side should give you an intuitive appreciation for how they are connected. Each component of the Invisible Structure has its "mirror" component in the Visible Structure. The moment you feel the need to write, the moment you find yourself trying to give form to that "big ball of information"—that is the Invisible Structure working on you, pestering you to find the physical expression it will finally take. Each and every time this happens, the form it seeks is the Visible Structure.

Knowing what you know about the Invisible Structure, let's look at the seven corresponding components of the Visible Structure to better understand this fifth foundation stone of the "7-Step Premise Development Process."

Protagonist

Your general impression of a character being present in your story idea with the Invisible Structure matures into an actual person with this component. The character you sense in the abstract is almost always your main character. It's possible you might get a sense of another character upon your initial excitement over your idea, but the longer you work with the Invisible Structure, the clearer the protagonist will emerge from that original abstraction. I would never recommend telling anyone to assume anything when it comes to story development, but in this case it's a safe assumption that your Invisible Structure character is your protagonist. And, as I stressed in our discussion of the character component of the Invisible Structure, this protagonist is human. It is not a setting, or a philosophical idea, or some ethereal theme. Remember, stories are about human beings on a journey, not inanimate objects or ideas on a journey.

Moral Component

Chapter seven is devoted entirely to this important and critical topic, but I will describe it briefly here to put it into context with the Visible Structure. This component corresponds to the constriction of the Invisible Structure. Recall that the constriction is the event or incident that pinches the character to change course, to begin moving toward the adventure that will be your story. It is a constriction because this pinch forces the character to make a choice to move off their current line of action onto a new line of action, moving from pre-story time into story time. In other words, the character had a life before your story opened, then they have their constriction and it forces them, or lures them, to leave their "life before the story" to engage the new adventure. This constricting event should not just be some random incident; it should be connected to this thing called the moral component. The constriction generates an action by the protagonist (they move in the direction of the adventure), propelled by that character's moral component.

The moral component is made of three parts (moral blind spot, immoral effect, and dynamic moral tension); for now, let's just deal with one part—the rest will be discussed in chapter seven. The piece that is relevant here is the moral blind spot. The blind spot represents a core belief that the protagonist has about himself or herself, which he or she is blind to, and that is fundamentally a lie. This lie, or self-deception, drives all their significant choices, decisions, and attitudes throughout the story. It's a blind spot because the protagonist doesn't see it, but others can.

Take our test character, Joe the bank robber, as an example. Remembering our discussion about Joe from chapter three, he is self-centered and entitled. He steals other people's money because he feels the world owes him, so he's unconstrained by conventional notions of right and wrong. Underneath this motivation is a core belief driving his actions: a belief that he is special, better than everyone else. He feels he's the exception; consequently, he deserves more than an average person. Joe does not see himself as special on the outside, but that's what he feels in his heart of hearts. This is his blind spot, and it has a moral component because it motivates him to act in the world in such a way as to damage others. He gets hurt too, but as you will learn in chapter seven, "moral" is more about how we hurt others than how we hurt ourselves.

So Joe has a distorted belief about himself that is motivating actions that are harming those around him, and the belief is a lie: he is not special, he is not entitled, and he is not the exception. Therefore, the constricting event that pinches Joe into the action story of robbing banks cannot be some random event. It needs to be related to his moral blind spot. It needs to be dramatically consistent with his overall motivation, otherwise Joe's launch into the adventure will not be in sync with his true character—his action will feel false, and audiences will spot this falseness immediately. In other words, whatever pinches Joe to move off his "life before the story" narrative and onto the "let's rob banks" narrative has got to be something that supports and reinforces Joe's false belief about himself—i.e., his moral blind spot. This is how the abstract constriction of the Invisible Structure grows into the more complex moral component of the Visible Structure. This is incredibly hard to do, and most stories fall short in this regard. Most screenwriters do not take the time, or have the development skills necessary, to craft a constriction that is deeply tied to their protagonist's core motivation. But when this is done, the ensuing drama can be seamless, leading to breathtaking storytelling.

Chain of Desire

Broad-spectrum desire in the Invisible Structure leads to specific desire in the Visible Structure. In the abstract, you sense that there is human want; you don't know what, you don't know how much, you don't know if it's vegetable or mineral, but you know that your character wants something. This sense of wanting distills out into a specific form, as something tangible that can be achieved in the Visible Structure. What's more, the specific desire reveals many of the building-desires that make the overall goal achievable. A "building-desire" is a subordinate goal that relates to the protagonist's overall desire, and without which the final achievement of the main desire would be impossible to realize. Once again, Joe the bank robber illustrates how this chain gets linked together. After deciding to join Vinnie in his heist, Joe does the following:

- contacts the old gang to act as the getaway crew,
- cases the bank and studies the comings and goings of the staff,

- sets the plan to execute the heist,
- covers his tracks to make sure there is no incriminating evidence in his old apartment.

All of these have a sub-desires associated with them. Joe wanted to get a reliable getaway crew, he wanted to be prepared for the bank logistics, he needed a set plan for the robbery, and he wanted to cover his tracks. Each of these "wants" supports the overall realization of his ultimate goal: to get the money. All of these sub-goals are also sourced from the same place inside himself as his main desire; they all come from his mistaken belief in his specialness. I cannot emphasize how subtle and intricate it is for a screenwriter, or novelist, to link together a chain of tangible desires that builds to an ultimate objective, while maintaining dramatic consistency with the moral blind spot. This is a complex development task, but when accomplished, it assures that the middle of your story will not only hold together with scenes that build one upon another, but the integrity of your protagonist's inner motivations will remain front and center, influencing even the smallest of dramatic interactions and character moments.

Focal Relationship

You know that your story is about relationships, because stories are conversations and not monologues. You know further, because of the Invisible Structure, that your story's protagonist will be working in relationship with one or more other characters in the story, and this relationship is central and significant to the telling of the story. The *focal character* is the personification of that relationship. This character (or characters) focuses the narrative, through the core relationship driving the middle of the story, by acting as a window into the protagonist's moral blind spot. The focal character reflects back to the protagonist some aspect of their own self that either reveals the light or dark side of their inner moral conflict. We will talk more about "reflection characters" in part three, but understand that the focal character acts as a lens, through which the audience or reader can more clearly see the inner dynamic driving the protagonist forward (or compelling them backward) in their change process. The strongest stories have a single focal character, but it is not uncommon to have two or more, especially in an ensemble story (*Crash, Thirteen Conversations About One Thing, The Big Chill*), where many characters can act as windows into a specific point of view.

Some genres have built-in structures that assure a clear protagonist-focal character relationship: romantic comedies, buddy stories, love stories, parent/child stories, etc. In these cases, the focal character is almost always the other lover in a love story, or the other buddy in a buddy story. The focal relationship is the relationship that you first sense when you are at the Invisible Structure level—unformed and foggy—that then takes on a clearer form when you decide who the players are in that relationship.

The focal relationship is critical for your story, because it is what holds the dramatic center of your story's middle together. It is this relationship, supported

by the chain of desire, that helps you avoid mushy middles and episodic writing. Besides your main character's personality, the focal relationship is your audience's other main window into the true-self of the protagonist. Every time you open that window through this key relationship, the audience becomes more invested in the hero or heroine, and their experience of the story deepens. The focal relationship makes the difference between having a formulaic, paint-by-numbers middle, and a complex and rich story experience.

Opposition

The generic sense of pushback and resistance sensed in the Invisible Structure gives rise to a human opposition focused on stopping the protagonist from getting what they want. The opponent structure of a story can get very complex, as there are many kinds of opposition in a story. It is beyond the scope of this book to detail all the various opponents that can populate a story, but there is one kind of opposition structure you absolutely need in order to develop a sound premise line: the central antagonist. This same construct is also required for a great situation, if you forego developing a story.

The central antagonist is the main resistance facing the protagonist in a story. This is the character (preferably a single person, but it doesn't have to be) that wants to stop the hero-heroine from getting their desire achieved by the end of the story. This opposition is not abstract, i.e., Nature, God, the inner self, Cosmic Consciousness, ego, or some other ethereal notion. Remember, we are trying to move from the abstract to the concrete in order to tell a visual story—not the other way around. Even when there is a lot of subtext and subtle innuendo, the writer still has to show that subtext on the screen in some kind of action or demonstration. Ideally, this antagonist has the same overall desire as the protagonist, but is driven for different reasons. The main antagonist can be a cookie-cutter bad guy who is trying to stop the protagonist from finding the ticking bomb that will blow up Manhattan (*The Peacemaker*); or it can be the other lover in a love story that is struggling with the protagonist to understand the relationship and the meaning of love (*When Harry Met Sally*); or it can be the other buddy in an action-adventure shoot'em-up where the protagonist is oil and the other character is water, and they have to learn how to mix if they are to defeat the bigger peril threatening their shaky collaboration (*Lethal Weapon*).

KEY CONCEPT

The central antagonist is the personification of the abstraction that you sense in the Invisible Structure—it gives a face, or multiple faces, to the pushback you know is there, but cannot yet see.

The strongest stories have central antagonists who are familiar with the protagonist. Knowing the hero-heroine personally allows the opposition figure to

know what personal buttons to push and what vulnerabilities to exploit as the hero-heroine and the antagonist race to find the bomb, or get the girl/guy, or save/destroy the world. It is in the personal attacks against the protagonist (or in the personal miscommunications) where drama is created and the stakes are raised. The more acquainted the protagonist is with the antagonist, the more opportunities there are for dramatic conflict or comedic moments. These personal attacks aren't generic insults or challenges; they are always related to the protagonist's moral component (i.e., blind spot). The central antagonist's main job is to continually test the protagonist, forcing them to make choices that expose more and more of the big lie they are living, i.e., the core belief about themselves that is actually false. Whether a demonic despot trying to take over the world, or a vengeful girlfriend trying to win back her man, the central antagonist knows the hero's moral blind spot, sees it, and takes advantage of it to gain leverage in trying to control the protagonist's fate.

Certainly, you can have a total stranger be the opposition character to the protagonist, but at some point you will have to have that opposition do their research to uncover protagonist weak spots to manipulate during the middle of the story. If you don't, then how will they stop the protagonist from winning, beyond using formulaic maneuvers, tricks, and traps? If the antagonist doesn't get under the protagonist's skin by using personal knowledge against them, then the drama will be shallow, predictable, and boring. Either way, as an intimate or as a stranger, a central antagonist bent on stopping the protagonist from achieving their ultimate desire is essential for any story.

Plot and Momentum

In the Invisible Structure, you sensed the chaos that was present. This sparked images of adventurous moments, or scenes of conflict, or high drama. You got a sense that there was an adventure to be found in this big ball of information that dropped into your awareness. And, there was a sense, vague as it may have been, of direction. Your story idea had a forward motion to it; there was a sense of movement. You may not have seen where it was going, but you "knew" that it was going somewhere; there was more waiting to be revealed. Knowing that plot is character in action, and having a sense of your story's narrative drive, you knew you had connected to your story's plot and momentum.

The adventure-chaos of the Invisible Structure gives way to the physical expression of the middle of your story—i.e., how things play out on the page, the nuts and bolts of connecting story beats to scenes, to sequences of scenes, to story milestones, and to a resolution and ending. The plot-momentum component of the Visible Structure relates directly to the "middle problem," i.e., the problem of what is going to fill up pages twenty through one hundred. This is the wasteland where most scripts (and novels) fall apart: great openings and closings but mushy middles.

Plot-Momentum speaks to a broader consideration of actual planning out scenes, or creating set pieces, or plotting story milestones, and outlining action.

These are not premise development issues; these are script development issues. Consequently, from a process perspective, while related and certainly relevant to the overall story premise, the plot-momentum piece of the Visible Structure needs to be open ended and less defined for the writer. This is where you can bring in your pet story system (e.g., *Save the Cat* by Blake Snyder, or the "Mini-Movie Method" by Chris Soth), or whatever tools you use to build out the middle of your story.

Whatever writing tool or system you use to solve your middle problem, there are at least four milestones every middle should try to hit in order to maintain a good pace and build narrative momentum. Any good writing teacher will mention these milestones, one way or another. They may use different language and terminology, but the same functions will almost certainly be included in any good middle-problem solution.

1. Overall Midpoint Stakes

This is the point in the story, usually around halfway, where the stakes get raised for everyone in the story. For example: Bill and Mary are secret agents chasing a terrorist who is going to blow up the subway station in lower Manhattan. As they close in for the kill, Bill discovers the bomb is actually a dirty bomb, and not just a little pipe bomb, and will take out the whole lower half of the city. So, rather than just a limited disaster in a subway station, the bomb will kill thousands. The stakes are raised for everyone in the story. Raising the overall story stakes lifts the tension, heightens the threat, pushes the narrative into a new level of drama and consequence, and re-engages the audience by giving a new level of mystery, suspense, or danger to look forward to.

2. Protagonist Midpoint Stakes

Ideally, this occurs at the same point in the story as the overall midpoint stakes, but here the stakes get personal for the protagonist. Continuing with our Bill/Mary example: besides realizing the bomb is dirty and all of lower Manhattan is in danger, Bill also discovers that the bomber is his former best friend and ex-partner at the CIA, now turned rogue, and also Mary's long-lost brother whom she loves, and Bill is going to have to kill him, thus threatening his passionate love affair with Mary. Not only will thousands die, but Bill might have to lose the love of his life. Again, not far from what many (bad) action movies do, but you see the power of coordinating the lifting of these two levels of stakes simultaneously. Bill will get tested, his love will be tested, and he will have to fight the nemesis of his past who is soon going to look him in the eye and do everything he can to push Bill's buttons and manipulate Bill into making a bad moral choice. None of this would have the dramatic power it does without the stakes rising to a higher level for Bill and the entire city. Most stories lift one or the other stakes and leave it at that. The best stories push the boundaries with both: overall stakes and protagonist stakes.

3. Doom Moment

This is the point in the story, generally between pages eighty and ninety (or in the last quarter of a novel), where it looks like all is lost: the protagonist will not get what they want, they become isolated and alone, find themselves on the run, etc. It appears the main antagonist has won the day. But, this is also the moment where the protagonist regroups and begins their moral revival. From this point to the end of the story they are slowly rewriting that internal belief about themselves; the moral blind spot is becoming visible to the hero-heroine, and they don't like what they see. They have not completely rewritten the lie, but the change has begun. It is this doom moment that is the critical first step in the protagonist's coming evolution or de-evolution.

4. Final Resolution

Some call this the dénouement, or climax moment, or resolution, or final battle. Regardless of the terminology, this is the point in the script, usually twenty or fewer pages from the end in a script, and certainly within sixty or fewer pages in a novel, where the protagonist and the central antagonist have it out over the protagonist's fate. Everything has led them to this confrontation and the protagonist's character will be tested once and for all: will he-she change, or will they be destroyed? Two things happen during this resolution; one is metaphoric and the other is behavioral. The metaphoric event is that the protagonist achieves their desire; they get what they have wanted throughout the whole story. This is a literal moment in the story where they get the girl, or the money, or save the world, but all of these are metaphors for the behavioral change that happens when the protagonist finally heals their moral component. Often at the end of the story, the protagonist will get what they want but discover they don't really want it anymore because they've changed; instead, they get something they need, something they've been *blind* to throughout the story (hint, hint: moral blind spot).

The protagonist has been slowly changing since the doom moment, but this final showdown with the central antagonist forces them to see the ugly truth about themselves and realize they were wrong all along. They change; they grow; they become their truer self. Or, they go in the opposite direction and become even more entranced in their self-delusion and fear (a la Michael Corleone in *The Godfather*). There is no rule that says your protagonist has to change for the better. The final resolution can be fireworks, explosions, and worlds colliding, or it can be two people sitting at a bus stop having a quiet conversation. The form of the resolution is a creative writing problem, that it occurs at all is a structure problem, one that every good story needs to address.

Evolution-De-Evolution

This is simply the change that occurs as a result of the crucible the protagonist has been through since page one. Whereas the Invisible Structure gives you

the sense that your story will lead to some change, the evolution-de-evolution component of Visible Structure defines exactly what that change will look like. Your protagonist will grow or they won't. But if they don't grow, they must disintegrate and get more obsessive, fearful, or controlling (whatever is their personal peccadillo). The reason for this is that nothing stands still in a narrative, characters are either moving forward or backward in their development. Even if a character doesn't change in a story, that is a metaphor for backward character development, in the same way that not making a choice is a choice.

A subtle but famous example of this is presented in the film *My Dinner with Andre* (1981), written by Wallace Shawn and Andre Gregory (each starring as the leads). This is the story of two men: Andre, who embraces life and lives to the fullest; and Wally, who just wants to survive, pay his bills, have his *Times* delivered to his door each morning, and live with his girlfriend, Debbie. Wally and Andre sit and have dinner, and as Andre extols the virtues of esoteric acting workshops with an eccentric Polish director and being buried alive on Halloween, Wally becomes more and more frustrated with the building tension between the two men. Wally is being asked to look at how robotic his life has become (even though he finds pleasure in "the little things") and to be more alive. He doesn't have to go to the extremes of Andre to engage life more, but he needs to be more open to really living. After dinner, Wally takes a cab back to his apartment and muses a bit about the memories filling his head as he drives though familiar streets, and then when he gets home he tells Debbie all about his dinner with Andre.

In this story, Wally is a good example of how a character can choose not to change. In his cab ride home, Wally decides to just tell his girlfriend about his dinner, not to let the dinner change him. His fear of change wins, and this demonstrates how having a protagonist not make a change—i.e., choosing to stand still—is actually a step backward into constricting patterns of old behavior.

THE PREMISE LINE CONNECTION

You now know the two structures needed to tell any story: the Invisible and Visible Structures. We began our discussion in this chapter talking about how stories move from the abstract to the concrete, from the imagined to the physical image, from idea to printed word (or moving picture). But the actual dynamic that moves something like a story idea from an abstraction to a realized thing is not readily obvious. In fact, without a serious understanding of story structure most writers can only guess at how they can productively move from an idea to an actual story. Story structure theory is wonderful and intellectually fascinating, but without practical tools to bring the theory into practice, all this is just academic research, not real story development. Fortunately, this book—and everything you have learned to this point—is all about bringing theory out of the ether and down to earth. This is why the next step in this process moves from

story theory to storytelling by introducing one of the most important tools any screenwriter can learn: the premise line tool. The premise line is the primary means that every writer can utilize to turn the abstraction of the Invisible Structure into the concrete experience of a physical story recognizable to any human being, anywhere on the planet.

THE POWER OF THE PREMISE LINE

STOP

REMEMBER

The premise line is the tool that makes it possible to discover the natural structure of any story, and acts as a roadmap to keep the entire story development process on track.

THE STORY STRUCTURE-PREMISE CONNECTION

You now have three of the six core foundation stones we are laying: story premise, Invisible Structure, and Visible Structure. This fourth stone is intimately related to the Invisible and Visible Structures, in that it acts as a kind of conduit allowing one to find its expression in the other.

Figure 5.1 shows the relationship between the premise line and the Invisible and Visible Structures. As I pointed out in the previous chapter, even if a writer

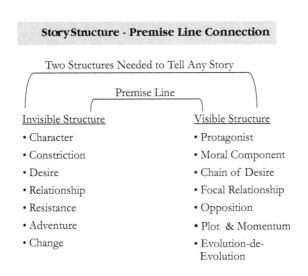

Story Structure - Premise Line Connection

Two Structures Needed to Tell Any Story

Premise Line

Invisible Structure	Visible Structure
• Character	• Protagonist
• Constriction	• Moral Component
• Desire	• Chain of Desire
• Relationship	• Focal Relationship
• Resistance	• Opposition
• Adventure	• Plot & Momentum
• Change	• Evolution-de-Evolution

Figure 5.1 Story Structure-Premise Line Connection

has some knowledge of story structure, few have the natural talent needed to intuitively know how to connect the two structures in order to make their abstraction of a story idea a physical reality. Most writers will simply start writing and cross their fingers and toes, and hope against hope "the story" will show them the way. This never happens; stories don't write themselves, and characters don't write themselves. But what does happen is that writers find themselves lost in the story woods after weeks or months of wasted writing (recall our discussion in chapter three about backing into the story). A few lucky souls possess the natural abilities to sense the natural connections between the Invisible and Visible Structures. They sense the one-to-one correspondence of the seven components in each structure, and they are able to bring the abstraction of their big idea into solid form. They don't know how they do it, but for them the "just do it" approach can produce productive results. For the vast majority of other writers, however, who may lack story structure skill sets, there is the premise line tool that can physically bridge the story structure correspondences.

Consider how electricity comes into your home. You don't use electricity straight from the power plant. If you did, you'd get fried right along with your toast. Direct power from the plant has to be down stepped, transformed, and converted into usable power. This is done through a series of power substations with transformers that decrease the voltage, stepping down the power so local transmission lines can distribute the electricity to your toaster without burning down the house. Figure 5.1 shows the premise line straddling both the Invisible and Visible Structures. It acts as a kind of transformer, stepping down the "power" of the big ball of information (Invisible Structure) that drops into your conscious awareness, converting that power into the usable and familiar story elements (Visible Structure) we all recognize, i.e., a love story, or horror story, or action-adventure. The Invisible Structure is too "charged" to be functional in its raw form. It needs to be down stepped either by a writer's natural talent for story, acting as that transformer, or through the use of a physical tool that can turn that power into usable information. The premise line is that tool, and it can be one of the most powerful tools available to any writer. In order to leverage the full force available from a premise line, however, you have to understand how a premise line is constructed, because the premise line framework is the key to capturing the essence of your story's premise—in one sentence.

ANATOMY OF A PREMISE LINE

Every premise line has the same basic construction. Remember, a story premise is a container that holds the natural structure of your story. The natural structure of your story is the Invisible Structure, which is invisible due to the fact that it comes into your creative field of awareness as a big, confusing "aha moment." The premise line is the form of that container, but more it is the tool that reveals the individual components of Invisible Structure. How? By mapping the Invisible Structure into a specific anatomy or template that lays out each piece of the Invisible Structure into a coherent grammatical clause. In English grammar,

KEY CONCEPT

*Clause #1—[**Protagonist Clause**] An event sparks a character to action, that . . .*
*Clause #2—[**Team Goal Clause**] joins that character with one or more other characters acting with deliberate purpose toward some end . . .*
*Clause #3—[**Opposition Clause**] when that purpose is opposed by a force of resistance bent on stopping/frustrating/ opposing them . . .*
*Clause #4—[**Dénouement Clause**] leading to some conclusion/ resolution.*

sentences are made up of clauses, and as we are constructing a sentence (or maybe two) then we want to incorporate clauses to build our sentence. The anatomy of any premise line consists of four essential clauses:

Every good premise line follows this template. As with any formula, it can vary and change to some degree to accommodate personal style and temperament, but the essential clauses *must* always be present. For example, if you want to bake a chocolate cake you need the recipe, so you pull out the best basic recipe you can find: Betty Crocker's chocolate cake recipe. Follow the recipe and you can churn out hundreds of cakes and they will all be flawless—one after the other. Until you start to get bored with the same old recipe (formula). So, you start to add in strawberries to the filling, and maybe a little cinnamon to the cake mix, and use whipped cream instead of butter cream for the icing. You bring some of your own personality and flare to the formula and it suddenly stops being boring and you love chocolate cake again. Regardless of your personal changes to the recipe, it still has the central ingredients that make it a great chocolate cake. Those essentials never change, and so it is with any premise line. You can make some stylistic changes and step outside the lines of the template (after you have mastered the basics), but the essential clauses must still be there for it to do its job.

Let's walk through each of the four clauses and break down the template specifically to see how each clause acts as a map to the Invisible Structure of any story. After the general discussion, I will show you how this maps out using one popular film, *Jaws* (1975). As I go through the test case, use your premise idea from chapter one and begin to think about the Invisible Structure components in your own story. In part two, we will actually work through the premise creation process using more test cases, and you will also work through your premise idea using the "7-Step Premise Development Process."

MAPPING THE INVISIBLE STRUCTURE: THE FOUR CLAUSES

The first clause is the *protagonist clause*. It consists of the first two components of the Invisible Structure (character/constriction). The objective with this clause

is to combine these two concepts into a clause that begins to tell the story in a narrative form.

Clause #1: Protagonist Clause

- Character

- Constriction

Protagonist Clause...something pinches the character and inertia stops —he-she is pushed onto a new line of action

You have a sense of a character. This is not just any character in the story; it is your main character. Who are they? If you don't know, make it up. You'll probably be right. But, if you really want to find your main character fast, then ask the following three questions:

- Who is in the most emotional pain?
- Who has the most to lose (physically *and* emotionally)?
- Who changes the most in the end?

Even if you have many characters who are in pain, who have stakes to lose, who will change over the course of the story—one character will do those things more than any other character. That is your main character.

This protagonist doesn't exist in a vacuum; they open this first clause in some state of action, even if you don't know what it is. They are a character and they are moving—even at this early stage of the formation of the idea—in some narrative direction. Then, something pushes them, pinches them, constricts them so that they choose to change direction and take a new narrative course. The feeling is that their options narrow, they are forced by an event to make a choice and this initiates the adventure they will go on. If this moment of constriction did not happen, then they would simply continue on their narrative way and there would be no story. So, your main character is engaged, confronted, or encounters some event that changes their action-line, and in this shift a bit of their motivation is revealed. Why does this constriction move them? Why not some other event? What is it about this pinch or crunch that speaks to this character so personally that he/she is willing to completely switch their dramatic focus?

Let's take our test case, Joe the bank robber. Joe opens the protagonist clause happily sitting in front of the TV fantasizing about being rich. Comes the fateful knock at the door and cousin Vinnie tells him he has get-rich-quick scheme that can't fail. Vinnie plays on his cousin's need for money and Vinnie knows Joe wants to prove he's not a loser living with his mother watching TV all day, but rather a player, someone to be respected. Vinnie knows he can play on Joe's vanity and his sense of entitlement ("the world owes me, I don't owe the world"). So, the moment of constriction relates directly to Joe's character flaw (his moral blind spot), and that's why Joe accepts Vinnie's proposal, rather than rejecting it and just watching TV. The protagonist's character flaw directly relates to the constriction that is presented—this is key in setting up what is motivating the

main character under their surface behaviors, and brings that motivation (even if vaguely defined) into the narrative in direct scene-level action. Here is how the clause would look with Joe and Vinnie:

> **[Protagonist Clause]**: . . . Joe, an entitled and vain thief, is approached by his gang-banger cousin Vinnie to lead a heist to make some easy money . . .

"Entitled and vain" is the part of the clause that identifies the protagonist and the protagonist's flaw (the thing they are blind to but that sources all their bad behavior), and "approached by his gang-banger cousin" identifies the moment of constriction, i.e., the thing that changes the protagonist's original line of action. Thus, the Invisible Structure constriction relates directly to a character flaw in the hero that will be central to the entire unfolding of the story. It is incredibly hard to make this connection between the protagonist's flaw and the constriction. Most writers do not make this connection successfully, and the resulting stories tend to be shallow and formulaic. We'll talk much more about this phenomena in chapter seven, "The Moral Premise," but know that when this connection can be made, it sets up a solid structure that can generate and sustain a solid middle and payoff for the story.

The second clause is the *team goal clause*. This clause is meant to capture the sense of want and human desire inherent in any story, as well as the relationship that will drive the middle of the story forward.

Clause #2: Team Goal Clause

• Desire

• Relationship

Team Goal Clause... the character joins with one or more people acting on some tangible desire with purpose

Now is the time to give a clearer idea of what the protagonist wants and who is going to work with him-her to achieve that goal. Most times this "other" is a single person: the other lover in a love story (*When Harry Met Sally, Titanic, The Notebook*), or the other buddy in a buddy story (*Lethal Weapon, 48 Hours, Men in Black*). But sometimes it can be an ensemble cast with two or more individuals filling in the role of "core relationship," (*The Big Chill, Crash, Thirteen Conversations About One Thing*).

A single individual usually creates a more solid middle in a story, as there is less opportunity to get trapped in episodic writing, which results in a mushy

Stories are dialogues not monologues—even in a one-person show there are many conversations going on with seen or unseen "others"—not the least of which is with the audience.

TIP

narrative. Regardless, this is the clause where that team relationship (one-on-one, or one-to-many) is identified. As well, you make clear what the hero-heroine wants—what their desire is. This should be tangible, something they can actually get at the end of the story, i.e., the money, the girl, or the shiny new truck. As stated earlier, avoid goals of wanting world peace, or oneness with God, or inner balance. These are all fine virtues, but they make terrible desires for a piece of dramatic writing where you the writer have to show action and movement and actual completion. Think about it, how do you as a screenwriter show at the scene level that a character has achieved inner balance and peace, other than putting a goofy smile on their face? The desire needs to be human, not abstract or ethereal desire. Here is how this clause would play out with Joe:

> **[Team Goal Clause]**: . . . Joe finally agrees to join Vinnie after the cousin pleads that only Joe's "leadership and talents" can get the money in the bank, with the help of Joe's old rival gang leader . . .

Here, Joe wants to rob the bank and get money (desire). This is a specific and tangible desire, and it is a desire consistent with Joe's opening motivation. The relationship is a one-on-one relationship, represented by the "Joe finally agrees to join Vinnie" phrase, that will drive the middle of the story (Joe and Vinnie), and the other supporting characters will act as support for this core relationship. So, this clause clearly sets up the relationship/team aspect of the story and sets up the clear goal and purpose for the teaming, i.e., to rob the bank.

Clause #3: Opposition Clause

• Resistance

• Adventure

Opposition Clause... the character's actions meet with some force that generates disorder and/or chaos

The third clause gives voice to the sense of resistance and pushback and introduces the adventure that will constitute the middle of the story. Resistance in the case of a screenplay means opposition. This is the clause that introduces the antagonist: the person or persons who will try to stop the hero or heroine from getting their desire fulfilled. Usually there is a central antagonist but occasionally some stories have multiple antagonists. But, if you are unsure who your main antagonist might be, ask these three questions:

- Who wants the same thing as the protagonist, but wants to beat the protagonist to the punch?
- Who knows the protagonist best and can use that intimacy to manipulate the protagonist?
- Who is a reflection of the worst kind of person the protagonist could become, unless they change?

As with the core relationship, the opponent/antagonist may be spread out among multiple characters, but there should be one that embodies these questions more than the others. Here is how the third clause plays out with Joe the bank robber:

> **[Opposition Clause]**: ... when Joe discovers Vinnie has double-crossed him and is setting him up to take the fall for the heist, so Vinnie and Joe's old gang-leader rival can take the money and run ...

In this clause the resistance stems from Vinnie, as he is the main antagonist who has set Joe up to be the fall guy. There are other opponents, but they are external to the core antagonistic relationship, which is personal and intimate between the cousins. The first impressions of the adventure are also introduced here with the suggestion that double-crossing is happening, along with a conspiracy to manipulate Joe to the advantage of Vinnie and the gang. This suggests lots of conflict, dramatic reveals, and emotional tension, though all those details do not have to be a part of the premise line.

Clause #4: Dénouement Clause

• Adventure

• Change

Dénouement Clause... the chaos leads to change and a new moral effect

Here the chaos and adventure spill into the final clause, much the way all chaos spills into the process of life-change. The adventure component of the Invisible Structure crosses the third and fourth clauses due to the nature of chaos: it spreads and is messy and is often indistinguishable from the resistance it creates and the change it generates. So in this final combination we see how chaos leads to resolution, the order implicit in all chaos. In this clause we get a clearer sense of what the final stakes of the adventure might be, how messy it might get for the protagonist, and we most importantly get a sense of the change that results from this crucible the hero-heroine has been through. For Joe, this takes the following form:

> **[Dénouement Clause]**: ... leading Joe to realize that his pride and vanity left him wide open for this betrayal, resulting in him confronting Vinnie's treachery, pulling a reversal on the scheming gang leader, and turning the whole situation around so Vinnie and the gang rival take the fall, thus giving Joe a second chance at a new life.

The adventure ratchets up with stakes building: Joe is forced to confront Vinnie (which can't end well), he has to come up with some clever plan to undermine

his old gang rival, and he has to turn the whole situation around to his advantage, allowing for justice to be done, while opening the door to a new life—after all, he learned his moral lesson, so he deserves a second chance.

Sample Premise Line

Here's how a first-pass premise line reads (slightly modified) written as a single sentence based on the clauses above. Yes, it's a tad long and complicated—but that's okay—you can always revise and condense as your refine later. The specific Invisible Structure mappings for the four clauses are bolded:

Joe, an entitled and vain thief, is **approached by his cousin Vinnie** to lead a bank heist to make some easy money [*clause#1*], with Joe only agreeing to **join Vinnie** after the cousin pleads that—with the help of an old gang rival—only Joe's leadership and talents can **get the money in the bank** [*clause#2*]; when Joe **discovers Vinnie has double-crossed him and is setting him up** to take the fall for the heist, so that **Vinnie and Joe's old rival** can take the money and run [*clause#3*], Joe **realizes that his pride and entitlement left him wide open for this betrayal**, resulting in him confronting Vinnie's treachery, pulling a reversal on the scheming gang leader, and **turning the whole situation around so that Vinnie and the gang rival take the fall, giving Joe a second chance at a new life** [*clause#4*].

PREMISE ANALYSIS

This could have been written in two or even three shorter sentences, and that is perfectly okay to do if you have a hard time writing like William Faulkner (infamous and famous for long sentence structures). But, one long sentence is a better approach because it forces you to cut out the fat and "kill your darlings." It is tempting to throw lots of adverbs, adjectives, and backstory into the premise line process; resist this as much as possible.

Notice that the ending did not end with the kind of vagary most premise lines end with: ". . . and the hero learns a life-changing lesson, while surprising everyone with an astonishing reversal of fortune." This is the kind of promotional hype most writers use at the end of pitches, because pitches are supposed to "leave'em hanging wanting more," so people think they need to hold back and not give too much information to the reader. Do yourself a favor: just tell your story. Don't leave anyone hanging, especially yourself. If you know how it ends, say so. The premise line is for you first and others secondarily. This tool is for your use to guide you in your writing, so put it all down, don't hold back thinking you're being clever.

Early passes on your premise line will always read like this one with Joe: long, a bit grammatically questionable, and dense. Subsequent passes and refinements

will hone the premise line down to a tighter and more eloquent expression. And if it remains cumbersome, so what? This is for you more than anyone else; if it works for you as a guide going forward, that is all that matters. If, however, you plan on using your premise line as part of the pitch process, then editing will surely be necessary.

The critical thing to notice with the above example, however, is how the clauses are constructed. Each clause contains clear markers for story structure elements needed to tell the story. The characters identified, the setups and reversals, the emotional components, even the specific goals of each character are all reflections of story structure in action. How did they get there? How did I decide what to put where, and why? How the heck did this thing come together, rough as it may read? In part two, the "7-Step Premise Development

TEST CASE: JAWS (1975)

CASE STUDY

Mapping Jaws	
Invisible Structure	Anatomy of a Premise Line
• Character • Constriction	*Protagonist Clause#1* … a fearful, "outsider" Police Chief of a small, coastal vacation town is asked to investigate the possible shark death of a local swimmer …
• Desire • Relationship	*Team Goal Clause#2* … his worst fears are realized when a marine biologist confirms the cause of death, prompting the Chief to hire a crusty local fisherman to hunt down and kill the beast—forcing the fisherman to take the Chief and biologist along on the hunt …
• Resistance • Adventure	*Opposition Clause#3* … only to find himself caught between the town's greedy mayor demanding a quick kill so beaches can be reopened to make money again, and the controlling, resentful fisherman who thinks the Chief is a woos, and who doesn't need or want the Chief and biologist on his boat …
• Adventure • Change	*Denouement Clause#4* … leading to the three men bonding as a team as they battle the monster; where the Chief proves his value and courage, overcomes his fear of the water, and secures his place in the community when he saves the town by killing the beast.

Image 5.6 *Mapping Jaws* (1975) Novel by Peter Benchley, Screenplay by Peter Benchley and Carl Gottlieb.

Final Premise Line:

A fearful, "outsider" Police **Chief** [Clause#1] of a small, coastal vacation town is **asked to investigate the possible shark death** [Clause#1] of a local swimmer, and his worst fears are realized when a marine biologist confirms the cause of death, prompting the Chief to hire a crusty **local fisherman** [Clause#2] to **hunt down and kill the beast** [Clause#2]—forcing the fisherman to take the Chief **and biologist** [Clause#2] along on the hunt; only to find himself caught between the **town's greedy mayor** [Clause#3] demanding a quick kill so beaches can be reopened to make money again, and the controlling, **resentful fisherman** [Clause#3] who thinks the Chief is a wuss, and who doesn't need or want the Chief and biologist on his boat—leading to the three men bonding as a team as **they battle the monster;** where the **Chief proves his value and courage, overcomes his fear of the water,** and **secures his place in the community when he saves the town by killing the beast** [Clause#4].

Premise Analysis

Jaws is a great test case to look at because the novel and the movie have some significant differences. In the film, the story is kept pretty much to the hunt for the monster and the Chief's personal growth, as he overcomes his fear of the unknown (as represented by the shark and water). Quint, the crusty sailor, pushes the Chief's "man buttons" by forcing the Chief to do menial tasks and treating him like an underling, challenging the Chief to stand up and be a man; the town's mayor and city council are just money-grubbing, small-minded folk who want to save the summer financially and get the darn beaches reopened. In the novel there was a lot more going on with subtext, subplots, and personal stakes for the Chief: his wife is bored and misses the life she used to have in the city; Hooper, the biologist, has a affair with the Chief's wife; the town's mayor is in bed with the mafia, which ups the stakes for him and the town should the mob lose any more money due to the crisis; and Hooper and Quint get killed by the shark, leaving the Chief to take on the monster alone. But, as you can see from the premise line, the film kept things much simpler, and if it were not for the Chief's personal peccadilloes (fear of the water, insecure about his role in the town, unsure of his sense of belonging), *Jaws* would just have been another generic monster movie with a paper-thin plot.

The critical things to notice in the *Jaws* premise line are the pieces of the Invisible Structure, indicated by the bolded text within the clauses. Whereas with the Joe-the-bank-robber premise line, I indicated each of the whole clauses, here with *Jaws* I actually broke out and identified each of the Invisible Structure components corresponding to each of the clauses, so you can see how they fit into the flow of the read. This could have been written in two or three shorter sentences, and you may prefer to approach your premise line designs that way, but I wanted to demonstrate how you do this as one flowing piece of text, with all the parts in play. Always remember, you can always edit, refine, and rewrite. This is how you map the Invisible Structure to the "Anatomy of a Premise Line" template, and this is what you will be doing in part two of this book with your own story idea.

Process," this will all be explained in great detail using examples from popular movies and literature. You will see exactly how to build the clauses and "map" your story's structure into this template.

While the "Anatomy of a Premise Line" template is mechanical and specific in its design, it still affords you great latitude in how you build your clauses. The "science" of premise development lies in the construction, the "art" of premise development lies in your natural story sense, and your ability to efficiently identify each of the essential components of the Invisible Structure within the template. This takes practice, practice, practice.

A solid premise line is not something you knock out in a few minutes on your word processor. Premise development can take (and often does) a month or more to get right. It is the first step in developing a script or novel, and it is the most important step, so take the time—do the heavy lifting at the premise stage. Better there than writing a hundred or more pages only to discover you are lost in the story woods and have to back into your story. Do this right; get it solid, and then you will never get lost again. This is how your premise line acts as a lifeline in your writing process. Once you have your premise line, then you know you have the basic structure of your story identified, and then you can start writing. If you start going off on tangents, then you go back to your premise line and read it. Does where you are going with your story fit your premise line? Does it make sense structurally? If the answer is yes, then keep writing. If the answer is no, then something is off: either the premise line is wrong and you have to redo it, or you are detouring into the story woods and you need to pull back and reorient your writing to the content of the premise line.

Part two of this book is all about application, i.e., taking your idea and walking it through the exercise I just showed you. But, one of the biggest issues you face, as you undertake this process, is to determine whether or not you even have a story—or something else. The logical question here is: what else is there other than a story? For that matter, what is a story? This is not as silly a question as you might imagine. Lots of writers, especially screenwriters, think they are writing a story, when they are not—they are writing something else. In the next chapter we're going to continue to build our foundation with three more critical stones: what is a story, what is a character, and what is a plot. They are not what you think they are, and their interrelationship is at the heart of any successful screenplay or premise line.

A STORY VS. A SITUATION

STOP

REMEMBER

Situations are parts of stories; they are not stories themselves.

WHAT IS A STORY?

In chapter two, I touched upon the phenomena of the terminology-language disconnect, and the fact that just because people use the same words doesn't mean they are communicating. As you've seen, this is the case with the phrase "story premise." It is also true with other words used broadly by screenwriters, novelists, playwrights, and just about anyone who writes creatively.

We now lay one more foundation stone to prepare for the "7-Step Premise Development Process." This stone is made up of three pieces: story, character, and plot. Just as with the "story premise" phrase, when I ask groups of writers to define these three basic storytelling terms, I get as many definitions as there are people in the room. Ironically, everyone intuitively knows what a story is, but when asked they tend to give very generic and canned answers, like:

- A story is a narrative.
- A story is the sequential beats of what happens in a story.
- A story is your plot.
- A story is what your characters do.
- A story is a narration of events coming to some conclusion.

All of these (and there are many others) have some ring of truth to them, and for the most part they suffice when it comes to answering the question "What is a story?" But, none of these conventional definitions actually define the thing itself in a way that has meaning and significance for storytellers. As writers, we need to be able to go beyond dictionary definitions of critical *terms d'art* like *story*, *character*, and *plot*. We have to get under the surface and see how they are inextricably interconnected because only when we can see how each term builds one upon the other can we fully utilize any of them as tools for telling a story.

So, let me begin our below-the-surface exploration by giving you my definition of a story. It will seem simplistic and perhaps even canned at first glance. It is not. We will pull it apart to show just how intricate and complex the term "story" really is.

KEY CONCEPT

A story is the combination and interplay of character and plot that is a metaphor for a human experience leading to change.

There is a lot going on in this straightforward definition. The first thing to see is the phrase "combination and interplay." This refers to a synergistic relationship. Synergy is best defined as an effect that is greater than the sum of the individual parts generating some outcome. For example, two individuals come together and fall in love, and the sum of their interaction results in a third thing that is more than either of them individually or together: they produce a relationship. The relationship is greater than the sum of its parts. And so it is with a story. A story is a synergistic effect of the interplay of character and plot. But, "character and plot" are fraught with their own troublesome definitions. What is a character? What is plot? We'll dive into these hornet nests in a little bit, but the other thing to notice in this definition of a story is the last part of the sentence, "a metaphor for a human experience."

Character and plot interplay and interact to create a metaphor. A metaphor is a representation or symbol of something else (usually something intangible). In this instance, that metaphor represents a human experience. Not an experience of a rock, not an experience of a city, not an experience of the Universal Consciousness, but the experience of a human being. As I said way back in chapter two, stories are about how we human beings teach ourselves about what it means to be human. Stories are about human experience—not some other experience.

The other part of this last part of the sentence is "leading to change." I can hear the moans and sighs now, "What a cliché, why does every story have to have characters that change? Can't people just be people? It's so formulaic." Here is the bottom line: if your story does not demonstrate your protagonist evolving into becoming more as a person, or de-evolving into becoming less as a person (the "growth" can actually be regressive), then what is the point of the story? What are you saying about the human condition if nothing is different at the end of the story than it was at the beginning? If you do this, then you probably do not have a story, you have the "something else" I've been alluding to in the earlier chapters. That something else is called a situation. Having a situation is perfectly fine, as long as you know that is what is happening, and you are consciously making this narrative choice. The problem is that most screenwriters think they have a story when they don't; they have a situation. If you want a story, you *must* have some form of change in your protagonist, either in a positive or negative direction.

To summarize: if you have a story, then you are dealing with characters and plot that combine to create a human experience that conveys some meaning about the human condition, and all this results in some change in the emotional

life of the character having that experience. The problematic issue facing us now is the problem of defining the two complicated terms "character" and "plot." In order to fully understand what a story is, you must understand how character and plot interplay and combine.

THE MAGIC FORMULA

KEY CONCEPT

(Character=Plot)=Story

The above formula makes no sense mathematically, but it makes perfect narrative sense. I call this the "magic formula" because there is magic in the telling. When you can understand the metaphorical representation that it captures, then a solid understanding of the meaning of story is sure to come.

The formula has the feel of an equation, and this is intentional. The natural tendency here would be to replace the first equal sign with a plus sign, indicating that character and plot are additive, and thus combine to create a story. But, that is not what happens. They are not additive, they are equivalent; not the same as in identical, but equivalent as in having equal weight or function. They are so interdependent that one cannot fully express itself without the other. Plot has no meaning (or is highly diminished) without character; character, if the character is three dimensional and real, must develop plot. Understand: we are not talking about a definition of story that is simply events strung together in some linear fashion with a beginning, middle, and end. We're talking about a metaphor of a human experience revealing the human condition. This is a crucial distinction, unless you are writing a script or novel that is a situation and not a story. And so the magic formula is a visual expression of the fundamental and inseparable relationship that character and plot possess, making it possible for a story to be born.

WHAT IS A CHARACTER?

KEY CONCEPT

Character is the combined effect of the personal motivation that generates a causal sequence of actions resulting in emotional change.

Character is the keystone of plot, and consequently of story. Every story is about a main character; we established this in chapter five as we unraveled the "Anatomy of a Premise Line." In any story, characters are the ones who carry out the story's action. You write scenes, set pieces (memorable and visual moments that

define the story), and sequences where characters do their "bits of business" and have their dramatic and/or comedic interactions. Some of those actions can appear random, some causally generated by events, and still others are present because the writer thinks it would be fun to have a bank robbery at page fifty.

Your protagonist acts out specific actions in a scene because of their motivation, not because you the writer think it's cool for them to do a specific action.

TIP

In the best stories, nothing is random or appears thrown into the dramatic mix because the writer always wanted to write a car chase scene to rival the one in *Bullet*. However, in the real world you the screenwriter will be asked to put things into your scripts that make no sense and have nothing to do with the story you want to tell. Welcome to the movie business. Be prepared for the "note" from creative executives, "Love your hero . . . edgy, a game-changer, sexy . . . but can we make him a robot?" This is an unavoidable hazard of script development both at the studio and independent production company levels. But what I am referring to is your story process *before* the script-by-committee meat grinder gets its hands on your work. While you are still the creative lead, you have to do the best job you can to make sure your central characters—especially your protagonist—act out of motivation, not out of whimsy or chance.

What does any good actor say to a director when they are not sure how to play a scene? "What is my motivation?" Until they understand what is motivating their character, the actor cannot know what actions will best illustrate that motivation. Without this, they will not be able to get the audience to buy into their performance and thus understand their character. It's the same with writers. What a character does on the page (or the screen) is not random—it must be by design. Characters act in specific ways because of who they are as people, not because the writer thinks it's cool. And who they are as people is defined by what is emotionally driving them to act. Joe the bank robber steals money because he can't do anything else; it's who he is as a person. The writer could have him do charity work at the local hospital, or have him decide to go back to college, or perhaps start a dog walking business, but how are any of those actions related to Joe's motivation? Remember that in our premise line, Joe is entitled and self-centered. Taking other people's stuff is consistent with his motivation, not pursuing self-improvement or charity work.

Every significant action taken by a character in a script is a window into who they are as a person. Character action is character development.

TIP

Given all of this, it should be clearer now what the first part of the character definition is referring to, i.e., the "combined effect of the personal motivation ..." The next phrase to notice is "generates a causal sequence of actions." This simply says that the motivated actions lead to causal events that make narrative sense. For example, Joe the bank robber decides he's going to rob the bank. He then, as outlined in chapter four:

- contacts the old gang to act as the getaway crew,
- cases out the bank and studies the comings and goings of the staff,
- sets the plan to execute the heist,
- covers his tracks to make sure there is no incriminating evidence in his old apartment,
- the list could go on.

He does not do the following:

- contacts the old gang to act as the getaway crew,
- makes friends with the local drugstore owner ... just because,
- sets the plan to execute the heist,
- goes to the movies because he's bored,
- the list could go on.

Joe could have done all these things, if you as the writer can devise a way to make them feel causal and connected to Joe's personality and motivation. There are no rules here (even the ones I'm apparently laying down); you get to do anything you want—*if you can make it work dramatically*. However, that is a very big "if." Many writers think they are throwing in crazy and wild character scenes that open windows into their characters, but in reality all they are doing is creating "out of the blue" moments that leave audiences or readers scratching their heads. If Joe goes to the movies because he's bored, right in the middle of planning a bank heist, then you have to establish this is part of his ritual whenever he does something bad. He goes to the movies to center himself and get into his game head. If you can do this, then it will work. The problem is writers don't make the necessary behavioral connections so that these "crazy" add-on scenes end up making dramatic sense.

The last phrase to notice is the "resulting in emotional change." This refers to the same issue as with the definition of a story. Stories are about a character on a journey of change. Obviously, that character has to change on the journey. Again, if they don't, then what is the point?

WHAT IS A PLOT?

KEY CONCEPT

Plot is the causal sequence of scenes that constitute the "what" of what happens in a story that originates from, and is at service to, the motivations behind the choices made by a character.

You should now be seeing the tight integration that is inherent in these three terms *story, character*, and *plot*. This integration is made more concrete when we consider the definition of plot. The first phrase to notice is "the 'what' of what happens in a story that originates from, and is at service to, the motivations …". What happens in the story is what happens on the page. What happens on the page is what the characters do. What the characters do is dependent on their motivations, i.e., who they are as people. So, what characters do on the page constitutes the "what" of what happens in a story, and this essentially establishes that character and plot are—at the level of the scene—essentially the same thing. Writers often speak in terms of "I'm writing a character-driven plot" or "I'm writing an action plot." There is no such thing as a character plot, or an action plot. There is only plot. And plot is what your characters do on the page.

I can hear the cries of consternation, "Are you saying, Jeff Lyons, that *My Dinner With Andre* is the same plot-wise as *Die Hard?*" —of course not. They are different in a million respects. *Die Hard* has a lot more "action," but the action is consistent not with something called an "action plot," but with a character who is a reluctant hero and is a kick-ass kind of guy. In *My Dinner With Andre*, a pure talking-heads, art-house movie, it would not be consistent with these two characters (Wallace Shawn and Andre Gregory) to start a food fight and destroy the restaurant; any more than it would have been a nice character moment for Bruce Willis (*Die Hard*) to have a quiet discussion with Alan Rickman about method acting in Poland. What your characters do is the plot, and what they do must be dependent on who they are, what their moral component is, and what they want to achieve. All these elements are about character and they *demand* certain actions while *denying* others. The most plot-satisfying stories are those in which the character's actions are consistent with their personhood, and the action that arises from who they are is entertaining.

What's more, plot is not just actions carried out by characters. All action is preceded by human choice. There is nothing that we do as humans, no action we take, that is not first preceded by a choice. Think about that in your own life; even the most mundane of actions you take every day is driven by some choice ("I will go to the store," "I want to brush my teeth now," "I think I'll sleep in"); thus, the last part of the plot definition says "… behind the choices made by a character." The choices made by characters are likewise consistent with their motivations. It's all interconnected and propelled by the emotional drives of the protagonist (or any other significant character). Character actions flow from motivation, actions lead to scene-level beats that build into scenes and sequences of scenes, and all along the way characters make choices to act or not act in accordance with the same emotional drives that sparked their journey to begin with. I will describe this flow of action-scenes and beat-choices in the next chapter on "The Moral Premise," but here you can see the main point: at the essential level of the scene, character doesn't just lead to or generate plot—*character is plot*.

WHAT IS A STORY AGAIN?

One more time, perhaps read this with new eyes:

KEY CONCEPT

A story is the combination and interplay of character and plot that is a metaphor for a human experience.

Now if you reconsider the original definition of story, the generic or cookie-cutter quality of the wording proves to be anything but generic. The word choices are precise and exact, and demonstrate that a story is a complex dance between character development, scene-level action, and choices and decisions made by characters—all of it adding up to an experience that teaches us something about out humanity and what it means to be human.

But, what if you have no need or desire to teach the world about what it means to be human? What if you could care less about teaching anyone about anything; all you want to do is have a good time and write a fun movie? Who the heck cares what you think about the human condition anyway? In this case, you don't have to write a story. You can write a situation. This is, in fact, the thing that most screenwriters write; they just don't know it. Understanding the difference between a story and a situation is one of the most valuable tools you can develop as a screenwriter. But, before I discuss why this is such a critically important skill to have, let's first look at what constitutes a situation.

WHAT IS A SITUATION?

A situation is one of the most common narrative scenarios used in screenwriting and commercial fiction. This is the case because most writers are great at coming up with clever openings and high-concept story hooks, but have little or no facility at generating and sustaining a satisfying middle. How many times have you come up with a killer opening and ending, but then asked yourself, "Okay, now what do I do for the other eighty pages?" It's the middle of your script that is the actual story, and the middle is all about character development, dramatic or comedic, and creating reveals into character personality, and relationships, relationships, relationships. Did I say it also was about relationships? It's about relationships!

Situations are not about relationships, they are not about character development, and they are not about anything other than entertainment and engagement. As you will soon see, if you can accomplish being entertaining and engaging, then you pretty much have a winner on your hands. You don't need

a story to be a successful screenwriter or novelist—you need to be entertaining. But, if you have more ambitious goals as a writer and want to actually say something about life and love and being human, then you don't want to write a situation, you want a story.

How do you know you have a situation and not a story? After all, stories can be engaging and entertaining too. There are five basic conditions that tell you if you have a situation and not a story:

THE FIVE COMPONENTS OF A SITUATION

- A situation is a problem, puzzle, or predicament with an obvious and direct solution.
- A situation does not reveal character; it mainly tests a character's problem-solving skills.
- A situation's plot twists ratchet up the puzzle or mystery, but rarely open character windows.
- A situation begins and ends in the same emotional space.
- A situation has no, or a very weak, moral component.

A situation is all about the puzzle, mystery, or problem being solved. Look at any police procedural TV show, or mystery story (Agatha Christie, *Murder She Wrote*, etc.), or most monster movies—they are all about one question: how quickly and cleverly can the protagonist get out of the pickle they are in and solve the problem. Let's take a classic (and my favorite) scenario: the twenty-something kids caught in a cabin in the woods with the monster/slasher killer/alien outside trying to get in to kill/slash/probe them. The only questions are how many kids are going to die/get probed, how bloody is it going to get, and who will survive? That's it. Nobody is going to have a big revelatory moment where they realize they have to change their lives in order to be happy; there will be no moments where we get profound insights into the inner workings of the protagonist (assuming there is a main character); and any twists or plot complications will be all about ratcheting up the tension of the problem, not pushing characters to some behavioral edge where we see who they really are—and the only change in the emotional space will be one of moving from happy-go-lucky (opening) to terror (middle) to relief at surviving (end). In other words, the hero or heroine will end the adventure in the same emotional place inside himself or herself as they started.

The most important factor of all is that in a situation there is no (or a very weak) moral component. The protagonist is not grappling with some personal flaw that results in hurting other people (emotionally) and then healing that flaw over the course of the story to undo any wrongs committed. In most situations, if the protagonist is grappling with anything personal it is merely that

they suffer from some personal demon like addiction or mental illness. Yes, these afflictions affect other people, but they are more of a personal nature than a social one. As you will learn in the next chapter, for a character's moral component to be moral it must be about how others are affected more than how the character is affected. In that sense, addiction and emotional troubles are only symptoms for deeper problems, but most screenwriters who write situations rarely go under the surface of the psychological into the real driver motivating any negative behavior a character might be exhibiting. Alcoholism is one of the favorites, and one of the most boring and formulaic. I think we can all agree that if we have to watch one more detective hitting the bottle because his wife left him, or another depressed CIA agent numbing out the pain of his lonely existence with tequila shots (no salt, or lime), we will just have to go running screaming down the hall and jump out the nearest window.

So, does it sound like I don't like situations? Does it sound like I'm advising you to not write a situation, because a story is better? If you think that is my advice, then you would be mistaken. I have no judgments about whether you write a story or a situation. In fact, just the opposite is true. My issue is: are you conscious about what you are doing? Do you know when you are writing one versus the other? I want you to be a conscious writer; one that can strategically make narrative choices based on creative objectives and goals, not one that stumbles in the dark, landing into a story or a situation and being clueless about which is which.

Consider Table 6.1; it gives you a little perspective on what I really think about writing situations instead of stories.

These are all situations masquerading as stories, and we should all be so lucky to write one of these kinds of movies. I say "masquerading" because if you asked most people who write screenplays, they would tell you these are all stories. They would think this because they don't know what you know—i.e., the difference between a situation and a story. Now that you have this key insight, you can perhaps better appreciate how powerfully situations satisfy audiences and clean up at the box office. Writing a situation, however, brings with it some unseen traps and pitfalls.

Table 6.1 Adapted from Box Office Mojo, IMDB.com, Inc., based on 2014 data.

Film Name	Box Office Performance
Battle: Los Angeles (2011)	$128.2 Million
Contagion (2011)	$135.4 Million
Gravity (2013)	$716.3 Million
Godzilla (2014)	$524.9 Million
Non-Stop (2014)	$212.5 Million

EXAMPLES OF SITUATIONS FROM CHART

E.G.

EXAMPLE

Contagion (2011, Warner Bros.):

Scenario: Average infected folks, members of Homeland Security, the Centers for Disease Control, and various scientists race to find a vaccine for a virulent outbreak of MEV-1. We follow multiple story lines as different individuals grapple with personal and scientific problems along the path to finally seeing the source of the disease and the origin of patient zero.

Structures Missing: No clear protagonist and no moral component. The story is purely driven by the outbreak and not by any single personal story. This is a race-against-time puzzle.

Analysis: The story is a classic cabin-in-the-woods setup. Instead of a cabin, however, we have a modern society being besieged by the monster, and the twenty-something kids are all adults and spread out geographically, but the state of affairs is the same: the monster (virus) is outside threatening to eat the kids, and the only questions are: how many are going to die, how bad is it going to get, and who gets out alive? It's all about the virus, the stakes, and the horror of thinking this could really happen.

Gravity (2013, Warner Bros.):

Scenario: A rookie astronaut on her first space mission finds herself struggling to survive after a random space accident generates a cascade of catastrophic events, leading to her having to race against time to find a way safely back to Earth before her oxygen runs out.

Structures Missing: No moral component. The story is a generic disaster movie, driven strictly by the dangers posed by the space accident.

Analysis: This film is a visual feast, but a narrative snack. Despite all the personal sharing and intimate banter between the rookie (Sandra Bullock) and her seasoned partner (George Clooney), the actual adventure is not driven by any personal story. The Bullock character is depressed over the death of her child, and has some guilt about what role she may have had in not preventing that death, but this has no connection to anything driving the actual story and is never developed, nor is the relationship between her and the Clooney character (who actually dies, thus eliminating any chance to develop that line). Events drive the protagonist, not the other way around. This is typical of all disaster movies: the disaster creates all the drama and generates all the jeopardy, and the protagonist (and others) can only react passively, jumping through hoops, rather than acting proactively.

WHAT DO I DO IF I HAVE A SITUATION AND NOT A STORY?

As I said earlier, if you write a situation you have two goals in mind: be entertaining and be engaging. You want to do these with a story as well, but the good news is that if you write a situation those two things are "all" you have to worry about. In other words, you don't have to worry about all the story structure

stuff that a story concerns itself with. The seven components of the Invisible Structure are not an issue. You will have a few of them in place, like a character (protagonist), desire (your hero/heroine will want to solve the problem), and some form of an opposition (the monster/killer/alien), but all the rest of it isn't necessary. Why? Because you don't have a story, you have a situation. Remember, stories have a structure; they must have a structure. If they don't then they are not stories, they are something else. Now you know what the "something else" is.

If you have a situation, and you try to impose all the structural elements of the Invisible Structure onto the situation you will create an unnatural, forced, and artificial scenario. Audiences will feel that the "story" is not working, even though they may not have the technical language or skill set to be able to identify what is wrong. They will intuitively know the story is not working as a story. How can audiences know this intuitively? Because we have all been reading, and listening to, and watching stories all our lives. We have all been raised with good storytelling and bad storytelling. We are attuned to the natural structure of good stories because we've seen, read, heard many thousands of them. People aren't stupid; audiences and readers know this stuff—they just don't know that they know this stuff. So, when you try to impose structure elements on a situation that only belong to good stories, audiences will know it, sense it, feel it. If you have a situation, focus on writing fun characters, great dialogue, impressive set pieces, and create the most complex and intricate puzzle/mystery/problem you can think of. That's a huge job, and that's exactly what all those films in the chart above succeeded in doing to become smash successes.

If you have a story, on the other hand, you have to do all these same things, but you also have to worry about the Invisible Structure components. As the screenwriter, you have the burden of being engaging and entertaining, but you also have to tell the story that is consistent with the right, true, and natural structure of the story.

The difference is that now you know something that ninety-nine percent of screenwriters and novelists don't know. You know how to tell what kind of story you are writing, and this knowledge can make an enormous difference in your ability to leverage any situation or story you decide to write because if you know what you're doing, then you can properly focus all your other skills as a writer to hone and target that situation or story into its sharpest and clearest expression on the page. This is what separates a pro from an amateur: being a conscious writer. The other thing that separates a pro from an amateur is having an intimate understanding of the moral nature of any premise idea. If you are writing a story, then the moral component can make or break your script, and if you can master this single story structure principle, then you will have a foundational tool that will deepen and expand every story you tell.

THE MORAL PREMISE

The moral basis of a story will make or break any story—every story needs a strong moral component.

WHAT DOES "MORAL" MEAN?

You now have in place five of the six foundation stones you need to understand the "7-Step Premise Development Process": story premise, Invisible Structure, Visible Structure, story-character-plot, and premise line. The moral component is the sixth piece, and in many ways this stone is so fundamental that it could stand alone. If you only accomplished having a solid moral basis for your premise idea, then you would be light years ahead of most other scriptwriters. You could throw away everything else in this book (please don't), if you successfully achieved a story with a protagonist who had a compelling and clearly defined moral component, and your story would work—it would simply fall into place. That is how commanding and influential this component is on the development of any story.

Screenwriting gurus, script doctors, creative writing teachers, and successful writers in film, TV, and prose fiction have all written about the moral aspect of storytelling. They all tell you, "You need a protagonist who is flawed," or "Your characters have to be broken in some way," or "Your hero/heroine has to be damaged goods." The idea, of course, is that the more damaged the goods the more vulnerable and sympathetic they will be, and with something broken, there is something to fix. Even with characters who are evil to the core, such as Hannibal Lecter (*Silence of the Lambs*) or Michael Corleone (*The Godfather Trilogy*), their evil has an unconscious quality to it that makes them likable beasts—they are oblivious to their own madness and this gives them the patina of innocence.

Entire books have been written about the moral underpinnings of storytelling and the need to have a moral heart to your story expressed through theme or some moral argument sewn throughout your story. So the idea of a moral premise is nothing new, and for many it may be a tired and overplayed subject that has been adequately written about. I disagree, not so much because what has previously been written about the topic has been wanting or lacking of substance— quite the contrary. There is a lot of great writing and teaching available on the

subject of moral storytelling. What is lacking is not the expression of the need to do it in stories—what is lacking is a clear demonstration of how to execute it on the page and in a piece of writing. Very few teachers and commentators articulate a clear strategy for creating characters with convincing and sustainable moral components. Mostly what you will get are the protagonists straight out of central casting: the self-pitying alcoholic lawyer crying in his beer because no one believes in him anymore; or the lonely, embittered hired assassin questioning the meaninglessness of life; or the neurotic, obsessive-compulsive, plucky comic relief who is really the sad-clown under all the affected happiness. Most writers never go below the surface of the familiar masks to get at the real motivations generating a character's behaviors. The reason they don't go deeper is that they don't know how to do it, or if they do know, they don't know how deep to go. This chapter will look at all the pieces you need to construct a powerful moral component, and then show you how to execute it (how deep to go) in your script to maximum effect. When you master this foundation stone, and then combine it with the other five foundation stones, every story you write will resonate with audience appeal, three-dimensional characters, and storylines that are unshakable.

"Moral" refers to the principles, behaviors, and conduct that define a person's sense of right and wrong in themselves and in the world.

WHAT IS A MORAL COMPONENT?

The moral component of any story is not just a single quality or trait you strive to achieve in your script. The moral component is an amalgam of three core elements that work together to achieve the kind of storytelling that lifts any story from the mundane to the memorable. The three elements of any story's moral component consists of the following:

- The moral blind spot
- The immoral effect
- The dynamic moral tension

Moral Blind Spot

The moral blind spot is literally that, a blind spot in the protagonist's sense of right and wrong, not just within themselves, but in the world. The blind spot is a core belief that the protagonist holds that twists their moral compass in such a way as to poison all external relationships. This *core belief* is generated by a *base fear* about themselves, a fear to which they are blind but that nonetheless

colors all their *choices, decisions, attitudes, and actions*—all of which results in the hurting of other people, not just themselves. The main character may have a superficial sense of their flaw, but is blind to their base fear and core belief, and is in denial about the negative impact they are having on others.

If you are starting to see how this is sounding a bit like the magic formula from the previous chapter, then you are catching on. According to the magic formula, characters act out of motivation, and their actions are consistent with those motivations. The moral blind spot is the fuel of character motivation, so any actions a character carries out must be consistent with those motivations. They take on a moral tone because the character's choices, decisions, attitudes, and actions affect other people. It's not just inner torment and angst directed against the self (though this could be going on as well). The moral blind spot is about how the protagonist is acting deficiently in the world, harming others, and all because they hold a false belief about the world, a belief that throws them into fear (equally false) and that then acts as the driver for all scene-level motivation.

Motivation is not about wanting something—motivation is the thing that makes the wanting exist at all. Characters have desire in order to find tangible objects that can feed the motivation driving their need to want whatever it is they want. Motivation sources from the inside out, not the outside in—it comes from the heart and soul of the character, and everything in the story is at service to this inner driver (remember the definition of plot!). The key to understanding is that this driver, while sourcing from the inside, is never purely interior to the character. It must find its physical expression outside the character in the form of scene-level action on the page. This idea is at the heart of the old motto and cliché, "Show; don't tell." The act of showing in a story is not just about making scenes visual, it is about externalizing in a tangible way, on the page, the internal driver that is wreaking havoc with the protagonist's moral compass.

Immoral Effect

The immoral effect is the moral blind spot in action; it is how you "show" instead of "tell." There is no point in having your protagonist suffer from a skewed moral compass unless that skew demonstrates itself in action at the scene level in the script. If your protagonist is hurting other people, then the audience needs to see it happen, not just intellectually know about the moral blind spot. To reiterate: your protagonist has a base fear (about self) that feeds a distorted belief about the world that, in turn, produces actions consistent with that fear and belief.

A good example of this is Joe the bank robber. Joe has a core fear that he is fatally broken and flawed and he'll never uncover what's wrong with him on his own (moral blind spot). So he develops a sense of entitlement (skewed belief): "The world owes me an answer to my problem. Somebody 'out there' has to fix me." In a sense, Joe is waiting for the cavalry to come over the hill to rescue him, but in the meantime he develops a twisted perception and belief that he's owed something because he is "the exception," he's the broken one. His core fear is that he is unfixable, his distorted belief is that this makes him entitled,

and the immoral effect is that he forcibly takes what is owed him—and screw the consequences.

Consider the following examples from literature, theater, and film:

EXAMPLE

Sunset Boulevard (screenplay Billy Wilder, 1950)
Protagonist: Joe Gillis (William Holden)
Moral Blind Spot: Joe feels he has no real value.
Immoral Effect: Joe uses people for advancement, even as he demeans himself; he manipulates others to look good.
Blind Spot-Immoral Effect Connection: Because Joe's lack of self-worth haunts him, he seeks out situations that remind him just how "less than" he really is, despite his hunger for achievement and the need to be admired. It is his ironic lack of value that drives his lust for being valued by others.

Amadeus (play Peter Shaffer, 1980; screenplay Peter Shaffer, 1984)
Protagonist: Antonio Salieri (F. Murray Abraham)
Moral Blind Spot: Salieri feels he is lacking talent, real genius—he's ordinary.
Immoral Effect: Salieri cannot tolerate anyone excelling at his expense, so he must destroy them.
Blind Spot-Immoral Effect Connection: Because Salieri is driven by a core fear that he is mediocre (i.e., ordinary), when faced with real genius in the form of Mozart he obsessively drives Mozart toward his own ideal of perfection—and Mozart's doom.

Of Mice and Men (novel John Steinbeck, 1937; screenplay Horton Foot, 1992)
Protagonist: George Milton
Moral Blind Spot: George fears he will be obliterated by the world if he lets down his guard.
Immoral Effect: He must compulsively protect Lennie from the world, or else it may destroy him—Lennie being a metaphor for himself.
Blind Spot-Immoral Effect Connection: Even while he resents his role as protector, he so completely identifies with Lennie's vulnerability to the world at large that he dooms both of them to a tragic end, when he is forced by his fear of the world to "protect" Lennie in the ultimate way: taking Lennie out of the world that threatens to destroy them both.

The Verdict (novel Barry Reed, 1980; screenplay David Mamet, 1982)
Protagonist: Frank Galvin
Moral Blind Spot: Frank is blind to the fact that he sees himself as valueless and not mattering.
Immoral Effect: He sees people as targets and easy prey for money; people don't matter, they're just a means to an end.
Blind Spot-Immoral Effect Connection: Frank takes advantage of people because they have no value to him, beyond what he can manipulate out of them, but he feels this about other people because he has no sense of worth about himself. He would not hurt other people if he found himself valuable; which is exactly what he does by the end of the story, reclaiming his own humanity.

Dynamic Moral Tension

While the moral blind spot is the driver that generates the immoral effect, the dynamic moral tension is the engine that keeps it all running. Throughout your script your protagonist will have to make choices—serious choices. He or she will not be choosing vanilla or chocolate, or pizza with or without pepperoni. No, the choices will be: do I cheat on my wife or not, do I kill this person or not, do I rob the bank or not, do I save myself or the baby on the train tracks? The choices are moral, in the context we have established with our definition of a moral premise. And the choices all stem from the other two elements of the moral component we have just covered, i.e., moral blind spot and immoral effect. Character choice does not exist in a vacuum, it is generated by the engine of the dynamic moral tension that is constantly testing, and prodding, and challenging your protagonist to change and grow or to disintegrate and spiral into a worse moral condition.

This is critical to understand, because the dynamic moral tension is what gives you a passive or active main character in your movie or novel. You want your hero or heroine to be active, not passive. What is the difference between the two? An active character is one that generates scene-level action based on the moral component. The active protagonist causes, directly or indirectly, everything that happens in your story. The passive protagonist is the main character that generates nothing, but who is constantly in reaction mode, responding to external events that force him-her to act. Passive main characters tend to be dull and boring, because they just get pushed around by events, rather than create the events of the story themselves.

The two loop diagrams (Figures 7.1 and 7.2) that follow illustrate these dynamics graphically.

THE PASSIVE PROTAGONIST LOOP

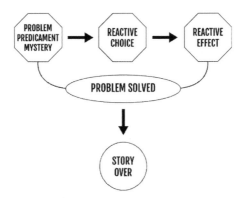

Figure 7.1 Passive Protagonist Loop

A passive protagonist faces a problem-mystery-predicament. They did not create the problem themselves; the problem finds them and they have to decide how to act. Their response to the problem is reactive, not proactive. The situation is leading them; they are not leading the situation. In fact, situations (and not stories) tend to have passive protagonists for this very reason. The situation drives the hero-heroine in situations, not the other way around. The passive protagonist is forced by events to make a reactive choice, which then leads to a reactive effect (their choice in action). The loop shows how this problem leads to choice, leads to effect, and keeps looping around back onto itself, thus generating a kind of engine that fuels the passive choice/decision making process of the main character. When the problem or mystery gets solved, the loop is interrupted and the situation is over. Situations tend to evolve into episodic storytelling, which can be distracting and off-putting to audiences (and readers). As suggested earlier, episodic writing is writing that is plagued by many narrative starts and stops, disconnected and standalone events, and mini-stories or situations within stories.

Sometimes, protagonists can appear to be the instigator of things, and so the events appear to be generated by them, but this is not the case. They simply do something stupid, or make a blunder "out of the blue" and then an ensuing cascade of events forces them to react. The blunder or stupid mistake does not source from their moral component (i.e., their character); it is just something they randomly do. Stories that portray the basically good and moral person caught up in the no-win scenario (*All Is Lost, Gravity*) follow this passive loop structure. These situations test the protagonist's stamina, or will, or perseverance, testing them to see if they have the mettle to get through the crucible they've been thrust into by random chance or by just being in the wrong place at the wrong time. Underdog stories follow this loop, unless they break out and make the story about why the protagonist is an underdog, examining the moral driver behind their passivity or underachievement (*Straw Dogs, Falling Down*), and this—not merely surviving the situation—is the real lesson to be learned.

THE ACTIVE PROTAGONIST LOOP

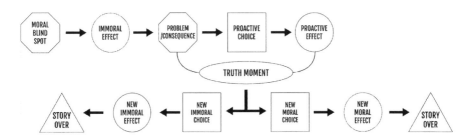

Figure 7.2 Active Protagonist Loop

In stories with active protagonists, all action is generated from the main character's moral component. When the hero-heroine is driven by that core fear (moral blind spot), and then acts consistently with the fear (immoral effect), then all events in the story are directly or indirectly sourced from character, not generated as random external events.

Let's look at how this plays out with an example: Joe the bank robber. Joe robs the bank because of his sense of entitlement, i.e., "the world owes me, so I get to take what I want" (*moral blind spot*), and he commits a crime (*immoral effect*); he does not blunder into a bank randomly and then pick up the wrong bag (filled with money) and accidentally rob the bank. Joe is the unwitting architect of his fall from grace. He is now a bank robber and on the run (*problem/consequence*), and must now find the best way to escape and not lose everything. So Joe calls up the best fixer he knows and arranges for his whole team to be snuck out of the country (*proactive choice*), leading to the whole gang becoming international criminals and targets for global law enforcement—something the gang did not sign up for! Joe's action creates a whole new complication: the gang becomes resentful and starts to conspire to maybe turn Joe in to save their own skins (*proactive effect*). Joe continues around the loop, making choices that lead to complications, that lead to effects that lead to new problems, and so on, until this loop is interrupted by Joe's moment of personal change, i.e., the truth moment. Joe is the source of the loop's action. Joe drives events; events don't drive Joe.

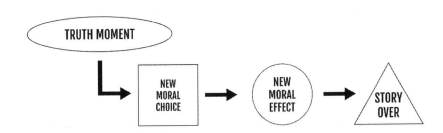

Figure 7.3 Active Protagonist Loop, Bottom Right

Through the course of choices, actions, and effects, Joe realizes he isn't owed anything by the gang (*entitlement blind spot*)—he, in fact, owes them. He owes them a chance to live normal lives and not go to jail because of him, so he does the right thing and sacrifices himself for the gang that has done so much for him (*truth moment*). This change then leads Joe down the right side of the bottom portion of the diagram: he turns himself in (*new moral choice*) and the gang escapes and their lives aren't ruined (*new moral effect*) and the story is over.

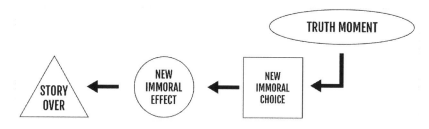

Figure 7.4 Active Protagonist Loop, Bottom Left

If however, Joe doesn't have a truth moment of growth, but decides that he must become even more self-centered in order to survive (a la Al Pacino in *Scarface*), then he follows the left side of the bottom portion of the diagram: he sacrifices not himself, but the gang (*new immoral choice*), takes all the money, and then lives a life on the run, never sleeping in the same place more than one night, trusting no one (*new immoral effect*). The story ends with him alone in a cheap motel, surrounded by piles of money he can't spend, watching bad game shows in the dark and eating junk food—story over.

In the active protagonist loop, the protagonist has a blind spot in their moral outlook, a blind spot that leads them to generate a false belief about the world that in turn generates action that hurts other people (*immoral effect*). This hurtful action leads to a problem or consequence. The *problem* or *consequence* is not some random, external thing, forcing a reaction—no, quite the opposite—the problem only exists because of the moral component in action. This problem forces the protagonist to make a *proactive choice*/decision, leading to a *proactive effect* (they've created this mess, now they'd better do something about it). The loop portion of the diagram shows how this feeds back on itself, generating more choices and more effects that act as an engine to create and source scene-level conflict. It is only when the protagonist has their moment of growth (*truth moment*), at which point they discover what they are doing wrong morally and heal their base fear (*moral blind spot*), that they can then make new moral choice and take a new moral action, effectively ending the story. If they do not have a positive growth moment, then they disintegrate down the path of de-evolution and their moral crisis deepens, perhaps to the point of self-destruction (again, think of the Al Pacino character in *Scarface*).

TIP

Conflict in any story sources from the protagonist's moral component, and this fuels the active protagonist loop, which drives the middle of any story—thus helping to avoid mushy middles and episodic writing.

As stated at the beginning of this chapter, the moral premise is so impor-
tant that it can stand alone as the keystone supporting all story development
and story structure components, regardless of the story system, guru, or writing
method you may prefer. Without a moral component, you have a situation with a
passive protagonist (even if they are shooting everything in sight), and you run
the risk of episodic writing.

SUMMARY

You now have all six of the foundation stones in place: *story premise, Invisible
Structure, Visible Structure, premise line, story-character-plot,* and *moral com-
ponent.* You have the basic understanding of the fundamental building blocks of
story development needed to begin to develop your story idea. In chapter one,
you wrote out your story premise, as best you could, and over the last seven
chapters you have probably applied some of the new ideas you've learned to
that idea. That's fine, because in the next part of this book, you and I will work
through the "7-Step Premise Development Process" using all of these six founda-
tion stones. We will walk each of the seven steps, and along the way introduce
new concepts and ideas, as well as new techniques and tools you can use going
forward with any new idea you have for a story, regardless of genre.

Keep in mind that the premise development process is not a quickie, not
a magic bullet, but rather a precision instrument that takes time, finesse, and
patience to fully master. A proper and usable premise line for any story can take
weeks or more to develop, and it may even change during the writing process,
because the premise line supports the writing, and the writing supports the
premise line. You will constantly go back and forth "testing" your idea as you
write. I will guarantee you that when you get your final premise line completed,
and then compare it to your original pass from chapter one, you will be shocked
at how different the two appear side by side. If they are not different, then you
have discovered something important about yourself as a storyteller: you have a
talent for this and you do it naturally and easily. Congratulations, you are one of
the lucky ones. Whether you are a natural or a mere mortal of a writer, part two
of this book will bring all this theory into dynamic action as we work through
the seven steps of the premise development process on your premise idea.

THE 7-STEP PREMISE
DEVELOPMENT PROCESS

This is a process that you can use for your entire writing career; it will always tell you the truth, not necessarily what you want to hear.

In chapter one, I introduced the seven steps of the premise development process. Before you could even begin to use that process we had to lay down six foundation stones, the base concepts and ideas essential to fully realizing the potential of the premise line tool and the seven-step process designed to create that tool. Now, with those stones in place, however securely, we turn to what could be called the practicum section of this book. Here, in part two, you will have the opportunity to apply all those new ideas and concepts in a practical, methodological way to your story idea—even if you didn't write out that idea in the first exercise.

THE 7 STEPS

"The 7-Step Premise Development Process" is designed to give you a repeatable, reliable, and validated methodology for consistently producing stories that will have narrative legs and survive the overall development process. As I said way back in chapter one, I cannot promise that every story idea you have will survive the process, but, in the end, you will be grateful for learning sooner rather than later that you may be running after the "wrong" story. Knowing upfront that you are working with a weak idea will save you countless hours, weeks, or months writing something that would ultimately lead you into the story flood plains. This process will empower you to be a conscious writer, i.e., give you the tools you need to make an informed and productive choice about where to put your creative energy, time, and money.

To that end, the "The 7-Step Premise Development Process" contains the following steps:

Step 1: Determine If You Have a Story or a Situation
Step 2: Map the Invisible Structure to the "Anatomy of a Premise Line" Template
Step 3: Develop the First Pass of Your Premise Line
Step 4: Determine If Your Premise Is High Concept
Step 5: Develop the Log Line
Step 6: Finalize the Premise Line
Step 7: Premise and Idea Testing

You and I will take each of these steps and systematically work through the process with your story idea. Some steps are straightforward and uncomplicated, like "Step 3: Develop the First Pass of Your Premise Line." But others require more detailed explanations and treatment, like "Step 4: Determine If Your Premise Is High Concept." In many ways, this part of the book is an iterative loop, meaning that you can work through the seven steps and loop back through the steps many times, tweaking, honing, and refining your premise line. After the first time through, you will not have to repeat "Step 1: Determine If You Have a Story or a Situation," because you will know whether you have a story or a situation, but you will repeat steps two through seven. I have known people, including myself, who have taken more than a month working through this seven-step process. In fact, I have had stories of my own that have taken me more than two months to refine into a workable premise line. I don't say this to discourage you—quite the contrary. One of the first myths I'd like to help dispel for you is that premise work is not real writing. So, use this part of the book as your ultimate resource, and as with a great search engine, you can come back time and again and always discover something new.

WHY A PROCESS AND NOT JUST A LIST OF STEPS?

It is important to realize that what you are learning here is a process and not just a list of seven steps. Lots of self-help books sell various steps as part of the hype to get you to buy the book: seven steps to perfect health, five steps to six-pack abs, three steps to finding the love of your life, and many more. This book promises seven steps to master premise and story development, and while I admit part of this is marketing copy, it is also literally the truth. But these seven steps are not just a numbered list of "to-dos." The "7-Step Premise Development Process" is a process, not a list.

A list is simply that: do step one, do step two, and so on. You work through the list in a linear way and carry out each list item slavishly, in order, and you don't skip any steps. You do the list as it's written and the final result should be the promised deliverable (your six-pack abs or the love of your life). A process, however, is very different. A process is a sequence of interdependent and related procedures, often involving inputs (data fed into the system) and outputs (outcomes resulting from the processed data) at various points in the process, leading to some expected goal or result. For example, in this process, each step does not stand alone; rather, each builds, one upon the other. Step one feeds into step two, and step two provides the input data needed to execute step three, and so on. This interdependence and input-output relationship is

essential in appreciating how working a process is different from just running a list of "to-dos."

The other important aspect of a process is that at some point you will make it your own. A list is a list; it doesn't change. It is always the list. Not so with a process. With a process, you learn the steps, work the process-procedures, become familiar with the inputs and outputs, and develop an intimacy with the inter-relatedness of all the parts. Over time, steps merge, combine, or seemingly disappear and you find that you can "skip over" whole steps because you just know what to do. It becomes so second nature that you don't have to think about it; you just do it. You are not a slave to the list—in fact, you change the process by customizing it to your style of learning and your creative process. You don't keep doing each step because Jeff Lyons (or anyone else) says you have to do it in any particular way. No, you make it your own; it becomes your process, and, as such, it becomes streamlined and self-engineered to facilitate your creativity, not some formulaic requirement dictated by a guru or teacher.

Listen to everyone, try everything—follow no one. You are your own guru.

When this happens, when you make the method yours, then you can say you have mastered the process. But this only comes with practice, practice, and more practice. If you just try it a couple times and then put this book up on a shelf or in a drawer, then you get what you pay for: a nice paperweight and not a powerful development tool.

FORMS, WORKSHEETS, AND SAMPLES

As you move through the seven steps, along the way I have provided some customized worksheets and development templates that you can use to facilitate knowledge transfer. You don't have to use these tools, you can just wing it yourself and do your own thing, but I find that the documents I've provided do help focus the work and make the steps easier to visualize. You can access the forms, templates, and worksheets at the companion website set up for this book provided by the publisher. You can find the web URL address in Appendix C of this book. Once you go to the resource webpage, instructions for downloading documents will be available on the website. You will find the following forms and worksheets.

Premise Line Worksheet

This is the primary tool you will use to develop your story's premise line. It guides you through the four clauses and maps the Invisible Structure to the four clauses of the "Anatomy of a Premise Line" template. This will be used in "Step 2: Map the Invisible Structure to the 'Anatomy of a Premise Line' Template."

Log Line Worksheet

This is the tool that you can use to develop your log line and tagline. It asks you basic questions to help you identify the hook of your story. This will be used in "Step 5: Develop the Log Line."

Premise Testing Checklist

This is the main tool that you can use to test your own premise ideas. This is a blank form that you can duplicate and use accordingly. This will be used in "Step 7: Premise and Idea Testing."

Premise Testing Checklist Example

This is a fully filled-out premise testing checklist that illustrates how to properly fill in the boxes and add up the totals. This is also used in Step 7.

So—let's begin.

STEP 1: DETERMINE IF YOU HAVE A STORY OR A SITUATION

Why This Is the Hardest Step

Many of the steps of this seven-step process may feel hard at first, but of all the steps, this one is the hardest, because you have to tell yourself the truth. You know the five main criteria for assessing a situation versus a story, and once you work through each of those conditions you have to be willing to face the empirical results.

Does your story idea present a puzzle, mystery, or problem that is all about solving the problem and almost devoid of revealing your protagonist's growth as a person? Is your protagonist challenged to almost exclusively out-think, out-maneuver, or out-fox the opposition, and not to change himself or herself? Are all of the reversals, complications, and subplots designed to complicate the problem and create more obstacles to be overcome, rather than open windows into character motivation? Does your protagonist end up in essentially the same emotional space at the end of the story as at the beginning? And is your protagonist grappling more with a shallow, personal psychological demon like booze or ADHD, rather than struggling to heal a profound moral component that drives all core dramatic action?

Take time with all of these five conditions and go over them carefully with impeccable attention. Don't rush. If you end up with a situation and not a story, tell yourself the truth; it is only then that you can make an informed and proactive creative decision about how to proceed. If you have a situation and you move forward as if you have a story, then you will end up getting lost in the story

flood plain. You will end up doing what I talked about in chapter three—losing your way and then backing into your story to find the right path forward. This is not the end of the world, but it is not a place you have to end up. As I've said before, this step is your first canary in that story coal mine. If it is lying dead on the bottom of the birdcage, you might want to start backing out of the cave. But, even if the canary dies, it doesn't mean the idea has to. Remember, situations can be fun, entertaining, and financially profitable at the box office (and in print). Just tell yourself the truth about what it is you are dealing with—a story or a situation—and then you can make the best development choices.

TIP

The Whistles and Bells Test

The whistles and bells test is a quick test you can carry out whenever you get the inspirational flash of a new story idea. It is a simple, cut-to-the-chase technique that can quickly give you a sense of whether you have a story or a situation. It is not a substitute for learning the difference between a story and a situation, or for working through the full premise development process, but over time, with a lot of practice, you can hone a kind of sixth sense for the presence of a story. Here's how you do it:

1. Take your idea and get rid of all the whistles and bells. Get rid of all the car chases, all the robots, all the aliens, all the quirky set pieces; everything that you think is cool or that makes your script special and unique. Strip out all the flash-bang and glitz.

2. Ask the question, "What is the story?"

3. Wait and see what comes. If you have a story you will get a gestalt impression, almost immediately, of something like the following:
 - This is a story about a man who has to learn how to love.
 - This is a mother-daughter story about the meaning of loyalty.
 - This is about a guy who will die if he doesn't learn how to forgive himself for the past.

The test is especially useful with genre stories (mystery, horror, action-adventure, romance, etc.). For example, if you have a murder mystery, take away the murder and the mystery elements and than ask yourself if the story can still support itself without these two elements. If it is a story and not a situation, then you will still have a sense of the story (the human experience) even without the presence of the murder mystery.

Don't look for lots of story details. Look for the big-picture sense of the thing: the protagonist and the main issue they face. You may get a clear picture of the opponent or core relationship too, but if you have a story you will get a gestalt sense of the hero-heroine and the core issue. The whistles and bells (action, adventure, mystery, etc.) are just noise, so when you get rid of them—if you have a story—it will hold up and shine through. A situation will just leave you with an action line or a puzzle-mystery to be

solved. If you get a statement in your head similar to the three bullet points above, then you know you are on the right track and you can have even more confidence moving forward with the premise process. The "Whistles and Bells Test" is a powerful and easy technique that, when mastered, can develop your story senses to a fine edge.

EXAMPLES OF SITUATIONS

EXAMPLE

All Is Lost (2013, Lionsgate):

Scenario: A lone sailor's (Robert Redford) small boat is rammed at sea by a cargo container and he must survive the elements and his own mishaps in an effort not to lose hope.

Structures Missing: No moral component, no core relationship, no opposition (no, the sea is not the opposition, it is the story context—inanimate objects can't be opponents).

Analysis: The story is about a guy battling himself to not lose the will to live in the face of overwhelming odds. This is a classic man-against-nature story, which is always a man-against-himself story. While these can be entertaining and engaging, they are almost always dramatically shallow and one-note. The sailor (unnamed in the story) is fighting for his life, but the message is more about "never give up," which is also the tagline for the film. The main character does not give up, but he does give in and gives himself over to his fate, only to be rescued in the final seconds of the film—thus proving all is not lost. The entire film is a puzzle-problem scenario that tests the mettle of the hero, but it is more about problem solving than character development. We learn nothing about this man, other than that he is all too human.

Godzilla (2014, Warner Bros.):

Scenario: A scientist (Bryan Cranston) who thinks he has discovered the true cause of a horrible disaster in Japan convinces his estranged son, Ford (Aaron Taylor-Johnson), to help him investigate. The father dies when his theories are verified and two MUTOs (Massive Unidentified Terrestrial Organisms) begin a rampage of destruction. Godzilla, the MUTOs' only natural predator, reappears after being thought long dead, and proceeds to hunt his natural prey, while Ford uses his special ordinance skill set to disarm a nuclear bomb that is meant to kill the MUTOs, but which also threatens to destroy San Francisco. Ford explodes the bomb safely away from the city, which kills the MUTOs' nest, and helps Godzilla get the upper hand in his own fight with the other monsters. Everyone is saved, and Godzilla goes back into the sea, presumably to arise again when nature calls him to save the day.

Structures Missing: No moral component, no core relationship (after father dies).

Analysis: This film follows in the tradition of the original, as a 1950s "B" monster movie. The father-son story promised some human depth, but was cut short with the father's demise, and Ford's "disarm the bomb" storyline only tangentially related to Godzilla; the real threat were the MUTOs. Ford started off as a promising character, as he grappled with his eccentric father, but then degraded

into a typical "B" movie hero as he raced to rescue the city (and save his family). After the Cranston character died, there was no human relationship to drive the middle of the movie—or the hero—it was all monsters, all the time.

Use the five criteria to assess your story idea. Take your time. Assess whether you have a story or a situation, and then move forward. If you have a situation, then you can still do the next step, "Map the Invisible Structure to the 'Anatomy of a Premise Line'," but you will not have a meaningful constriction, moral component, or change. There is still benefit, however, in going through the mapping process to come to a strong, situational premise line.

STEP 2: MAP THE INVISIBLE STRUCTURE TO THE "ANATOMY OF A PREMISE LINE" TEMPLATE

Once you know you have a story, you can then map the Invisible Structure to the premise line template introduced in chapter five. If step one of the process is the hardest step, then step two is the longest. This step will benefit from you taking your time and having patience. I suggest you spend at least two weeks working through the Invisible Structure of your story idea. If you can allow yourself the discipline and fortitude to take even longer, that will be fantastic. I am usually of the school of thought that "less is more"—however, not in the case of this step of the process. In this case, "more is more."

Apply the Map to Your Story Idea

If you did the first exercise in chapter one, then you have your first premise line written out. If you did not do the exercise, I suggest you go back and do it now. I'd like you to have some form of your premise written out so that you can do the mapping and have something concrete you can tweak and change as you repeat this step as many times as you need to. Take your story idea and do the following:

1. Let your idea roll around in your head, and as you do, look over the seven components of the Invisible Structure (*character, constriction, desire, relationship, resistance, adventure,* and *change*).

2. Read over your premise the way you have it written down and begin to look for each of the seven components in your writing. They will often jump out at you as single words, or more likely as phrases in the sentences. Write them down on a separate piece of paper to easily identify them. Repeat this as many times as you need to in order to get a solid feeling that you have found all the structure pieces obviously present in the writing.

3. Now write down the missing pieces of the Invisible Structure, if some are absent. Which components did not jump out at you? Which appear lost? Maybe they are lost, or maybe they exist between the lines, and you just have to tease them out a bit? Go over your premise one more time (or many times) to get a sense of which Invisible Structure components are truly absent and which are just hiding behind the subtext.

4. Map your premise to the "Anatomy of a Premise Line" template. Use the "Premise Line Worksheet" accessible through the e-Resources/Companion website URL provided in Appendix C, or refer to the worksheet example supplied in Appendix A, "Worksheets and Forms." Build each of the four clauses of your premise line (protagonist clause, team goal clause, opposition clause, and dénouement clause). If you don't use any of the provided worksheets, then duplicate the example premise maps given below.

Repeat this as many times as you need to, until you have a premise line that reflects the seven components of your story's Invisible Structure, as best it can. You don't have to get this perfect—in fact, you won't. The key to this second step of the process is to listen for the structure talking to you, because it will "talk" to you as you work through the mapping. The pieces of the Invisible Structure that are clearly present will stand out, and the missing or hidden pieces will slowly make themselves known as you play with the language and rearrange sentences, manipulate phrases, and have fun with the wording. If you need to go back and review chapter five, "The Power of the Premise Line," to re-familiarize yourself with each clause and its internal structure, then please do so. When you're ready, follow the worksheet and write out your clauses as best you can. It helps to put the Invisible Structure elements of each clause in bold or underline so that you can visually identify them in the writing, thus assuring yourself that you are including the key structure pieces you need for each clause.

Be meticulous in the mechanics of the mapping process, but also be fluid and flexible in the creative writing taking place. This will be work, and can frustrate and challenge you. But, as I pointed out early in this book, it is better to sweat, strain, and work hard at this phase of the development process—before you have written a hundred or more pages of your script—than to write, write, write and find yourself lost in the story woods.

And don't be discouraged if this step takes more time than you think it should take. Step two is the longest step of the process and juggles all the concepts you learned in part one. It is complex, but complexity breeds ease, not struggle. It may not feel that way as you work through the mapping, but you will see the truth of this when you come out the other side.

Three Test Cases

Use the following three films as guides to your own mapping process. Notice how the four clauses for each premise line are mapped to specific language

reflecting the narrative of each story, and how that narrative, in turn, reflects back on the Invisible Structure. These are good examples that can help you visualize how your story might look after it is mapped.

THREE TEST CASES

CASE STUDY

Mapping *Twilight*	
Invisible Structure	Anatomy of a Premise Line

- Character
- Constriction

Protagonist Clause … 17-year-old Bella agrees to move to Forks, Washington, and live with her father …

- Desire
- Relationship

Team Goal Clause … she finds herself powerfully drawn to classmate and bad-boy vampire Edward Cullen, with whom she begins an obsessive love affair culminating in her desire for him to turn her into a vampire …

- Resistance
- Adventure

Opposition Clause … the affair and Bella's life are threatened by James, a predatory vampire who targets Bella for death because she is a "hard target," as he loves the hunt more than the kill …

- Adventure
- Change

Dénouement Clause … Bella uniting with Edward and his vampire family, who kill James, effectively bringing Bella closer into the vampire fold.

Figure Pt2.1 *Twilight* (2008) Novel by Stephenie Meyer, Screenplay by Melissa Rosenberg.

Final Premise Line:

When 17-year-old Bella agrees to move to Forks, Washington, and live with her estranged dad, she finds herself powerfully drawn to classmate and bad-boy vampire Edward Cullen, with whom she begins an obsessive love affair culminating in her desire to be turned into a vampire so that they can be together forever, until the affair, and Bella's life, are threatened by James, a predatory vampire who targets Bella for death because she is a "hard target," and he loves the hunt more than the kill. This leads Bella to unite with Edward and his vampire family, who kill James, effectively bringing Bella closer into the vampire fold.

Note: This premise "line" demonstrates how two sentences can be used, and this works just fine. However, try for a single sentence, as this forces you to cut and kill your darlings. Definitely avoid more than two sentences.

Mapping *The Godfather*

Invisible Structure	Anatomy of a Premise Line
• Character • Constriction	*Protagonist Clause* … the "innocent," youngest son of a mafia Godfather discovers his beloved father has been shot in a turf war …
• Desire • Relationship	*Team Goal Clause* … he agrees to join with older brother Sonny, and step-brother Tom, to exact revenge and re-establish the family's honor and his place within the family …
• Resistance • Adventure	*Opposition Clause* … when his innate ruthlessness to keep his family safe emerges causing Sonny and Tom to question his methods, distrust from his wife, and escalating an already out-of-control war with the other mafia families …
• Adventure • Change	*Dénouement Clause* … leading to Sonny's death, his wife's growing trepidation about the marriage, a bloody but final end to the war, and his own metamorphosis into the new Godfather.

Figure Pt2.2 *The Godfather* (1972) Novel by Mario Puzo, Screenplay by Mario Puzo and Francis Ford Coppola.

Final Premise Line:

The "innocent," youngest son of a powerful mafia Godfather discovers his beloved father has been shot as part of a turf war, and agrees to join with older brother Sonny and step-brother Tom to exact revenge to re-establish the family's honor and reclaim his own place within the family; when his ruthless need to keep his family safe emerges, causing Sonny and Tom to question his methods, distrust from his wife, and escalation of an already out-of-control war with the other mafia families; leading to Sonny's death, his wife's increased fear about what kind of man she's married, a bloody and final end to the war, and his own dark metamorphosis into the new Godfather.

Note: This premise line demonstrates that a sentence may be very long, but can be written using proper grammar and punctuation as a single sentence. William Faulkner wrote this way and won a Nobel Prize (meaning he wrote long sentences with compound punctuation and many clauses), so don't be put off by a complex sentence structure. The semicolon can be your friend; learn how to use it properly.

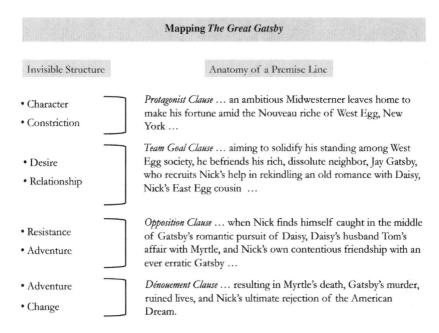

Figure Pt2.3 *The Great Gatsby* (2013) Novel by F. Scott Fitzgerald, Screenplay by Baz Luhrmann and Craig Pearce.

Final Premise Line:

When Nick Carraway, an ambitious Midwestern trader, leaves home to make his fortune amid the glamour of Long Island's Nouveau riche, he attempts to solidify his standing among moneyed society by befriending Jay Gatsby, Nick's rich and dissolute neighbor, and finds himself recruited by Gatsby to help rekindle an old romance with Daisy, Nick's East Egg cousin; Nick finds himself caught in the middle of Gatsby's romantic pursuit of Daisy, Daisy's husband Tom's affair with Myrtle, and Nick's own contentious friendship with an ever erratic Gatsby, resulting in Myrtle's death, Gatsby's murder, ruined lives, and Nick's ultimate rejection of the American Dream.

Note: This premise line demonstrates that you can change some of your wording in the final premise line so that each of the clauses don't have to be slavishly followed word for word. In the Gatsby final premise line, I revised some of the text so that it captures the same effect, but reads a bit better than the individual clauses. Let yourself be flexible in how you render your final premise line. Let the mapping process act as the heavy lifting, and then refine or alter as you see fit for the final pass. Remember, this isn't about being a mindless drone and doing the steps the way some guru tells you to—including me—do this the way you need to get results.

STEP 3: DEVELOP THE FIRST PASS
OF YOUR PREMISE LINE

Now that you have worked through step two, you should have a fairly good map of the structure of your story in the form of the four clauses. They may be rough and grammatically awkward—that's fine. Now is the time to refine and improve the narrative flow of your raw clauses. Use the map as your guide. This is the step that takes the output from step two and turns it into a narrative. Take some serious time with this step—don't be rushed. Here is a basic approach that might help in the refining process:

1. Don't worry about having this be one sentence at this point. Write out each of the clauses as separate sentences, if that's what feels right. You can condense and edit later.

2. Literally mark up your writing and identify all the Invisible Structure pieces. If you are working off a computer screen, then highlight the seven components in a bright color. They may be single words or phrases, but look for them and mark them so you can physically see them in the text. If you have a print-out, mark up the copy accordingly. The idea here is to validate that you have the structure pieces in place.

3. Once you have as many of the pieces in place as you can identify, start to rewrite the text with an eye toward killing your darlings; meaning, get rid of the adverbs, adjectives, and all the colorful and superfluous language that you think is clever or even "necessary" writing, but that doesn't really tell the story. Here is an example of what I mean:

Text with lots of "Darlings" to kill:

Belfast, Ireland, 1967—When heavyweight contender Mickey Kerry, obsessed with becoming the Northern Ireland Area Champion, is approached by the reigning champ, Barney Wilson, for a title fight, Mickey hides the news, as well as his terminal illness, from his blond-haired, blue-eyed wife Jane, knowing full well that this fight is his last chance at the championship title—and the only hope for keeping his family from becoming homeless and penniless. Mickey teams up with Ben, his boxing manager, to secretly prepare for the Wilson fight, setting up a training camp and working secretly with Barney Wilson's team to better prepare himself for the battle, a battle Mickey fully expects will kill him. At the same time, Mickey tries to set Jane up in her "dream business," to prepare her for a life without him. Jane discovers he's lying about the Wilson fight and kicks him out, turning then to a potential suitor, Inis, a local cop and "normal guy," the kind of guy Jane had hoped Mickey would become someday. Inis is ready to step in and replace Mickey. Mickey loses the Wilson fight, and all his dreams, and in desperation arranges a winner-take-all fight

with his worst nemesis, Rufus O'Reily, a fight that Mickey wins—thus winning back Jane and saving his family from ruin. He finally succumbs to his illness on Boxing Day, 1967, but not until after showing Jane the new store he bought her with his O'Reily winnings and spending the best Christmas of his life with his family.

Analysis:

As you can see, this premise has six sentences and lots of "value-added" language that could be considered fluff. But this is a great example of what your first-pass premise line might look like. Don't worry about the early passes, they will all look and sound like this: long, flowery, and a bit overwritten. This is what you want. Once you know you have all the components of the Invisible Structure present, then you can start pulling out all the extraneous text and refining your language down to essential clauses. As I keep emphasizing, this may take time—lots of time. Take that time and let that be okay; it's part of the process. Eventually, you will cut your premise down to a single sentence, or maybe two. In this case, the final result is spliced together with punctuation—not the best stylistic technique—but it's still grammatically correct. One of Faulkner's sentences from his novel *Absalom, Absalom* clocked in at 1,288 words. So, don't worry if your sentence is long and a bit unwieldy—concern yourself with how smoothly it reads and what it says.

Text with the "Darlings" cut out:

Heavyweight contender Mickey Kerry, obsessed with becoming world champ, is approached by reigning champ Barney Wilson for a title fight and joins with Ben, his manager, to secretly prepare for the fight of his life, hiding the truth of his terminal illness from everyone, while trying to set his wife Jane up in her dream storefront; when Jane discovers Mickey's scheme and kicks him out, she turns to a potential suitor, Inis, who is ready to step in and replace Mickey. When Mickey loses the Wilson fight, he is exposed as a liar, and in desperation arranges a winner-take-all bout with his worst nemesis, knowing it will lead to his death—he wins the fight, wins back Jane, and saves his family from ruin—only to succumb to his illness on Boxing Day, 1967, after spending the best Christmas of his life with his family.

Analysis:

As you can see, this version has only two sentences and is cut down to just the essentials needed to tell the story. We will use this same storyline in the next chapter as part of our synopsis-writing exercise, and you will see the premise line expand a bit to accommodate more of the story. The example here is meant to illustrate just how much you can cut from most prose and still retain your intent and the story's integrity. "Killing your darlings" is a necessary craft skill every writer needs to learn, and one of the hardest to execute (no pun intended).

TIP

The premise line is for you foremost and for others secondarily. It is your lifeline as a writer, so make sure it speaks to you as a writing tool. If it speaks to you, then it will speak to others.

STEP 4: DETERMINE IF YOUR PREMISE IS HIGH CONCEPT

At this point in the process we have defined your premise: we have broken it down to reveal your story's Invisible Structure and validated that structure to demonstrate that you do, in fact, have a story and not something else—and you have settled on, at least preliminarily, your first premise line. Now it is important to understand what kind of premise you are working with: is it high concept or soft?

The obvious question you are probably asking at this point is, "I have a working premise—I'm happy! Who cares what kind of premise it is?" And that is a good question, a very understandable question, especially considering all the good work you've done to get a premise line. So, allow me to list exactly who will care a great deal about this issue:

- Literary, film, and television agencies
- Story development executives at production companies
- Movie studio creative executives
- TV network executives
- Independent film and television producers
- Film distributors and foreign sales agents
- Story department gatekeepers (readers, story analysts, story consultants)
- Essentially anyone and everyone that will be involved in marketing and selling your screenplay in the world marketplace

A lot of people will care what kind of premise you have. This concern affects you creatively, but it also affects your professional bottom line. In a moment, we will look specifically at what high concept means in the context of developing a story, but the essential point here is that the kind of premise you have is not so much a creative writing problem as it is a business issue. High concept sells scripts and novels, and gets movies made. Soft premises have a harder time getting optioned or sold, because marketing departments at movie studios have a difficult time conceptualizing effective sales campaigns, or identifying clear target markets for soft story ideas. They love high-concept ideas; those they can sell with gusto.

Screenwriters understand this better than novelists because the idea of high concept is endemic to the screenwriting trade. The term is part of the

entertainment industry lexicon, even though few actually know what it really means. The stronger the high concept, the more likely a writer will get a pitch meeting or break through the gatekeepers at a production company or studio. But the same is true for novelists. There is a reason why Stephen King sells more books every year than most other novelists, and it has nothing to do with any perceived literary qualities of respective writing styles. Stephen King sells more books because he is a terrific prose writer and has mastered the art of the high-concept genre novel. He has found that magic balance between creating a piece of prose literature and commercial publishing.

Which Is Better: High Concept or Soft Concept?

If high concept translates into more sales, then high-concept premises must be better than soft premises—right? Wrong. The objective is not to make some judgmental assessment of right or wrong, better or worse, or to suggest some hierarchy of artistic worth. The point is simply that there is an economic reality to writing screenplays; what's the point of writing if no one ever reads (or sees) your work? I suppose there are some who write for themselves and who put all their writing safely away in a drawer each night, and who could care less if the world knows about them, but these are the exceptions, not the rule. Writers write to be read, and more people will read your stuff if it is high concept.

The value here for a writer lies in knowing, before they send their work out into the world, what kind of premise they have so that they can appropriately respond to the business of being a writer and prepare themselves accordingly. For example, you wouldn't want to send that horror-slasher script to Woody Allen's production company, or conversely, send that introspective study in psychological angst to Twisted Pictures (*Saw, Saw II-VI, Saw 3D*). Rather, you will know ahead of the game that the horror-slasher script has a huge and specific target audience and a long list of genre-specific producers who will be interested, and the introspective angst script will probably have a small, niche market, so there is no point in expecting a bidding war to break out with the major studios (could happen, but probably not). Knowing your premise type helps make you a savvy entrepreneur and sets real anticipation and expectation for your post-writing job of being a writing brand and a professional.

It is important to understand that there is no market for screenplays outside of the established acquisition channels. What this means is that if you can't sell your screenplay to a production company, or directly to a studio or network, you're mostly done. I say "mostly" because there are distribution channels available now that were not available several years ago, like streaming video and web series production. But streaming video is more and more controlled by the large media companies, and unless you can self-finance a web show of your own, you are going to come up against the same obstacles and gatekeepers as in the "old" channels. The bottom line is: there will be no one publishing an anthology of the *Best Unproduced, First-Time Screenplays* anytime soon. At least novelists can self-publish, if their work goes "nowhere"—i.e., they can't find a traditional

publisher (or not). There is a "somewhere" they can go to find creative satis-
faction and an audience: the Internet. Not so for screenwriters. As I often say,
the beaches of Malibu are littered with the bodies of first-time screenwriters,
because there is no market for physical screenplays. Consequently, knowing
whether your premise is high concept or soft is not just a nice thing to know.
It is an essential thing to know, as it helps you set your course and your com-
mercial sights appropriately. As a screenwriter you won't get many chances to
break through the gatekeepers, so when it finally happens, you want your best
presentation and your strongest high concept possible.

In order to know how to set your sights, you have to know the difference
between the two types of premises. What does it mean for a premise to be
high concept or soft? First, let's look at what it means for a story to be high
concept, then we'll look at how this contrasts to a soft premise, and then we'll
talk about what you do as a writer after you know what type of premise you are
working with.

What Is a High-Concept Premise?

As writers, we have all come up against the agent, producer, executive, or fellow
writer who, when asked to give feedback on our story, retorts, "Yeah, good idea,
but it needs to pop more. There's no high concept." But when asked to explain
themselves and define their terms, these same people only deliver clichés:

- It's your story's hook.
- It's what's fun about your story.
- It's your story's heart.
- It's your story as a movie one-sheet.
- It's the essence of your premise.
- And so on . . .

While many of these speak to the idea of a high concept, none of them really
explains what a high-concept idea is. "High concept" has become a *term d'art*
that everyone uses and that almost no one really understands.

High concept applies to any idea: motorcycle design, toothpaste, cooking,
comic books, novels, and movies—the list is endless. High concept is about
essence, that visceral thing that grabs you by the scruff of the neck and doesn't
let go. From a writing perspective, a story idea that is high concept captures the
reader's or viewer's imagination, excites their senses, gets them asking "what if,"
and sparks them to start imagining the story even before they have read a word.
More than this, a high-concept idea can be thought of as a cluster of qualities
that exist on a continuum, rather than as a single trait that a story possesses or
doesn't possess. When these qualities are working together they convey the
meaning of high concept for an idea in the same way personality qualities help
define the individuality of a person.

There is an elegant construct that I think both defines the term "high con-
cept" and that also gives you a tool for testing your ideas to quickly see if there

is a high-concept component present in any premise idea: "The 7 Components of a High-Concept Premise."

The 7 Components of a High-Concept Premise

The following are the seven components of any high-concept idea:

- High level of entertainment value
- High degree of originality
- High level of uniqueness (different than original)
- Highly visual
- Possesses a clear emotional focus (root emotion)
- Targets a broad, general audience, or a large niche market
- Sparks a "what if" question

Let's look at each of these to get a better idea of what they mean.

High Level of Entertainment Value

This can be elusive. Defining "entertainment value" is like trying to define pornography; it's in the eye of the beholder. Simply put, you know if something is entertaining if it holds your attention and sparks your imagination. If you are distracted easily from the idea or interested purely on an intellectual basis, then it is safe to say that the idea may be interesting, engaging, and curious, but not entertaining.

High Degree of Originality

What does it mean to be original? Some common words associated with originality are: fresh, new, innovative, novel (no, not a book). Think of originality as approach-centric. The idea may be centered in a familiar context, but the approach (original take) offered to get to that familiar context has never been used before.

So originality is more about finding new ways to present the familiar, rather than inventing something new from scratch.

EXAMPLES OF ORIGINALITY

/E.G.\

EXAMPLE

Dog Day Afternoon (1975, Warner Bros.):
Familiar idea: A man robs a bank for money.
Original take: A man robs a bank to get sex change for his transsexual lover and wins the hearts and minds of the people.

Toute une vie (And Now My Love—1974, AVCO Emabssy Pictures):
Conventional context: Boy meets girl.

Unique take: We see all the generations that led to the boy and girl being born, their love affairs, lives, and all the things they experience that make them who they become as adults; the lovers don't meet until the end of the movie.

Frankenstein (1994, TriStar Pictures):
Familiar idea: The evil monster terrorizes the humans.
Original take: The monster and humans switch moral ground and the humans terrorize the monster.

High Level of Uniqueness

Whereas originality is about approach and fresh perspective, uniqueness is about being one-of-a-kind, first time, and incomparable. Being original can also involve uniqueness, but being unique transcends even originality. Sometimes this is achieved in the content or in the execution of a work. This often means taking a conventional context and rethinking it in a unique way.

EXAMPLES OF UNIQUENESS

EXAMPLE

Finnegans Wake (novel by James Joyce):
Conventional context: Episodic, slice-of-life vignettes of HCE, ALP, and other characters.
Unique take: One-of-a-kind writing style never before used in modern fiction.

Sallie Gardner at a Gallop (1880, Eadweard Muybridge):
Conventional context: No precedent.
Unique take: Believed to be the first motion picture exhibition anywhere.

Highly Visual

High-concept ideas have a visual quality about them that is palpable. When you read or hear about a high-concept idea, your mind starts conjuring images and you literally see the idea unfold in your mind. This is why high-concept books make such good films when adapted. Books with cinematic imagery are almost always high-concept stories, like *Wild: From Lost to Found on the Pacific Crest Trail*, by Cheryl Strayed, and *Gone Girl*, by Gillian Flynn.

Possesses a Clear Emotional Focus

Like imagery, high-concept ideas spark emotion, but not just any emotion— usually it is a root emotion: fear, joy, hate, love, rage, etc. There is no wishy-washy

emotional engagement of the reader. The involvement is strong, immediate, and intense.

Possesses Mass Audience Appeal

The idea appeals to an audience beyond friends and family. The target market is broad, diverse, and large. Some ideas are very niche, appealing to a specific demographic, but this is usually a large demographic. High-concept ideas are popular ideas, mass ideas, and often trendy ideas.

Usually Born from a "What if" Question

What if dinosaurs were cloned (*Jurassic Park*)? What if women stopped giving birth (*Children of Men*)? What if Martians invaded the Earth (*War of the Worlds*)? High-concept ideas are often posed first with a "what if" scenario and then the *hook* becomes clear. The hook is that part of the high concept that grabs the reader. It is often the one piece of the idea that is the original concept or the unique element. In the three examples just given, each of them has a clear hook that leads to a high-concept premise line.

As we will see later on when we cover premise testing, most ideas never have all seven components. Stories usually express their high concept along a continuum, meaning they may have two of the components, or five of the components. The more of them you can identify in your idea, the stronger the high concept. Having one quality out of seven does not mean you have a bad idea, it just means that you are closer to a soft premise than a high concept one. It is important that you know how to assess your premise idea. Knowing the kind of premise you have makes you knowledgeable, prepared, and fully conscious as a writer. You can take full ownership and responsibility for your work product, and any decisions you make with regard to the marketing and sale of your story idea will be fully transparent to you and consensual. This is a good thing; it only adds to your professionalism and helps build your confidence as an entrepreneur.

What Is a Soft-Generic Premise?

We've spent a long time talking about the high concept, so now let's turn to the soft concept. What is a soft premise and how does it differ from a high concept one? As with the idea of high concept, a soft premise is often defined with clichés and generalities. When asked to define "soft premise," proponents will often offer the following:

- It means there is little or no action.
- It means you have a "character" piece.
- It means you are dealing with internal, not external, action.

- It means your story doesn't have a plot.
- It means your story is dull.
- And so on ...

Once again, as with the conventional definitions for high concept, there is some truth to all of these conventional soft premise definitions, but none of them accurately describes the idea of a soft premise. Defining the soft premise can only have meaning in relation to the high concept. If you are missing the seven components of the high concept, then you are left with a soft premise. This is a "simple" reductionist approach that yields practical results. The weaker the high-concept premise is, the mushier the overall idea will feel. The less original, visual, or generic the premise idea, the more uninspired and "low-concept" the idea will play.

Every story is high concept to one degree or another—the question is to what degree. High concept exists on a continuum; it is not a single trait that is or is not present in a story. So, the more of the "7 Components of the High-Concept Premise" that are present, then the more high concept the idea. The fewer components present, the weaker the high concept.

As I said at the beginning of step one of this process ("Determine If You Have a Story or a Situation"), the premise line is your lifeline as a writer. Knowing you have a soft premise (by process of elimination of the "7 Components of the High-Concept Premise") tells you a great deal about what may not be working in your idea. Even if you think the idea is fantastic, you may not always be the best judge. Consider the other side of this problem. "Soft" doesn't mean the idea is bad, but sometimes realizing an idea is soft can help you realize the idea is, indeed, bad. Consider some premise lines that writers have given me for their screenplays:

- When a retired woman finds herself on a trip to Peru, she visits Inca historical sites and discovers the richness of past cultures.
- When a schoolteacher moves to a new town, he finds himself teaching a new subject that has never interested him, but when the students respond positively to his teaching, he decides to keep the class.
- When a grandmother turns one hundred, the family organizes a family reunion and the entire family gets together for the first time to celebrate.
- When a man plays golf for the first time he falls in love with the game and commits himself to a lifestyle of golf and recreation in order to master the sport.

These are not just boring good ideas; these are boring bad ideas. The above examples illustrate a circumstance where knowing what type of premise you

have can be a major red flag tagging story problems you are developing at the premise level, which if not handled immediately will cause you days, weeks, or months of grief down the development road. The writers of each of these thought they had good ideas, until they applied the high-concept/soft premise analysis to their stories. All the other validation tools built into this process failed to register with them, but for some reason it all clicked when they typed their premise ideas.

The High-Concept / Log Line Worksheet Exercise

Using the "Log Line Worksheet" form in Appendix A (and available electronically on the e-Resources/Companion website URL found in Appendix C), fill in each of the seven components of any high-concept idea, as they pertain to your premise line. Don't do the log line or tagline portions yet; those will be done in the next step of the process. Right now, focus on your story's high concept and work with this form to identify as many of the high-concept components as you can for your story. If you do not use the provided worksheet, then do the work on your own using whatever method works for you. Hang on to the output from this step, as it will help you in the final step of the process when we cover premise and idea testing.

When you have a concrete technique like this one for assessing your premise type, as opposed to relying on tired, old clichés, you arm yourself with one more tool for the story development toolbox, and you bring yourself many steps closer to being a master of the premise development process. Soft or high-concept premise: knowing how to distinguish between both can pay off in terms of sales, but also in terms of saving precious writing blood, sweat, and tears during the development process.

STEP 5: DEVELOP THE LOG LINE

Premise line in hand, or at least a version you feel is solid enough to work with, it is now time to create a log line for your story. The log line and premise line are often used interchangeably in the film and television worlds. Many people, including experienced producers and executives—and screenwriters—make little or no distinction between the two terms. Premise and log lines are, in fact, different things and provide different functions in the development process.

What Is a Log Line and Why Should You Care?

It was no accident that high concept was included here as step four, because to understand the log line you must first understand the meaning of high concept. The reason for this is the true nature of the log line:

The log line is your high concept stated in a single (short) sentence.

The log line is not your premise line. It is not related to the premise line in any way, beyond the connection it has to the same story the premise line is describing. The premise line is the entire core structure of your story in one sentence (or two)—often a complex and long sentence. But the log line captures a single component of your story: its high concept.

Remember, way back in chapter three, I talked about what happens when you get an idea for a new story. That big ball of undifferentiated information called the Invisible Structure drops in and you have that "aha" moment, and a story is born. Or at least you think a story is born. Then, you begin to unravel that Invisible Structure, piece by piece, to validate that you have a story and not a situation.

But, let us back up for a moment and revisit this idea of the "dropping in" of the story idea. When that story structure drops into your awareness, before you sense a story, before you sense any of the parts of the structure, something else happens in that moment that catches your breath and leaves you with that "aha" sensation. What happens is that you get an image in your mind that captures that sensation. This happens to everyone, not just writers, when they get an idea for anything new they are creating. The Invisible Structure of the idea drops in and immediately gives them a visual impression of the idea itself. Sometimes it is just a single image, sometimes it is a tableau of images creating a mini-movie, and sometimes the image is accompanied by a strong core emotion (love, fear, hate, shame, etc.). Regardless of how detailed the image, or how complex or simple, it excites you and sets you on fire to want to explore this new idea in earnest. This is your story's hook. This is the thing that grabs you first, and then pulls you into the complexity under its surface. And if this hooked you, then it will hook an audience (or reader).

Just as with the story's overall structure that must be captured and expressed in a usable and practical form (i.e., the premise line), so the hook/high concept needs to be captured and represented in a practical and usable form. That is the log line. The premise line is your story's structure in a single sentence (or two), and the log line is your story's hook captured in a short sentence. The log line holds that image and makes it accessible to others so they can share the same sense of excitement you had when the story dropped into you, but whereas you were compelled to go deeper under the surface, others will simply be hooked and compelled to read the script and make your movie.

How Do Premise Line and Log Line Work Together?

A natural question at this point is, "Why would I need a log line, when I have a working premise?" There are many reasons why a screenwriter needs a log line.

The log line accomplishes the following:

- It can lead you to the hook and entertainment value of your premise BEFORE you write your premise line.
- It can often help you develop the pitch-perfect, high-concept title (e.g., *Jaws, Cowboys & Aliens*).
- Producers will ask for one. The log line—not the premise line—is tailor-made for pitching. The log line is what ninety-nine percent of all producers or agents will ask for when you submit a query or trap them in an elevator to pitch your story. You don't want to be unprepared.
- It validates your original moment of inspiration.
- The log line works with the premise line to help support the overall development process. Your log line and premise lines should fit together like a hand in a glove. They should not be different; meaning, they should have the same narrative tone, genre, and context.

EXAMPLE

LOG LINE EXAMPLES

- A monster shark terrorizes a small coastal town. [*Jaws* (1975), Peter Benchley, Carl Gottlieb]
- A cop battles über-thieves when they take over an office building. [*Die Hard*, novel Roderick Thorp, screenplay Jeb Stuart, Steven E. de Souza]
- A young boy discovers he's a wizard and goes off to wizard school. [*Harry Potter*, J.K. Rowling]
- A man saves a pregnant woman in a world where women no longer give birth. [*Children of Men*, novel P.D. James, screenplay Alfonso Cuaron, Timothy Sexton, David Arata, Mark Fergus, Hawk Ostby]

Note: You may get the feeling that log lines sound a lot like situations—they are not. They are not stories or situations; they are log lines. They are the hook of your story in a short sentence, so don't overthink this, or confuse them with premise lines, stories, and situations.

What Is a Tagline?

If log lines are the story's hook, the tagline is the bait on the tip of the hook.

The tagline for any movie is pure hype. Taglines are advertising copy and nothing more. They will not help you write your premise line, but they will help catch the eye or ear of someone you might want to read your script or fund your movie. They can also look nice on the cover of your film's novelization. Typically, you will not have to come up with this slick little piece of salesmanship, but sometimes it is worth writing on your own just to see what you come up with. Occasionally, it might help you find your way into the best idea for expressing

your log line, playing a similar kick-starter role for the log line as the log line can for the premise line.

But, most often, this is not a critical piece of the process and can be considered value-added if you decide to conceive a tagline on your own. The more sales tools you have for your pitching effort, however, the better, so why not arm yourself with all the tools possible?

TAGLINE EXAMPLES

EXAMPLE

- Just when you thought it was safe to go back into the water. [*Jaws* (1975), Peter Benchley, Carl Gottlieb]

- In space, no one can hear you scream. [*Alien* (1979), Dan O'Bannon, Ronald Shusett]

- The trap is set. [*Flytrap* (2015), Stephen David Brooks]

- A romantic comedy. With zombies. [*Shaun of the Dead* (2004), Simon Pegg, Edgar Wright]

It should be no surprise to you that the higher the concept of a story, the stronger the tagline will be. Advertising loves high concept, and taglines are used with everything from toothpaste to Winnebagos. Sales is sales, and no one knows how to sell a widget better than the major film studios and television networks. Their marketing departments are geniuses when it comes to coming up with catchy and memorable taglines. To come up with your own taglines, just follow their example and you will find a great piece of bait.

The Log Line / Tagline Worksheet Exercise

Using the "Log Line Worksheet" form in Appendix A (and available electronically on the e-Resources/Companion website URL found in Appendix C), fill in the sections that apply to creating the tagline. If you do not use the provided worksheet, then do the work on your own using whatever method works for you. Hang on to the output from this step, as it will help you in the final step of the process when we cover premise and idea testing.

STEP 6: FINALIZE THE PREMISE LINE

What Does *Final* Mean?

Are you ever really done with writing your premise line? You are never really done writing anything; you just decide to stop. At some point you just have to set goals, meet them, and then come to an end. What will happen with your premise line is that you will feel a physical sensation in your body, or have a strong emotional sense, or "hear" a voice in your head tell you that it's time

to stop. The premise line will feel balanced, alive, and will tell a story with an economy of words that will impress even you. You are now ready to move to the next phase of your development process and either start pages, or write a short synopsis or a long synopsis. Whatever you do—celebrate the moment. You have been through a long, hard slog, and you deserve to reap the rewards.

As you get into the writing process, post premise line, you will find yourself going back to it time and time again, checking your progress on the page with the story in your premise line. They may fall out of sync as you write. Perhaps you have gone off on a narrative tangent—no problem. Go back to the premise line and see where in the premise you need to come back to in order to maintain the through line. Or perhaps you go off on a story tangent and it feels right and true, and your premise line has fallen out of sync with your writing. This can happen. If it does, then rewrite the premise line to incorporate this more true story tangent. All it means is your premise line was wrong, so fix it and move on. This is how it goes over the course of the entire writing process. The premise will inform the writing, and the writing will inform he premise line. At some point they will just settle down and stay in sync; that's when you know you are truly done with premise development. So, "final" is a relative term, not just for your screenplay as a final piece of writing, but also for your story's premise. *It is a work in progress as long as the work itself is in progress.*

STEP 7: PREMISE AND IDEA TESTING

What Is Premise Testing and Why Should You Care?

Premise and idea testing are two things most writers don't even think about. Here's what they think about instead:

1. They get an idea for a story.
2. They start brainstorming scenes, characters, set pieces.
3. They start writing pages.
4. They write, write, write—then stop.
5. They're stuck—and the depression begins.
6. They start to back into their story (see chapter three)—and realize the premise is off.
7. They hire a story consultant, or script doctor, or get notes from someone they trust.

Invariably, if the consultant or editor knows what they're doing, they bring the writer back to their core premise idea. The writer almost always has to start over with story fixes the consultant or editor suggested. If they know what they're doing (they don't always), then things move forward in a "correct" direction and the story is saved. But, the writer is often left with a lot of pages they can't use—pages that are simply the legacy of lost time and creative effort.

Some say there is no such thing as wasted writing time; all writing is useful and helpful and better than not writing. I understand this sentiment, and it is a nice sentiment, but it is not true. I've worked with too many screenwriters, novelists, and producers, some of whom have wasted months or even years of writing time only because they didn't know there was a craft solution to the problem of what I call "premature writing."

Premise testing isn't sexy, it isn't creative, it isn't artistically satisfying, and it will not bring you closer to your muse. But, what it will do is give you invaluable information about the state of your development process before you have committed countless hours to writing and script design. It is a pure exercise in marketing and product testing. Anyone who sells any product market tests that product. So, why not writers? Writers who have no interest in commercial success will find all this pointless. No problem. If you are writing for the pure joy of writing, and art for art's sake, more power to you. But, if you are looking for work and maybe having a career as a professional screenwriter, then premise testing is a necessary skill you need to learn as an entrepreneur and businessperson.

It is in this spirit that I offer this practical tool that you can use to get objective and meaningful feedback about the potential of your story—before you write a first draft. As part of this week's written assignments, you are being asked to fill out the "Premise Testing Checklist." This checklist is designed to ask a series of questions to inform you about all things that make a book attractive to readers: commercialism, high concept, story vs. situation, etc.; all the things we've been discussing and exploring for the last two weeks. This checklist gives you a gestalt picture of the "appeal factor" of your story to your target audience, but more so it validates your premise, premise line, and the story idea itself.

Even if you couldn't care less about commercial success, learning how to do this checklist will give you one more level of confidence that your book idea will work and actually have legs for the long haul of writing. This alone is enough of a reason to learn how to use this tool.

The key to using this to maximum effect, however, is that when you give it to third parties to fill out, you only give it to people who know what they're talking about. Don't give it to people who will tell you what you what to hear (like your mother—unless she's an story editor at Paramount). Give the checklist to editors, other screenwriters, movie producers, writing teachers at local universities, or even hire story consultants to give you feedback. You need real advice and opinion. Only people who don't know you well and who have no personal investment in the process will be able to give you that kind of feedback.

You may find that you have to explain some of the ideas behind high concept, story vs. situation, etc., but now you know those concepts and can explain them. You may be surprised how receptive people may be to learning new ideas from you. You may also be surprised how many people will respect the fact that you are asking for their feedback. If they want you to pay them for the privilege, then do it. It's worth it (if they know what they're doing with story). Their expertise is worth the price of admission. But, a lot of people will just say "okay" and help you. If you can only do friends and family, then go for it. But tell them to tell you the truth, not what you want to hear. Then take that feedback and use what you

can, and discard what is not helpful. Go for objective feedback first; get knowledgeable writers and editorial people to help you.

How to Use the "Premise Testing Checklist"

The seven steps are as follows:

Step 1: Determine if premise is soft.
Step 2: Determine if premise is high concept.
Step 3: Determine if it's a story or a situation.
Step 4: Does the log line work?
Step 5: Does the tagline work?
Step 6: Revise premise with any new insights; is it better? Worse?
Step 7: Unit test your final premise line.

You can see that the seven steps all cover things we've explored and have used throughout the first two parts of this book. The two-page "Premise Testing Checklist" worksheet combines all that you've been using to develop your story idea.

The basic process unfolds as follows:

1. Give the checklist to objective third parties and have them fill out steps one through six.
2. Then give it to friends and family and have them do the same.
3. Then, you answer both questions in step seven yourself.
4. Add up all the checks in both columns and assess the outcomes.

The higher the "needs work" column number is, the more the message to you is "this needs more work." Then you have to look at your responses and get a sense of where your respondents had common issues/checks. This can tell you a lot about where in the premise process you may need to go back and redesign the premise line. Your structure is off—this can tell you where to look.

Obviously, if you have more checks in the "yes" column than in the "needs work" column, then you are in good shape. It is still worth looking at the checklist responses for trends and patterns. You can learn a lot about what most appealed to respondents about your idea. And obviously, if your "yes" and "needs work" columns are about the same weight, then you have to look closely at where respondents checked their boxes to see what problems or strengths the respondents noted in common.

The bottom line here is that this checklist, and the process for getting it filled out, can be another assessment tool for you, giving you more feedback about your premise line and the story idea as an idea. As I said earlier, this may not be sexy and creative and artistic, but it is practical and useful and powerfully simple as a tool to help you know—before you start writing—that your premise idea will have legs strong enough to carry you (and your story) to the end.

E.G.
EXAMPLE

Anatomy of a Premise Line™:
Premise Testing Checklist
<Your Story Title Here>

Storygeeks
Story Consulting - Training - Editorial

Step 1: Is your premise soft or generic?		
Questions	**Yes**	**Needs Work**
The idea feels well developed and complete.	X	
The premise is engaging and interesting when I hear it spoken out loud? (*You may not be the best judge of this.*)	X	
The premise has a sense of movement, forward or backward, in time and space?	X	
The premise mostly plays out in the world, not inside someone's head?		X
Step 2: Is your idea high concept?		
Questions	**Yes**	**Needs Work**
Is there a clear level of entertainment value?		X
Is the idea original?		X
Is the idea unique?		X
Is the idea visual?	X	
Does the idea focus on a primal emotion?	X	
Is there a broader target market appeal to the idea, beyond friends and family?	X	
If you add "what if" to the beginning of the idea, does it lend itself to an exciting question?	X	
Step 3: Is your premise a story or a situation?		
Questions	**Yes**	**Needs Work**
The true character driving this idea is revealed by unfolding events, more than by some problem being solved.	X	
This idea requires subplots, twists, and complications to be properly told.		X
This idea is about a human being on a journey leading to emotional change?	X	

© 2015 Jeff Lyons
Copying or distributing without written permission from the author is prohibited.

Figure Pt2.4 Premise Testing Checklist Sample

	Yes	Needs Work
There is a strong moral component.		
Step 4: Does the tagline work?		
Questions	Yes	Needs Work
Is the tagline short and root emotion focused?		
Step 5: Does the log line work?		
Questions	Yes	Needs Work
Is the high-concept evident?		
Is the hook clear?		
Is the hook reflective of what originally excited you about the story? *(Does it bring you full circle?)*		
Is the visual image of the log line effective and memorable?		
Step 6: After Re-evaluating your premise line, are these questions true?		
Questions	Yes	Needs Work
Does the premise line align with the log line and tagline properly?		
Does the premise line tell the story you want to tell?		
Step 7: After unit testing your premise line, are these questions true?		
Questions	Yes	Needs Work
Was the response inside friends and family positive?		
Was the response outside friends and family positive?		
Totals:	18	6

© 2015 Jeff Lyons

Copying or distributing without written permission from the author is prohibited.

Page 2 of 2

Figure Pt2.4 (Continued)

DEVELOPMENT: A FEW REMAINING NUTS AND BOLTS

—8—

I NAILED THE PREMISE
AND LOG LINES—
NOW WHAT?

A story synopsis is not just for script coverage or pitch fests. A story synopsis can be the next step to solidifying your story's foundation and a successful launch into writing pages.

After a writer has learned the "7-Step Premise Development Process," the obvious next question is, "What do I do next?" Presumably, you now have at least one workable premise and log line. Even if it is not in the best shape, you have worked the process and know you have a story or a situation, you know the Visible Structure components, you have a working moral component, and you may feel ready to start pages. And you have probably started pages on earlier scripts with a lot less in place than you have now, so where's the harm, right? The fact is, you could start pages, if you really wanted to. Regardless of how strong or weak your premise line might be, you probably have a stronger foundation now than ever before at this stage of your writing process. While some screenwriters prefer to dive in at this point and get the writing done, I would strongly suggest you wait. There is value in delaying a shift to script pages, and focusing instead on short synopsis writing.

THE CASE FOR A SHORT SYNOPSIS

Screenwriters are familiar with synopses, as are novelists. But few screenwriters see synopses as part of the development process. Synopses are meant for readers, or agents, or producers that you are trying to pitch for a job or a sale. Or they are meant for script submission websites, where you upload your script for social networking, crowdfunding, or script competition purposes (e.g., Amazon Studio, The Black List, or contest sites). All these, and more, can be leveraged by a good synopsis, but a synopsis can also be powerful next step in your script's development.

I should mention here that many screenwriters, when they get to this point in the development process, rely on a tried-and-true method for breaking out their stories: the index card method. There are many books and Internet resources that detail how to use this method of script outlining. I use it myself and love it. Basically, you take a standard index card and write a slug line at the top to identify what scene you are in, and then add a short few sentences under the slug line describing the action of the scene, and maybe a line or two of important dialogue that might happen in the scene. You do this for every scene in your script and then arrange them in order on a corkboard using pins to hold the cards in place. You can then rearrange, delete, or add to the cards as required to get the perfect flow and pace of scenes. This is an incredibly low-tech tool, and one of the best screenwriting (or novel-writing) tools you could imagine. While you could ignore all other solutions, including synopsis writing, and just jump right into using index cards, I recommend you first do a short synopsis, for the following three reasons:

1. Your first-draft script is meant to be read. In other words, you are not writing a movie, you are writing a piece of prose that a reader will read as a piece of prose. Yes, the script has to use the language of film and follow the standard conventions of screenplay format, but you as the writer are trying to catch a reader first, not a director or an actor. You want your first draft to be a great reading experience; consequently, you want it to flow like a piece of writing, using all the prose tricks and techniques you can to pull your reader in and hook them. Writing a short synopsis helps you find your prose voice quickly, and you can then translate this to index cards or some other outlining tool as you see fit. Jumping in with index cards first often results in "script speak," short truncated scene descriptions and scenes that read like shorthand, not engaging prose. Even if you are going for a shorthand kind of style with your writing, as a means of breaking conventions and establishing your style apart from other writers, you still want the prose of a synopsis to inform that style. Consider the examples of Walter Hill (*Alien*, uncredited), Alexander Jacobs (*Point Blank*), and Andrew Stanton (*Wall-E*). These writers all use a style of writing that is anything but prose-like, but it still possesses the effect of a prose sensibility. "Prose" in this context does not mean Marcel Proust or William Faulkner, i.e., long ponderous sentences with deep embedded meaning. Nothing will get your script filed in the round file at a production company faster than scene descriptions written like a 18th-century romance novelist. Prose can also be short, powerful, pithy sentence fragments that convey movement, emotion, and imagery (like Hill, Jacobs, and Stanton). Writing a synopsis can give you those fragments, emotions, and images in a way index cards or other methods may not readily accomplish.

2. The second reason for writing a short synopsis first is that you get an important deliverable that you can use to support your writing and promotion efforts. The script will take you many months to write. The

synopsis will take you a couple of weeks to write. And unlike the index card method for breaking your story, which yields every scene in your script, a synopsis doesn't need every scene identified. "All" you need are the major structure milestones, reversals, complications, set pieces, and character moments, as we've identified them in previous chapters. With a synopsis in hand, you can "pre-sell" your script and promote yourself and your writing to producers and potential stakeholders. You don't have to have your script finished in order to gather interested parties and get them on board as potential partners.

3. The third reason does not speak to the need for doing a synopsis first thing, but does speak to the need for a long synopsis (10–20 pages), the kind routinely used by novelists. More and more screenwriters are discovering that to be successful as a writer means expanding their horizons as writers. Screenwriters have discovered that the rise of e-books, which have been evolving in the publishing industry over the last few years, signifies a sea change of opportunity, not just for novelists, but for screenwriters as well. Many screenwriters are choosing to take their legacy—unpublished screenplays—and adapt them to novels for self- or subsidy publishing. Even traditional publishers are hungry for new material, especially if the writer has worked in the film or television industries as a writer. Publishers and book agents almost always ask for a detailed synopsis along with a formal book proposal when considering new acquisitions or clients. Their requirements, however, are more stringent than film producers or studio creative executives. They want long and detailed synopses that can sustain a 280–350 page novel. Even for shorter works they want more substance and less flash. For a novel, unlike a screenplay, a synopsis must mention just about every major scene, and some novel synopses run thirty pages. A synopsis has to show the agent or editor that you know how to tell a story with a beginning, middle, and end. It has *always* been this way for novelists.

Any smart screenwriter knows that in the 21st century to have a viable career as a writer, he or she needs to be writing in multiple platforms across different industries. The days of "just being a novelist," or "just being a screenwriter" are over. A synopsis for the New York Times bestselling novel *Pictures of You*, by Caroline Leavitt, is included in Appendix B. The format is different from screenplay synopses, but it is instructive and worth reviewing, especially if you are considering branching out into writing novels or adapting your unproduced scripts (which I highly recommend).

THE SYNOPSIS PROCESS

The short synopsis is your first opportunity to translate your premise line into a real narrative. If you can get the flow of the synopsis to reflect the structure of your hard-won premise line, then you know you have hit your mark and are on

solid ground. If the synopsis doesn't come easily, or feels forced to write (based on your premise line), then one of two things is happening: the premise line is wrong, or you are focusing on minutia and not on the big-picture story structure that tells the story. You will readily see, given your experience now with premise development and your understanding of the Invisible Structure, whether it is the former problem or the latter.

We will assume that the premise is in good shape. The idea now is to break out the structure of your story into a more determined form, i.e., to make it more *visible*. To do this, you will need to use the second structure you need to tell a story: the Visible Structure. The Invisible Structure revealed the core structure of your story, and you used the "Anatomy of a Premise Line" template tool to map that Invisible Structure into a usable and practical form, i.e., the premise line.

The synopsis is a more detailed expression of the Visible Structures of your story. So, to realize this in an actual narrative you have to know what you're looking for. You have to create actual scenes that illustrate all of the structure components held within your premise line. The job now is to expand and unpack the riches held within your incredible premise line. To facilitate this process, you can use the "Short Synopsis Worksheet (blank)" (see Appendix A for the hard copy or Appendix C for the website where you can download the electronic version). It walks you through each of these Visible Structure components in the context of your premise line, and then prompts you to come up with actual scenes illustrating them in action. This is challenging but critical as a first step in writing your script. All this story structure, premise writing, and synopsis writing are designed to get you into a space where you trust your story and its flow so that you are not writing blind. Imagine starting pages and never having any of this premise and structure work under your belt. You would almost certainly be lost in the woods after the first fifty pages.

HOW TO USE THE "SHORT SYNOPSIS WORKSHEET"

Beginning a synopsis can be as intimidating as starting your script pages. Many a time I have found myself staring at the blank page, unable to write, my head so filled with first sentences that I couldn't decide which to write down. Writer's block for some—but not really. As you will learn in the very last chapter in this book, writer's block is a myth and doesn't exist, but the experience of it can seem real enough. The solution—the breaking of the "block"—lies in falling back on craft, and specifically your knowledge of story structure. That is what gave birth to the synopsis-writing process I am showing you below.

THE "SHORT SYNOPSIS WORKSHEET" EXERCISE

There are four forms used for this exercise. These can all be downloaded from the e-Resources/Companion website URL listed in Appendix C. They are also listed in hard copy form in Appendix A and B.

Short Synopsis Worksheet (blank): This form can be used to kick-start your short synopsis writing process. It walks you through a detailed list of questions, helping you brainstorm key scenes and story milestones that can assist you in fleshing out the first pass of your short synopsis. This form emphasizes the Visible Structure components of the premise process. This is found in Appendix A.

Short Synopsis Worksheet Example: This form shows you a sample worksheet filled in with all the story detail needed to generate a short synopsis from a sample script, *Green Gloves*. This is found in Appendix B.

Full Short Synopsis Example: This is an actual short synopsis of the *Green Gloves* script, developed from the "Short Synopsis Worksheet Example" of that story. This document demonstrates how the worksheet data is translated into a real narrative. This is found in Appendix B.

Full Short Synopsis Example with Notes: This is the short synopsis of *Green Gloves* with annotations in the right margin illustrating exactly where text corresponds to the "Short Synopsis Worksheet." This is found in Appendix B.

As you fill out your blank worksheet, you will use everything you have developed to this point to take the next step and begin the actual narrative of your story. If you feel blocked, fear not—the Invisible and Visible Structures, and the supplied worksheets, will come to the rescue. Even if you can't fill the form out exactly, the questions asked on the "Short Synopsis Worksheet" will get you thinking structurally about how to write your story, and guide you through some of the main story milestones every synopsis needs. The important point to remember is to try to come up with actual scenes that reflect each of the premise line clauses. These scenes are the "stuff" that will make your synopsis a story and not just an intellectual exercise filling in blanks on a form. Try for two to three scenes per clause and try to have them be visual scenes that show in action the Visible Structure elements related to that clause. The scenes don't have to be in any order here, and you don't have to do three, but you need enough to fuel 3-6 pages of narrative. Be careful not to get caught up in descriptions, minutiae, irrelevant filler like backstory, etc. Just address the Visible Structure components in action scenes between characters. It may be helpful for you to take some time and review the synopsis example document and the "Short Synopsis Worksheet Example" in Appendix B. They will show you how the worksheet relates to an actual synopsis narrative, or you can just dive in and begin.

Filling in the "Short Synopsis Worksheet"

The form is broken into four sections, one for each of the four premise clauses: protagonist clause, team goal clause, opposition clause, and dénouement clause. Each section prompts you for specific Visible Structure data that can help you connect your narrative dots and flesh out the story structurally. Again, this isn't

about getting into the minutiae of every scene, but only the big-picture story beats needed to tell the story. If you don't feel confident identifying what a "big-picture story beat" is, don't worry. This is a craft skill that comes with time and experience. The more you do, the easier it will become.

SHORT SYNOPSIS WORKSHEET EXAMPLE

EXAMPLE

Project: Green Gloves (screenplay by Jeff Lyons)
Genre: Family Drama, Sports (Boxing)

Premise Line:

When Belfast heavyweight contender MICKEY KERRY, obsessed with becoming the Northern Ireland Area Heavyweight champ, is approached by reigning champ BARNEY WILSON for a title fight, Mickey joins with BEN, his manager, to secretly prepare for the fight of his life, hiding the truth of his terminal illness from everyone, while trying to set his wife JANE up in her own business so she and Mickey Jr. won't be homeless when he dies. Jane discovers Mickey's scheme and kicks him out, turning to a potential suitor, INIS, who is ready to step in and replace Mickey. When Mickey loses the Wilson fight, he is exposed as a liar, and in desperation arranges a winner-take-all bout with his worst nemesis, knowing it will lead to his death—he wins the fight, wins back Jane, and saves his family from ruin, after buying Jane her dream sandwich shop—only to succumb to his illness on Boxing Day, 1967, after spending the best Christmas of his life with his family.

Write the "Protagonist" clause (Character-Constriction: Protagonist-Moral Component):

When Belfast heavyweight contender MICKEY KERRY, obsessed with becoming the Northern Ireland Area Heavyweight champ, is approached by reigning champ BARNEY WILSON for a title fight . . .

Constricting Event (moves them from life line to action line):

- Mickey and Ben (Mickey's manager) are approached by the area champ, Barney Wilson, for a title fight.

Moral Blind Spot:

- Mickey's blind spot is infidelity: the sin of lying and manipulating others as a result. He's also obsessed with winning the title. This fuels his tendency to lie.

Belief Under the Blind Spot:

- "If people know the truth about me, I'll lose everything." This is a fear he has battled all his life, the fear of truly being seen. What will they see? Someone weak and unworthy of love.

Immoral Effect (show in action):

- Mickey lies to Jane about the Wilson fight, his job situation, and his terminal illness. Also lies to Ben about his illness.

Scenes:

Scene 1: Constricting Event (Call to Action/Key Incident/Inciting Incident/Whatever):

- Mickey meets with his doctor who tells him he's got a few years to live if he stops boxing, a few months if he continues. Mickey tells doctor he can't tell anyone, not even his wife; if truth gets out, he'll never be able to get a fight. So, he consciously keeps this secret for selfish reasons.

Scene 2: Moral Blind Spot Revealed (the moment we first see the blind spot appear)

- Ben and Mickey are approached by Barney Wilson's camp with an offer to fight a title bout. They are invited to a secret meeting with Wilson's inner circle to quietly plan the fight. First consequential reveal of his lying (i.e., keeping a secret) to Jane.

Scene 3: Immoral Effect in Action (in addition to the reveal in scene 2)

- Jane, who hates boxing, reminds him that they have a deal: Ten years—if he didn't have the title after ten years he had agreed to give up the fight game and live a normal life. He lies to her and says he's working as a car dealer (having lost that job and not telling her) and has no plans to fight and only wants to give her the private business she's always wanted.
- Later, after the losing the Wilson fight, Ben discovers Mickey has lied to him all this time about being sick, and he feels betrayed and confronts Mickey.

Write the "Team Goal" clause (Desire-Relationship: Chain of Desire-Focal Relationship):

Mickey joins with Ben, his manager, to secretly prepare for the fight of his life, hiding the truth of his terminal illness from everyone, while trying to set his wife Jane up in her dream business so she and little Mickey Jr. won't be homeless when he dies . . .

Chain of Desire (Overall goal and smaller "link" goals supporting the overall goal, if you know them):

- Overall goal: To buy Jane her sandwich shop and make her secure for the future financially, when Mickey's dead and gone.
- Link goal: Beat Wilson and win the title and the huge purse; save the day.
- Link goal: Beat O'Reily and win the purse; save his family.
- Link goal: Convince Inis to marry Jane, if he dies in the ring.
- Link goal: Teach Mickey Jr. how to fight, so he can take care of himself when Mickey is gone.

*Focal Relationship or Teaming (Who's spending the most time
with the protagonist during the middle of the story?):*

- Jane and Ben (Mickey's manager) alternate this role together throughout
the middle of the story.

Scenes:

Scene 1: Overall Goal Revealed

- After a successful fight and ensuing celebration, Mickey drives Jane past
an available storefront in the local business district to see that the store
is still for sale, with Mickey leading her on that he intends to make Jane's
dream of having her own business come true (for him and her).

Scene 2: Focal Relationship Established

- Through back channels, Ben is approached about the Wilson fight and he
tells Mickey. They both go to a secret meeting and strike a deal to do the
fight. The partnership is sealed between Ben and Mickey.
- Jane opens the story already in relationship with Mickey.

*Write the "Opposition" clause (Adventure-Resistance: Opposition-Plot &
Momentum):*

... until Jane discovers Mickey's scheme and kicks him out, turning to a potential
suitor, INIS, who is ready to step in and replace Mickey. When Mickey loses the
Wilson fight, he is exposed as a liar ...

Who is the opponent/antagonist?

- Jane is the main antagonist/opponent. Other opponents are "outside" op-
ponents: Wilson, Inis, O'Reily, Arnone, and Ben, with Ben being the central
one of those.

What is at stake at the midpoint overall?

- If the Wilson fight goes bad, or Mickey dies, everyone loses his or her
dreams.

What is at stake for the protagonist at midpoint?

- Mickey could die; he could lose his marriage; he could lose the fight.

What is the Doom Moment (at about 3/4-way through the story)?

- Mickey has lost the Wilson fight, lost Jane, alienated his family, alienated
Ben, and lost all hope.

Scenes:

Scene 1: Introduction of Opponent/Main Antagonist

- Opening scene with Mickey fighting Rufus Bigalow in the Belfast Hall.
Jane is the only woman in an all-male audience; she later joins him after

the fight in the locker room and we see the tension in the relationship, but also the love.

Scene 2: Midpoint Stakes (overall stakes rise)

- Wilson's manager, Ricky Smyth, meets with Mickey and Ben to seal the deal for the fight with Wilson; now all are committed to success or failure.

Scene 3: Midpoint Stakes (protagonist's stakes rise)

- Estranged from Jane, Mickey sees that Inis (the local cop) is getting very friendly with his wife, and Jane is not discouraging him. Mickey realizes he's very close to losing her because of his decision on Wilson.

Scene 4: Doom Moment

- Mickey loses the Wilson fight and is nearly killed. Jane is closer to Inis than she is (publically) to Mickey, and Mickey has lost all hope of the title and saving his family's future. His lie about his health is also exposed to Ben for the first time, and this is another emotional blow to Mickey. He is truly alone.

Write the "Dénouement" clause (Adventure-Change: Plot & Momentum-Evolution-de-Evolution):

. . . and in desperation arranges a winner-take-all bout with his worst nemesis, O'Reily, knowing it will lead to his death—he wins the fight, wins back Jane, and saves his family from ruin, after buying Jane her dream sandwich shop—only to succumb to his illness on Boxing Day, 1967, after spending the best Christmas of his life with his family.

How does the protagonist change (what does he learn about his moral blind spot)?

- Mickey finally stops lying and is exposed and vulnerable. He is no longer driven by ambition to hide perceived weakness. He realizes he can be himself and be worthy of love.

Final resolution with main antagonist (and minor opposition)

- Mickey confronts O'Reily in the ring during the winner-take-all fight, and Jane comes to the stadium to confront him about his illness and to tell him it's more important he live than win and they fall back in love at ringside.

Protagonist's change in action (how is he/she going to act differently now?)

Scenes:

Scene 1: How the protagonist changes.

- Mickey decides to go see Inis and convince him to be with Jane during his winner-take-all fight with O'Reily. This is implicit permission from him to Inis to get ready to step into Mickey's place as her husband because he doesn't expect to survive this fight. Until this point all his motives have been colored by ambition to achieve, but now it's not about him, it's about something bigger than him.

Scene 2: What does the final confrontation look like?

- Mickey confronts O'Reily in the ring during the winner-take-all fight, and Jane (main antagonist) comes to the stadium to confront Mickey about his illness and to tell him it's more important he live than win.

Scene 3: How does the protagonist's change show itself in action in the end?

- Mickey tells Jane the truth, he's fighting for her now, not anything else, and that "sometimes dreams really do come true," meaning that his dream of having her safe and secure is all he cares about, and that's the real truth. They fall back in love at ringside.

This is how you fill out the "Short Synopsis Worksheet." You should be able to see how this form will help you take your high-level premise line and begin to break it out into scene-specific story beats that can eventually inform all your further development efforts, be they index cards or pages themselves. After you work on this form and get it into shape, once you feel ready to tackle the actual synopsis, then you translate all this story data into narrative.

Review the "Full Short Synopsis Example with Notes" in depth, as it shows you (in the right column comments) how to tie the content back to the work you did on the "Short Synopsis Worksheet." Here are some key points to keep in mind as you expand your worksheet into a full-fledged synopsis:

- Keep the voice third person, present tense. You want the story to sound immediate and active, and have the same voice and tense as a standard screenplay. Third person, present tense is the voice/tone used in the example document.
- Double-space the synopsis section. The log line and premise line sections should be single spaced.
- Keep to the points; meaning, take your scenes and let them build toward milestones (beats lead to sequences of scenes, lead to milestones). This synopsis is "just the facts ma'am." Fight the tendency to wax poetic about locations, character descriptions, backstory, etc. Just write to the structure points as you've identified them in the worksheet.
- Don't include dialogue—not in this short version.

What follows next are the first couple of pages of the *Green Gloves* full short synopsis. The full synopsis is included in the appendix for reference. Once again, you can compare the worksheet example above with the "Full Short Synopsis Example with Notes" and look at the right column comments to find where they correspond back to this sample. This will be very instructive for how to flow your own content. Notice that not all the correspondences are sequential in the text. Meaning, some of it gets a bit out of sync in terms of the linear progression on the worksheet. This is fine; I don't want you blindly following the list of "to-dos" on the worksheet and just plopping them in sequence into the synopsis. Make the prose flow; let it be natural. Tell the story. This is actually the time to do

creative writing and stop all the process-procedure, seven-step this and seven-step that stuff. Now you get to write!

EXAMPLE

Project: Green Gloves, (screenplay by Jeff Lyons)
Genre: Family Drama, Sports (Boxing)
Type: Short Synopsis

Log Line:

A 1960s Irish heavyweight contender, with a terminal illness, fights one last bout to save his family from ruin, knowing the fight will kill him.

Premise Line:

When Belfast heavyweight contender MICKEY KERRY, obsessed with becoming the Northern Ireland Area Heavyweight champ, is approached by reigning champ BARNEY WILSON for a title fight, Mickey joins with BEN, his manager, to secretly prepare for the fight of his life, hiding the truth of his terminal illness from everyone while trying to set his wife JANE up in her own business so she and Mickey Jr. won't be homeless when he dies. Jane discovers Mickey's scheme and kicks him out, turning to a potential suitor, INIS, who is ready to step in and replace Mickey. When Mickey loses the Wilson fight, he is exposed as a liar, and in desperation arranges a winner-take-all bout with his worst nemesis, knowing it will lead to his death—he wins the fight, wins back Jane, and saves his family from ruin, after buying Jane her dream sandwich shop—only to succumb to his illness on Boxing Day, 1967, after spending the best Christmas of his life with his family.

Synopsis:

ANCIENT ARENA—A boxing match is underway in the style of the first Olympics: naked, brutal, bloody, to the death. MELANKEMOS, "The Untouched Boxer," fights a bloody, broken fighter. The broken boxer is unrecognizable. Melankemos benevolently looks down on the broken boxer, who now takes on a recognizable face, MICKEY KERRY. Mickey looks up to Melankemos in fear. He hears the crowd shouting for Melankemos to end it. Melankemos looks down to Mickey silently as if to ask, "Ready?" Mickey hesitates and then nods, yes. Melankemos smiles, but not malevolently; mercifully, as he raises his fist. The arena grows silent. Only the wind can be heard. Mickey closes his eyes. Melankemos's fist moves rapidly in to strike him.

BELFAST, IRELAND 1967—MICKEY KERRY comes to on the mat, waking from being knocked out. He's in a fight with Rufus Bigalow, a fight Mickey intends to win. Determined, he gets back up and makes short work of Bigalow, to the crowd's delight, flashing his trademark green boxing gloves. Mickey's wife, JANE, finds it hard to be upbeat about the win; she's tired of the fight game and wants

him to quit. During the post-fight party, Jane reminds him of their deal. If after ten years he was not world champ, he would hang up his gloves and they would live a normal life; well, ten years are up. Jane expects him to abide by their agreement.

After the party, Mickey drives Jane past her dream location for a small sandwich shop she wants to open, and she gets very wistful about "dreams coming true." They both know the store is beyond their means to buy, but keeping this dream alive helps deflect Jane away from Mickey's fight ambitions, so he doesn't discourage her dreaming, in fact, he makes a strong suggestion she should expect a miracle.

Visiting his doctor, Mickey pees red into a cup. His doctor tells him he's got months to live if he keeps fighting; years if he quits and settles down. Mickey knows no one would fight him if they knew he was terminally ill, so he decides to hide the truth from everyone, including Jane and his manager, BEN. He's not sure what to do: fight or give up.

But when Barney Wilson's team approaches Ben and Mickey about a possible title fight, all bets are off for Mickey; he makes his choice at last.

(The entire synopsis can be found in Appendix B, "Examples.")

Synopsis writing can be the next step in your development process, after the premise and log lines have been created. You don't have to do synopsis writing next, but I highly recommend it, as it informs all your other writing and development efforts, and gives you a useful promotion tool—before you have a final draft.

9

THE THREE STAGES OF DEVELOPMENT

"Development" is a creative process and a business process, and is the royal road to Purgatory, Heaven, and Hell.

"Development" is a term every screenwriter comes to know at some point in their writing career. For new screenwriters, they learn about the term from being exposed to screenwriting books, writing workshops, celebrity screenwriter blogs, or through second-hand and third-hand horror stories of other screenwriters who have been through "development hell." More experienced screenwriters have the advantage of experiencing firsthand the process of development, working directly with the various movers and shakers at agencies, studios, networks, production companies, and story departments who shepherd scripts from concept to green light to screen.

The development process can take years or even decades, and there are no guarantees that a script will ever make it to that final green light or thumbs-up from the powers-that-be, assuring at least a first day of principal photography and the commencement of physical production. Most often scripts languish in a kind of literary limbo, but occasionally the "buzz" on the tracking boards (the private bulletin boards where industry insiders troll for "hot properties" and get the latest status on who's hot and who's not) sets creative executive hearts a-fluttering, word spreads, requests for script copies increase, and that one-off spec sale happens—only to end up getting sidelined because the creative executive who made the sale gets fired and their replacement decides a new draft is required, which alienates attached talent, who drop off the project, forcing packaging agencies to find new attachments. And as new revisions by up-and-coming scribes (because the original writer won't get to write any of the revisions) generate lackluster coverage from readers and story analysts, the project goes into turnaround (the rights of your script get sold off over and over to new buyers until someone finally gives a green light), where it can languish for years, trapped in the dreaded "development hell."

This is the development process familiar to most screenwriters, and the development experience every writer and producer loathes beyond words. It is unpredictable, chaotic, at times psychotic, and in its way acts like an uncontrollable force of nature that can just as easily smother your screenwriting dreams in quicksand as lift them into the bliss of being a working, professional, produced screenwriter. This is one side of development, the side known well by the consensus; the random generator of screenwriter horror stories or wildest-dreams-come-true.

But, development is not so simplistic as just described. It is not a monolithic process with many moving parts; it is at least three separate processes, each of which constitutes a distinct, functional course of action along a script's development path.

It should be noted that while I am treating all these development stages separately, producers and executives will be less likely to do so. In the take-no-prisoners world of the entertainment business, time is of the essence, and sales, marketing departments, and business affairs wait for no man, or woman, or screenwriter. The business and script development stages can often bleed together because of the demands of schedules, financing, and other factors. Indeed, business processes can even begin at the story development stage. But, it helps to see these stages of development as siloed functions from a screenwriting perspective, especially the story development stage. Until a screenwriter can approach scripts story-first, rather than writing-first, or business-development first, real story development will be elusive and the script development process will likely be fraught with false starts, missteps, and frustrating excursions into the writing wilderness. Executing proper story development *before* you engage script development is an essential first step to producing a screenplay that will survive the rigors of the overall development process. And successful development begins with the screenwriter knowing why the job of storytelling is not the same as the job of writing.

The three stages of development include the following:

- Business development stage
- Script development stage
- Story development stage

BUSINESS DEVELOPMENT STAGE

The process of business development refers to the people, entities, and business processes needed to take a script and turn it into a saleable product on an international scale. (Even if the script is an independent production, and not a big studio tent pole, international sales are essential for achieving financial success and product longevity.) This is the stage of development where the Hollywood business machine does what it does better than anyone in the world. Once a script enters into this process, it is further honed, enhanced, and reformed to

be market friendly, and generally manipulated in a myriad of ways to make the product launch (i.e., the movie or TV show) a market success. The list of players in this stage is long and formidable: talent agents/packagers, talent, studio creative executives, talent managers, literary agents, lawyers of various disciplines, marketers, producers, executive producers, investors/financial entities, story editors, story analysts/readers, domestic/foreign sales agents, distribution companies, and even screenwriters. The final objective of this stage of development is the coveted green light, the go-ahead signal that this is a project a studio or distributor will put its considerable resources behind, in order to turn a profit.

EXAMPLE

Key Function: Navigating all the business-related tasks associated with packaging, selling, and the green-lighting of a literary property.

Key Players: Talent agents/packagers, talent, studio creative executives, talent managers, literary agents, lawyers of various disciplines, marketers, producers, executive producers, investors/financial entities, story, story analysts/readers, sales agents, distribution companies, screenwriters.

Key Objective: Get a script into production.

SCRIPT DEVELOPMENT STAGE

This is the stage of development that makes all of the business development stage possible. The script development stage is focused on the creative and technical process of completing a physical script that can then move through the refinements and script-by-committee mentality that produces the final literary property. "Script-by-committee" refers to the industry-wide practice of passing a screenplay draft between multiple business and creative project stakeholders (distributors, talent, creative executives, etc.) and incorporating their script notes into script revisions. After all, without a literary property to package and sell, there is not much point in all the chaos and mayhem that is sure to follow during subsequent development activities.

The primary player in this stage is the screenwriter or screenwriters. Depending on how the project comes into existence, various other players will have their fingers in the process as well: producers, executive producers, and maybe a production company story editor (if the script is being produced in-house). But, basically the screenwriter is the central player, and the one most accountable for successful execution.

The final objective of this stage of development is a solid script that will pass the scrutiny of all the gatekeepers coming down the line in the green-light process. Script development is usually where most people think the development process really begins. But this is not the case. There is another stage before this one: the story development stage.

EXAMPLE

Key Function: Physically write all the various drafts required to have a producible and saleable property.

Key Players: Screenwriters, but often executive producers, producers, and other production company staffers related to story department.

Key Objective: A final draft ready for green light (not a shooting script).

STORY DEVELOPMENT STAGE

The previous two stages of development are pretty much out of your hands as a writer. You have little or no control over what happens to your story once it passes into the meat grinder of active script and business development. Even in the script development stage (the actual writing phase) you will get input, notes, and suggestions from other players with agendas already in motion (marketing, packaging, sales, etc.). The story development stage is the *only* stage of development where the screenwriter holds the full reins in his or her hands; where the writer can run the show. This is critical to understand, because if you get this stage "right," then it will influence all the other stages down the line, so your authority as the storyteller can shape your story's ultimate fate—because it will be your story, not a story by committee. The director Alfred Hitchcock was notorious for shooting his movies and editing them in the camera during filming, consequently if a studio executive wanted to make cuts to the final film it would be impossible because of how tightly Hitchcock shot his scenes—further cutting would simply ruin the story. Nor did Hitchcock leave much "extra" footage (called coverage), so a studio would have almost nothing available to add into the final cut, if they wanted to muck around with Hitchcock's edit. This is what the story development stage affords you as the writer. It is a way for you to limit the changes that can be made down the development line, by assuring your story is as tight and integrated structurally as possible—before it goes into the meat grinder. Changes will be made, they always are, but if you do your job right, as the architect of the story, at this stage of development, then changes will be mitigated by your story skills. With that said, nothing can stop the business stakeholders from completely rewriting everything and essentially writing you out of your own work. This can happen, regardless of how tightly you write your draft. When this does happen, forces are at work that have little or nothing to do with your writing. Fight for what you can save, let go of what you can't, move on. "Hey, it ain't personal," as the mafia likes to say, "it's just business."

The story stage of development is not generally recognized as a part of the overall development process. Most in the development universe lump story development into the script development stage, just as most screenwriters lump the functions of writing and storytelling together as one task in their own writing processes. In reality, story development is a separate function that needs to occur before any of the other stages. In fact, in a fundamental and essential way the story development stage is the most important phase of development,

because it is here where the foundation of the final product is built. If this foundation is weak, then the entire structure upon which the bigger development effort rests will be weak or compromised, and the results will not be optimal, i.e., the producers will not be happy.

The story development stage has primarily one key player: the screenwriter. One or more producers may be involved, but this is normally the central task for the writer of the story. The final goal is not a script. The objective is to find the story, establish the structure, and validate that the story will have legs to stand on. Without a story there will be no script, and without a workable script there will be no business process to package, produce, and sell the final product. It is worth repeating: if you master this stage of development (which this book helps you to do), then you can reduce the risks associated with the story-by-committee gauntlet sure to come.

EXAMPLE

Key Function: Establish and validate the story and its structure so that the script development stage will be unencumbered by story development issues.
Key Players: Screenwriters and creative producers.
Key Objective: A solid story that has a validated structure.

Knowing where the storytelling function lies within the overall story development universe is a valuable gem of knowledge, because most screenwriters do not see the power this little gem gives them in the bigger picture of making their vision successful. We all go into the development process knowing the script-by-committee meat grinder will spit out a script much changed from our original intent. Even screenwriters working on independent productions will not escape this experience. At some point they will find themselves sitting around a table "taking notes" from various stakeholders who are clueless about how stories work, or how a screenplay needs to be written. In some ways it's even worse for independent creative producers and writers, because they have to deal with stakeholders who are often completely inexperienced in the entertainment industry. At least at the studio or network level you will be dealing with experienced people accustomed to working with writers, and who have a somewhat clear agenda creatively—even if their story suggestions make you cringe.

As a screenwriter, if you are fortunate enough to make a sale—and your lottery ticket gets hit by lightning on your birthday in a leap year—and you find yourself actually writing your own movie or TV show, you *will* find yourself staring into the black maw of the meat grinder. But if you have done your work; if you have honed your premise line; and if you have found the right, true, and natural structure of your Invisible Structure, then you will be in a much stronger position to enter the story development stage knowing that what comes out of that stage will be closer to your story's truth than not.

---10---

CHARACTER DEVELOPMENT—WHAT THEY DON'T TEACH YOU

STOP

REMEMBER

One story; one main character. It's all about the protagonist.

THERE CAN BE ONLY ONE

The opening reminder for this chapter says it all: every story should have one protagonist. This may sound obvious to many, but you would be shocked at how many screenwriters believe that the more protagonists, the better. After all, more protagonists means more drama, more subplots, more scene material, etc. Wrong, wrong, and wrong. It is important to establish the primacy of a single protagonist because the hero/heroine of your story is the hub of a wheel from which spokes of supporting characters radiate. All these spokes support the protagonist and spread the weight of the drama evenly so the wheel doesn't collapse. Imagine a wheel with multiple hubs, with each hub having its own spoke-characters. The weight might still get distributed, but the ride would be pretty wobbly even at a slow speed—assuming you could build such a wheel.

Regardless, the wheel metaphor works for storytelling. Just as each spoke carries its share of the weight, each character carries their portion of the drama. But not just any piece—the drama they support is the story of the protagonist, even if that supporting character has their own subplot running parallel with the protagonist's line. Such characters cannot be in service to two or more masters. Their dramatic support should always be directed toward one main character; otherwise, the drama overall will be dissipated and underdeveloped.

Having one protagonist means that there is one dramatic throughline, one central adventure, and one dramatic focus for the audience. Every character in the story, in one way or another, is at service to this protagonist and telling his-her story. The very term "supporting character" gives this relationship away in the most obvious way possible: "supporting" what? If not supporting the protagonist,

then what is this character supporting? This idea that all supporting characters are actually connected to, or clarifying, or mirroring the protagonist's dramatic development is not a notion most writers use when developing characters. Most often, writers will add in a character because it adds spice to a scene, or creates a set-piece moment that will stand out in the action, or just because they like the character so they want to include them in the story. None of these are sound reasons for adding a character to a script. In fact, these are all the wrong reasons for adding a character. No one should be in the script who does not convey information needed to understand the mystery or puzzle, create obstacles or increased stakes for the protagonist, or open windows into the dynamics working inside the protagonist's character. If a supporting character doesn't do one of these three things, then the screenwriter must ask, "Why is this person in my script?" If the answer is, "I think it's just a cool thing to have," then okay. You have made a conscious choice based on your needs and not the needs of the story. Bravo, you are becoming a conscious writer—meaning, making story choices because you understand those choices and their consequences—and this is one of the big lessons of this book.

But if the answer is, "No, I don't want to do that—I need this character to actually support the story," then again, bravo. You have made another conscious choice, only this time, one that will strengthen the storytelling and not weaken it. Be clear, I have no judgment about the choice you make in this regard. You are not a bad person or a bad screenwriter for following your needs versus the story's desires. You have simply made a choice, and all choices have consequences. This is true for your protagonist, and it is true for the writer. So know what you are doing and why you are doing it, and be prepared to live with the outcome.

THE ENSEMBLE

There can be only one—unless there is more than one. The protagonist issue does get muddled when you have something called an ensemble cast. An ensemble story is an assembly of stories which may or may not touch one another, but are instead connected based upon some organizing idea-theme like love, happiness, race, forgiveness, etc. (e.g., *Crash* [2004], *The Big Chill* [1983], *Thirteen Conversations About One Thing* [2001]), or a physical design element like a setting, an event, or a symbol (e.g., *New Year's Eve* [2011], *Valentine's Day* [2010], *Contagion* [2011]). In ensemble stories, individual characters act out their personal lives giving different perspectives of the organizing idea-theme, and the degree to which there is any resolution among the competing perspectives is what determines the power and effectiveness of the story on the audience or reader.

The central distinction, however, is that ensemble stories do not support a single, key throughline featuring a main protagonist. These are stories where there are three or more characters carrying the weight of the drama as equally as possible. They are very hard to write well, but there are many fine examples where screenwriters have weaved multiple, dense, and powerful narratives together in

this fashion—often not having any of them directly touch one another—while still managing to keep audiences focused and engaged. The great beauty of ensemble stories is that by taking away the focus on a single protagonist, they give the writer the ability to emphasize the affairs between characters based on big ideas, thus giving readers and audiences multiple windows into the story, rather than just one. The great danger with ensemble pieces is that they can result in works that lack a center of dramatic attention and narrative force. With no main character as the center of the storm, something must unite the other characters so that there is a sense of narrative unity, purpose, and flow. The challenge for the writer lies in finding that unifying theme, idea, or physical component that can help the reader or audience stay focused and engaged. So, while in most cases having a single protagonist is the soundest, and most satisfying way to tell a story, the ensemble story can also deliver an effective and powerful experience.

Novelists are really in the best possible position when it comes to writing ensembles, compared with screenwriters. It is much easier for novels to have many characters, each with an equal point of view and an equal dramatic weight. It is just the opposite for film and television writers. Writing effective ensemble pieces in film and television is one of the hardest and most challenging forms of writing. Why is it easier for novelists to execute the ensemble? The answer is simple: story real estate.

Novelists have no constraints when it comes to writing a book. There are no limits, besides those imposed by publishers for their various imprints. Basically, novelists do what they want. The canvas is broad and expands endlessly. Not so with a screenwriting. For example, feature screenplays have an artificial ceiling of 120 pages (more like 110 pages for many genre films), and in television, half-hour sitcoms are only about 22 pages. Story real estate is cramped and costly for screenwriters. We simply don't have the story space to juggle multiple characters the way a novelist can.

As contrast, consider the fantasy series *A Song of Ice and Fire* (Random House), by George R.R. Martin. In each book of the series, some volumes being over one thousand pages, many characters share equal story space and time telling their individual tales. Readers love the series, and Martin's ensemble-writing style works because he can take as long as he likes to pull readers in and luxuriate in character details, backstories, changing emotional states, and grisly goings-on. Over the years, one of the reasons Martin resisted attempts by film producers to turn his series into a feature film was that he didn't think a two-hour format could do justice to his books. And coming from the world of television writing himself (*Beauty and the Beast, Twilight Zone, The Outer Limits*), he knew his concern was justified. It was only after the *Game of Thrones* (HBO) showrunners, Dan Weiss and David Benioff, shared their vision for a multi-season, serialized vision of his books that Martin agreed to let *A Song of Ice and Fire* to be adapted for television. The serialized, limited series, and mini-series formats that are now popular with primetime and cable networks afford producers and writers the same broad canvas as novelists to give television audiences immersive and complex story worlds. In this serial/series environment, ensemble stories flourish and make for great entertainment—and some great writing.

THE THREE GROUPS OF CHARACTERS

All supporting characters will fall into one of three groupings in any story (beyond your main character): messenger/helper characters, complication/red-herring characters, and reflection/cautionary tale characters. This may seem reductionist to the extreme, but when you consider the three groupings that constitute the functions of supporting characters (when they actually support the story), these groups make sense.

Messenger/Helper Characters

Messenger/helper characters are the characters that show up; deliver some crucial piece of information so the audience has what it needs to follow the mystery, puzzle, or complicated situation; and then, after delivering the message, they disappear, never to be seen again, unless they are found dead in a snow bank. After all, sometimes they do kill the messenger. These characters exist simply to help you the writer keep the protagonist (and the audience) in the plot loop, so they have just the right details about the mystery, puzzle, or situation. They don't do anything except deliver information, facts, or clues to help move the problem-solving process forward. These kinds of characters are most clearly present in police or detective procedural stories, where the protagonist is busy gathering clues and information to solve the mystery or puzzle. Television police procedurals demonstrate great examples of messenger characters through shows like *Law & Order* (1990-2010, NBC Universal Television), or *Lie to Me* (2009-2011, Fox Television Network). Messenger characters are essential in any situation script, but they are also important in a story. Often, they can also supply important context that heightens comedic or dramatic moments in the script. Sometimes, however, they may not bring any new information or promote the plot in any concrete way, but still fill a needed function in the flow of events, acting in a purely helping or facilitation capacity.

The Producers (1967—AVCO Embassy Pictures)
Context: Max Bialistock (Zero Mostel) and Leo Bloom (Gene Wilder) come to the New York City brownstone where the "playwright" Franz Liebkind (Kenneth Mars) lives. They want to convince him to let them produce his play *Springtime for Hitler*. The "concierge" (Madlyn Cates) is hanging out of her window and gives them information they need in order to be prepared for their meeting with Franz.

Message Delivered: He's a crazy "Kraut," he isn't in his apartment, he's on the roof with his ". . . dirty, disgusting, filthy, lice-ridden birds." Now, Max and Leo have some idea of what they are up against.
Fate of Character: We never see her again.
Story or a Situation: Story
Type of Character: Messenger

World War Z (2013—Paramount Pictures)

Context: Gerry Lane (Brad Pitt) arrives at Camp Humphreys, South Korea, to investigate the supposed origin of the zombiepocalypse. He meets an ex-CIA agent (David Morse) who, between pulling out his own teeth, gives Lane crucial information for the next steps in his journey to find a cure for the zombie disease ravaging the world.

Message Delivered: The Israelis were prepared for the outbreak a week before it occurred, and that Mossad agent Jurgen Warmbrunn (Ludi Boeken) is the man to talk to if Lane is to be successful stopping the disease.

Fate of Character: We never see him again.

Story or a Situation: Situation

Type of Character: Messenger

The Exorcist (1973—Warner Bros.)

Context: Karl (Rudolf Shundler) provides various kinds of support and help to Chris MacNeil (Ellen Burstyn) over the course of the story. He is driver, caretaker, houseboy, and all-around good guy.

Message Delivered: No real information is conveyed directly by the character, but he does create a bit of mystery in that we know he has a dark secret and he seems haunted by something serious. The film plays down the red-herring quality of his presence after Burke's killing.

Fate of Character: Remains tangential to story, but maintains helper function throughout.

Story or a Situation: Story

Type of Character: Helper, but in the novel Karl played more of a hybrid helper/red-herring character. His role providing misdirection for the murder investigation was more important than in the movie, and the subplot with his drug-addicted daughter played more of a counterpoint to the Regan possession. Karl's daughter was possessed in her own way by her own devil.

Complication/Red Herring Characters

Complication characters throw monkey wrenches into the works and create havoc and chaos at the worst possible moments. They don't bring important information, they don't drop pithy clues to the mystery, and they don't do anything to move the plot forward. All they do is enter a scene, do the wrong thing, or what they think is the right thing, and then all hell breaks loose. Their actions usually raise the stakes for the protagonist by initiating the first crisis in the story, or adding to that crisis and making it worse. These are often the characters that exist mainly to die horribly, and in their grisly ends they reveal just how awful things are going to get for the protagonist and other characters. Genre stories use these kinds of characters in abundance, as you can tell from the examples below.

The red herring variety of this group represents characters who are not what they seem. A "red herring" is a clue or a character that deflects attention from

the truth to a false conclusion about the truth. It seldom if ever deepens a story by contributing substance; it is almost always pure story slight-of-hand designed to create a moment of surprise or shock. Red herrings, if done badly, can anger audiences, as they will feel manipulated rather than pleasantly surprised by the reveal of the truth behind the distraction. When this happens using a character, as opposed to a clue or some bit of business in a scene, then such characters can fall out of favor and you can begin to lose your audience. Always use red herring clues with caution, but be extra careful using a red herring character.

EXAMPLE

The Blob (1958—Paramount Pictures)

Context: An old man (Olin Howlin) finds a newly fallen "meteor" and is curious about it, so he does what anyone would do with a piece of solid iron from space, he pokes it with a stick.

Complication/Red Herring: He cracks open the "meteor" and out oozes a blob-thing that crawls down the stick and onto his hand. And away we go—grisly deaths quickly follow. If he'd just left the darn thing alone ...

Fate of Character: Absorbed into the blob in a slow and painful manner, across several scenes, ultimately never to be seen again.

Story or a Situation: Situation

Type of Character: Complication

Aliens (1986—Twentieth Century Fox)

Context: Bishop (Lance Henriksen) appears as though he will betray Ripley (Sigourney Weaver) the same way as his android predecessor, Ash, did in *Alien*, i.e., secretly pretending to support the mission, but working for the bad guys to acquire a xenomorph for the "company." But, it turns out Burke (Paul Reiser) was the one who really wants to bring in an alien, and Bishop was only being a good robot and following his innocent programming.

Complication/Red Herring: Distraction from the real bad guy.

Fate of Character: Bishop is revealed as a true ally and takes one for the team, but lives on to tell the tale.

Story or a Situation: Situation

Type of Character: Red herring

28 Days Later (2002—Twentieth Century Fox)

Context: Various nameless animal rights activists break into an animal research lab and, thinking they are doing the right thing, release chimpanzees who are infected with a virus that leads to insane and uncontrollable rage, which leads to the end of civilization in the U.K.

Complication/Red Herring: Creates the root cause of the epidemic and ensuing chaos, without which there would be no movie.

Fate of Character: Presumably they are all turned into rage zombies.

Story or a Situation: Situation

Type of Character: Complication

Reflection/Cautionary Tale Characters

Reflection characters are the ones that relate directly to the issue of the moral component. They may bring messages or help, they may die horribly to ratchet up the tension, or they may only appear once or twice in the story, but they play a crucial role because they reflect some aspect of the moral component of the protagonist, and thus represent "windows" into the behavior and motivation of the protagonist that the audience can "look through" to get a deeper perception of who the hero/heroine is as a person. If the protagonist is dealing with a moral blind spot associated with forgiveness, then you could have a character working a subplot that mirrors some thematic expression of giving or being forgiven. If your protagonist is acting out in the world in such a way as to demonstrate a problem with greed, then another character could demonstrate the positive consequences of having everything taken from them, as they refuse to be defeated by greed, while another character might provide a window into the opposite behavior, i.e., losing everything and then blowing their brains out in despair. All of these examples show how characters around the protagonist can act as mirrors reflecting back to the protagonist different aspects of their moral component in action in the story world. On some level this may seem obvious, but many writers populate their stories with characters who have minimal or no behavioral connection to the protagonist of the story. This is not bad or wrong, but it does miss an opportunity to connect story action directly to behavioral and motivational drivers that deepen an audience's understanding of who it is they have invested so much of their emotional time into. Every significant character in the story should be a reflection of some aspect of the protagonist's moral dilemma.

The cautionary tale variety are characters that reflect a specific aspect of the protagonist's personal story: they represent what kind of person the protagonist will turn into unless they change, i.e., unless they heal their moral component. These can be reflective characters as well, but the mirroring is more profound than a "simple" window into character or motivation. The message from these characters is, "Be careful, I'm your negative future if you don't make a change in your core self." This caution does not have to only be in the negative direction of growth. The cautionary tale character can also give the message, "Be careful, I am a positive future you can have, if you wake up and change." Either of these cautionary messages is best delivered by the central opponent or the focal relationship character (see chapter six) because these are the characters who spend the most time with the protagonist during the story, and through whom the protagonist will grow and change, or constrict and de-evolve.

EXAMPLE

The Dark Knight (2008—Warner Bros.)
Context: Batman (Christian Bale) is suffering a moral crisis: if Gotham is to have order, the Joker (Heath Ledger) must die, but Batman has one rule: he will not kill. The Joker has no rules. He is chaos personified, and he is out to make Batman break his one rule so that he can prove to Batman that they complete

one another. The problem is, Batman is not sure the Joker isn't right.

Reflection Delivered: Batman is watching his worst possible reflection in the Joker. It would not take much for him to turn into his own version of chaos personified and lose his moral compass.

Fate of Character: The Joker is taken away to an insane asylum.

Story or a Situation: Story

Type of Character: Reflection and Cautionary Tale

The Odd Couple (1968—Paramount Pictures)

Context: When he is thrown out of his house by his wife, uptight, fastidious, and stick-in-the-mud news writer Felix Unger (Jack Lemon) moves in with let's-have-fun, slovenly, and easy-going sports writer Oscar Madison (Walter Matthau). Their friendship is quickly tested by both men's refusal to accommodate the other's style of living.

Reflection Delivered: The easy answer here is that these men are opposites. But they are not. They are reflections of one another. They each reflect back to the other the qualities the other needs to live a more balanced life. This is pure reflection, not simplistic opposition.

Fate of Characters: Oscar and Felix influence each other's behaviors and, in the end, their friendship survives and both are changed men.

Story or a Situation: Story

Type of Characters: Reflection

Frankenstein (1994—TriStar Pictures)

Context: Victor Frankenstein (Kenneth Branagh) has no deep relationships with others, preferring to lose himself in his work. Despite the presence of Elizabeth, Victor has a more emotional connection to his monster (Robert De Niro) than to her. As he denies himself love, so he denies the monster love; as he denies himself social acceptance, so he denies the monster access to society. The monster and the scientist become codependent, even in their mutual hatred. They need one another, and perhaps it is this very need they hate most about each other.

Reflection Delivered: The monster reflects Frankenstein's own alienation from love, from society, and from himself.

Fate of Character: Weeping over his dead creator, the monster laments his own isolation, regret, hatred, and loathing and realizes that now he too can end his own suffering; he disappears to the icy north to die.

Story or a Situation: Story

Type of Character: Reflection

(*Note: This film version of the Mary Shelley book captures better than any other film adaptation the spirit of the novel.*)

It should be noted, although you may have already gathered this from the examples, that any supporting character can represent one or all of the various groupings of characters. Minor characters (i.e., characters nonessential to the telling of the story) most often represent one group and variation, but major characters (i.e., those characters essential to telling the story) can combine any

grouping and variety as required to tell your story. For example, as we have seen, the main antagonist often plays out as a complication and reflection character. The Joker from *Dark Knight* is a perfect example of this. The Joker is definitely creating chaos and raising the stakes for the hero, Batman, and he is also reflecting back to the hero what Batman might become unless Batman gets out of his own way and stops obsessing about his own potential dark side. Joker's line, "You complete me," illustrates the reflection quality of the character in dialogue. In lesser films, this same sentiment is usually expressed with the clichéd line, "We're not so different, you and I," implying that the bad guy and the good guy share more in common than the hero or heroine would like to admit. The focal character (e.g., the lover in love stories, or the buddy in buddy stories) can similarly play reflective and complicating roles. In fact, for them to be the powerful characters they need to be in any story, the central antagonist and the focal relationship characters need to cross-pollinate all three groupings in order to meet their narrative potentials. You as the writer are only limited by your imagination and the requirements of the story's right, true, and natural structure.

Knowing what kinds of character groupings populate a story, and the specific roles they play and narrative responsibilities they possess, can add to your writing toolbox by making you a more conscious screenwriter. You can make sound development choices based on story structure needs that serve the story, and not just some whimsical sensibility. Chances are good that if a character and its associated scenes do not fall into one of the three groups, then you have to ask yourself: what are they doing in the story? If you can't see how they fit—in relation to the groups—then they are probably superfluous, and their scenes can be cut without hurting the flow of the script, and the pacing will probably be improved when you do so.

FINAL THOUGHTS

> *You have to first understand what's real and what's fabricated about the myth of writer's block before you can really bust it!*

Now you have all the building blocks, foundation stones, tools, and techniques that you need to write a working story premise. But there's more to it (isn't there always?). You also need the discipline of writing. Sometimes your writing will flow easily, other times you'll wish you'd gone to dental school. With that in mind, I have decided to end the book with an iconic subject: writer's block.

I do this because the belief in this thing is almost universal, and the amount of wasted effort writers expend trying to solve it, heal it, break it, and be free of it is depressing, when considered against what other things writers could be doing instead—like writing. People buy books, take classes, hire therapists, run in circles, and chase their tails all in the hopes of avoiding or resolving one of the biggest flimflams in creative writing. So, read this chapter and be prepared to walk away from writer's block once and for all.

THE MYTH OF WRITER'S BLOCK

Writer's block—we've all been there. We've all suffered. And we've all been duped. What would you say if I told you writer's block is a fiction? What would you say if I told you that writer's block was a complete boondoggle foisted upon writers for decades? Would you feel shocked? Would you feel had? Or would you defend a strongly held, personal belief that writer's block is real because you've been there—too many times?

Sadly, most writers I know fall into this last category. Myself among them, until I realized the truth: writer's block isn't real. The man we have to thank for the pernicious idea that we writers have a special neurosis all our own is a long-dead psychoanalyst named Edmund Bergler. He first coined the phrase "writer's block" in 1947, as only one example of what he called "unconscious masochism." The

psychoanalytic analysis of writer's block is impenetrable in its own right, but that the term's origins came from the world of psychoanalysis—the Holy Grail for the neurosis model of emotional upset—should be the first red flag as to its illegitimacy.

Writer's block is a lot like racism. Race is a myth; it does not exist. It is a socio-economic construct, not a biological fact. We are literally all the same race: human. That is not wishy-washy liberalism; that is what science tells us. But, the experience of race is another matter entirely. Race may be a fabrication, but racism is a real and destructive thing. And so it is with writer's block; it does not really exist, but the experience of the thing gives it a substance it does not possess.

Consider the usual suspects as to the popular "causes" of writer's block:

- You have a blank mind and no ideas come whatsoever; the well is dry.
- You have written yourself into a dead end and can't get out.
- You're afraid of making a mistake, fear of failing.
- You're afraid of being judged by others for what you write.
- You're distracted and torn by other issues besides your writing.
- You're pressured to produce deadlines and fulfill the expectations of others.
- Your brain is at fault; under stress, the brain goes into "fight-flight" and is not creative.
- And the list goes on . . .

"But wait," you say incredulously, "I've experienced it! Writer's block is real. It exists; it is the Great Satan!" Well, yes, writers can get clogged up, but that blockage is so easily handled and so uncomplicated that many writers will be shocked at the simplicity of what is really going on. It turns out that writer's block is 99.9 percent smoke and .1 percent substance. The .1 percent part is the only part you can do anything about.

The conventional view of writer's block is that it manifests when a writer (screenwriter, novelist, whoever) feels stuck, unable to write, bereft of ideas, and left hanging in the wind by the creative process—helpless and hopeless. The form it takes is universally recognizable, and for those who have drunk the Kool-Aid, as we have seen above, the causes of writer's block are as legion as the devils of Hell.

Our writing culture identifies creative void, fear, stress, and neurological and physiological complications as the causes of writer's block. In short: writer's block is multifaceted, multicausal, and multi-problematic. What is a writer to do with something so diffuse, nondescript, and scattered? Unfortunately, this phenomenon has taken on a life of its own, so much so that what is actually a clear and definable problem has been turned into a multi-headed Siren that will lure you onto the rocks of *process interruptus*. Don't buy into it! Instead, consider the simple logic of a reasoned argument.

THE ONLY REAL REASON WRITERS GET BLOCKED

TIP

Everyone has it all wrong when they talk about why writers get blocked. So-called writer's block boils down to one actionable cause.

The "argument" is not so much an argument, as it is a simple statement of fact; there is only one cause for so-called writer's block: *you have too many ideas in your head, and the creative pipeline is so full you don't know where to begin or what to write.* You are so full of things to say that you can't say anything at all. *You don't trust your ability to make the right creative choice!* That's it. That's all there is to it. All the other "reasons" that I mentioned earlier are manifestations of problems that have nothing to do with the writing or creative process. They may impact writing, but they are not related to, or sourced from writing.

Anxiety, fear of failure, stress, etc. are not writer's block. They are life blocks that may need to be addressed, but they are not writer's block, because they do not originate from the writing or creative process. This is a key distinction that everyone misses, when they discuss this problem. Even so-called blockages due to character development problems, plotting problems, or story structure issues are not writer's block. They are part of the writing process that every writer has to deal with when they write any story. These things might slow you down, and you will have to work through them—you always have to work through them—because they are always present to one degree or another. They are part of writing, not part of being blocked.

And so it bears repeating: *it is only when you are so clogged with creative ideas, and you don't trust your ability to choose what's next, that your writing drags to a halt and gets stuck.* It's not because you can't pay the bills, it's not because your lover left you, it's not because your mother dropped you on your head at 18 months, and it's not because you're afraid of what other writers might think. Those may all be problems that may or may not haunt you as a human being, but they are not creative-process problems, they are life problems affecting everything in your life—including your writing. But, isn't all that the same as writer's block? Blocked is blocked—right? What does it matter what you call it? It matters a lot!

If your life is in chaos or stalled out, so will be your writing. But, if your writing is stalled out, your life will be unaffected, unless your life is so out of balance that all you do is write, so when that is not working, nothing else is working. Again, this isn't a writing problem; this is a life problem. And this is where so many people get tied up into knots. For example, if you get hit by a car and can't write for six months, is that writer's block? No, it's a major medical problem, i.e., a life problem. You can call it writer's block, but your doctor will have a much longer medical name for it. Figuring out which is which (writing vs. life) is hard when

all the advice you're getting on this issue is muddled with psychobabble, New Age bubblegum metaphysics, and generic self-help mumbo jumbo.

It is critical that you learn how to distinguish between life problems affecting everything, including your writing, and creative-process problems affecting your writing but not the rest of your life—before you tackle any blockage. One is personal pathology, or life circumstance, and needs to be handled outside of your writing process (like therapy or surgery); it's bigger than just your writing. The other is sourced from your creative process, not a car wreck or your cranky inner child.

So, what's a writer to do? There is a solution to this artificially complicated and overinflated dilemma called writer's block. There is something very specific you can do to nip this trouble in the bud, without being derailed by all the psychobabble and self-help sleight-of-hand offered up by pop-culture gurus. The first step to freedom lies in understanding that this problem is mostly smoke and mirrors. You have to take your power back from the myth before you can face the true beast.

Writer's block is a writing problem—therefore you have to look to writing for a solution—not Yoga, a therapist, or Tarot cards.

THE ONLY REAL SOLUTION TO WRITER'S BLOCK

Any lasting solution to writer's block must lend itself to real freedom, not airy-fairy workarounds. To that end, consider these scenarios:

- When a professional musician is on stage and the pipes get stuck, the music doesn't come, and he/she can't deliver (and it happens) what do they do? Throw their hands up and walk off stage? Hardly.
- What does a professional actor do when the cameras are rolling, or the audience is watching, and the juice is gone? The character leaves them, and they can't deliver! Do they run off to their trailer in a snit or walk off stage? Well . . . sometimes.
- When a professional athlete is exhausted, spent, and at the end of their physical limits, how do they safely get to the finish line, sink that putt, or swing that bat, when every fiber of their being wants them to shut down and stop? Do they crumble in a heap and give up? Rarely.
- When blocked, professionals know what to do and they do it seamlessly. They don't take a Yoga class, they don't write in their journal, they don't doodle, or take long car rides into the countryside—they fall back on craft skill and technique. The musician has skill and technique and this saves them. The actor has skill and technique and it is always there for them. The athlete has muscle memory and technique that are second

nature. Once they tap this resource (craft), the juices flow and they are "back"—blockage removed. That's how professionals deal with "musician block," "actor block," or "athlete block."

So, what should a writer do? The same thing! Fall back on craft. For writers that means story structure. As we have established throughout this book, story structure is part of storytelling craft skill. It is the airbag that catches you when you fall. You learned this in chapters three, four, and five. The Invisible Structure is always there if you have a story, it is always available, because story structure doesn't depend on you. It is there for you to depend upon it. Story structure is your lifeline for premise development and for curing writing blocks.

THE 7-STEP PROCESS FOR BUSTING WRITER'S BLOCK

This is a proven, repeatable, and effective process that is guaranteed to work. All other solutions to writer's block beat around the bush; this process tackles the issue once and for all.

What follows are the concrete steps of the solution, illustrating how craft and technique are the writer's salvation, not handcuffs of constriction or limitation. This process will always work to get you unblocked. I use it with all my clients. I use it myself.

Step 1:

Determine if you are dealing with a life problem or a creative-process problem. Remember, life problems can affect your writing, but they are not writer's block. They need to be handled, but you're dealing with something bigger than just being creatively blocked. This process won't help you with that. Go get other help—talk to a friend, call your mother, get therapy. When dealing with serious life problems, not writing might be the healing thing to do. You may need to take a break and focus on your divorce, your illness, or whatever. If, however, you're clear this is a creative problem and not a bigger life issue, then move to the next step; you're in the right place.

Step 2:

Tell yourself the truth: this block is a good thing. You have so much flowing you can't think straight. Be grateful and thank the writing gods. Really, take

some time and think about and feel that gratitude. This isn't psychobabble. You are not just "turning that frown upside-down"—this is a critical shift of your mental-emotional state that is essential to move forward. The shift that occurs is one of going from victim to owner. You own your process, you are accountable for what happens next. This is not something that is happening to you; you are generating the block yourself because you have so much trying to get out, and you haven't created the proper conduit for the creative ideas to flow. This simple act of owning your personal responsibility for this situation cannot be understated. Nothing changes until you do. So, change your mindset. This blockage is a good thing.

Step 3:

Filled with gratitude, solid in your personal responsibility, or at least no longer feeling suicidal, look to your story's structure. Take a piece of paper and map it out as best you can. Write down your story's Invisible and Visible Structure components as best you know them: moral component, chain of desire, main antagonist, focal relationship, midpoint stakes, protagonist stakes, doom moment, final resolution, and the protagonist's evolution-de-evolution. Define these pieces and work with them until you have the big picture solid in your head. Even if you know all these steps, do this anyway. If you have been through the first two parts of this book, then you know what I'm talking about. Do your homework on this and break out your story. Maybe you've been away from this process for a long time and haven't kept up on the ideas and concepts? Do your homework and go back to part one and review. If this is all news to you and you are reading about story structure for the first time, get educated; stop where you are and walk away from this, because it won't work. You have to know your story's structure to break through the blockage. Do it now.

Step 4:

Assess the output of step three. You are blocked. You are blocked at a certain point in your development process. Think about where you're stuck in your story and look at the list of structure steps you just completed. Where does the point where you're stuck fall in the list of structure components? Which step does it relate to most closely? Get your bearings for the spot in your story where your clog is stuck. If you are just starting your story and the page is blank, the begin at the beginning and build your premise line. This will always get you off the blockage. If you are well into your story and you are stuck, then look to the structure notes you created in step three. Find where you are stuck. You have to have the source of the clog to break it up. Circle this on your list of structure elements with a big, black magic marker. This is what you bring into step five.

Step 5:

Once you get your bearings, once you find specifically (or as closely as possible) where in the structure you are stuck, then pull this out and work with it separately. Meaning, brainstorm scenes, possibilities, scenarios—but all of this needs to be geared toward moving you forward to the next story structure step from where you are stuck! For example, if your protagonist doesn't have a clear desire for the story, then solve this structure step and then think about the next step: who's trying to stop him-her from getting what he-she wants (i.e., the opponent)?

This is the only time where you will ever hear me advocate the "just do it" philosophy of writing. In this case it can work. Just write. Maybe everything you write is gibberish. That's okay. This is where you have to just force yourself. Like the musician or actor from the earlier examples—just do it. Don't censor, don't correct spelling, and don't judge it, just write. *Do not stop.* No breaks, no interruptions.

Step 6:

At some point the writing will stop being gibberish; it will start making sense. Keep going until you feel you have moved forward—even if you can't fully define what that means. The feeling of it is enough to bust the jam. This might take two pages, five pages, or ten pages. Keep writing until you make that breakthrough. Once you do, you're unblocked. Celebrate and get back to writing. If you get to page 30 and all the writing is still nonsense, then stop because you're just playing a game with yourself and this is now a form of self-sabotage. Back off and come back when you are ready to really be done with this.

Step 7:

Drink lots of coffee. You're unblocked, so you need caffeine! This is a serious step, by the way.

Trust in your story's structure to break the logjam and bust the myth of writer's block.

This process always works. Writer's block is 99.9 percent smoke and .1 percent fact. So, don't fall for all the hype about writer's block; that only feeds the monster. If you are blocked, it is a good thing, because it means you have ideas and creativity ready to flow. Use this process, trust in your story's structure to break the logjam—and bust the myth of writer's block.

I conclude this book with gratitude and joy—for your dedication to see the journey through, for your willingness to learn new ideas and explore alternate perspectives, and for the knowledge that some amazing writing will come out of this experience.

And I leave you with this final gem: my mantra. You have seen it in this book before, but I repeat it here because it is not just clever marketing spin, it is a life lesson:

> *Listen to everyone. Try everything. Follow no one—you are your own guru.*

Tattoo this into your forehead, chip it into the sidewalk where other writers will see it, but above all learn to trust it, because when you live this life lesson you will be a true free spirit, and the artist you've always imagined yourself to be.

Now, go be brilliant.

ABOUT THE AUTHOR

Jeff Lyons is a freelance story editor and story development consultant at Kensington Entertainment, Burbank, CA. He also teaches story structure and story development through Stanford University's Online Writers Studio, and guest lectures through the UCLA Extension Writers Program. His writing can be found in *Script Magazine, Writer's Digest Magazine*, and *The Writer*. Jeff is the founder of Storygeeks, a professional services company offering story consulting, professional development, and editorial services to screenwriters, novelists, film and television production companies, and indie producers. His popular workshops on premise development and how to use the Enneagram system for story development—for novelists and screenwriters—are offered throughout the United States and will be expanding to Europe and Asia in 2016. Along with his lecturing and teaching, Jeff is a regular presenter at leading storytelling and writing industry trade conferences. He has also taught at the Producers Guild of America's Diversity Workshop, coaching emerging writer/producers on story and script development. In 2016, he will be publishing *Rapid Story Development: How to Use the Enneagram-Story Connection to Become a Master Storyteller* through Focal Press.

Websites: www.storygeeks.com, www.storytellerstoolbox.com
Blog: www.storygeeks.com/blog
Twitter: @storygeeks
Facebook: www.facebook.com/storygeeks
Author Website: www.jefflyonsboooks.com

NOTES

CHAPTER 2

1 Heath, Malcolm. "Epic." In *Poetics*. London: Penguin Books, 1996.

2 Freytag, Gustav, and Elias J. MacEwan. "The Dramatic Action." In *Freytag's Technique of the Drama, An Exposition of Dramatic Composition and Art*, 6th ed. London: Forgotten Books, 2012.

3 Egri, Lajos. "Premise." In *The Art of Dramatic Writing: Its Basis in the Creative Interpretation of Human Motives / by Lajos Egri*, 8. [Newly Rev.] ed. New York: Simon and Schuster, 1960.

CHAPTER 3

1 Johnston, Bret Anthony. "Don't Write What You Know." *The Atlantic Magazine*. July 11, 2011. Accessed September 7, 2014. http://www.theatlantic.com/magazine/archive/2011/08/dont-write-what-you-know/308576/.

2 Merriam-Webster Dictionary. "Gestalt." Accessed March 10, 2015. http://www.merriam-webster.com/dictionary/gestalt.

3 Einstein, Albert. *A. Einstein: Autobiographical Notes; a Centennial Edition*, Pbk. Print. ed. by Schilpp, P.A., La Salle, Ill.: Open Court, 1992.

4 Roberts, Royston M. "Kekule: Molecular Architecture of Dreams." In Serendipity: Accidental Discoveries in Science, 77. New York: Wiley, 1989.

5 Kaempffert, Waldemar, ed. *A Popular History of American Invention*, Vol II. New York: Scribner's Sons, 1924.

APPENDIX A

WORKSHEETS AND FORMS

PREMISE LINE WORKSHEET (BLANK)

Anatomy of a Premise Line™: Premise Line Worksheet	**Storygeeks**
	Story Consulting – Training – Editorial

Mapping the Invisible Structure to the Anatomy of a Premise Line

Invisible Structure	Anatomy of a Premise Line
• Character • Constriction	*Protagonist Clause*…something pinches the character and inertia stops—he-she is pushed onto a new line of action
• Desire • Relationship	*Team Goal Clause*… the character joins with one or more people acting on some tangible desire with purpose
• Resistance • Adventure	*Opposition Clause*… the character's actions meet with some force that generates disorder and/or chaos
• Adventure • Change	*Dénouement Clause*… the chaos leads to change and a new moral effect

Premise should be thought of not so much as a definition, but rather as a physical construct that can hold the essence of your story's Invisible Structure.

Write the "Protagonist" clause:

Write the "Team Goal" clause:

Copying or distributing without written permission from the author is prohibited.

Write the "Opposition" clause:

Write the "Dénouement" clause:

Final Premise Line: (Write as one sentence.)

© 2015 Jeff Lyons

Copying or distributing without written permission from the author is prohibited.

Page 2 of 2

LOG LINE / TAGLINE WORKSHEET (BLANK)

Anatomy of a Premise Line™:
Log Line Worksheet

Storygeeks
Story Consulting - Training - Editorial

High-Concept Premise — 7 Components

1. High level of entertainment value
2. High degree of originality
3. High level of uniqueness
4. Highly visual
5. Possesses a clear emotional focus
6. Targets a large target audience
7. Sparks a "what if" question

The log line is your high-concept stated in a single (short) sentence.

Step 1: Define the high-concept:

- What is the entertainment level/value? (Express this as best you can.)

- How is this an original take on a familiar context?

 o *Familiar Context:*

 o *Original Take:*

- How is this a unique idea?

© 2015 Jeff Lyons

Copying or distributing without written permission from the author is prohibited.

Page 1 of 2

- How is this a visual idea?

- How is the root emotion underlying the premise? (fear, anger, humiliation, rage, shame, etc.)

- Describe the target audience:

- Write the "what if" question:

- Write the hook: (Keep concise and visual.)

Step 2: Write the log line

- Final Log Line: (Write as one short sentence.)

Step 3: Write the tagline

- Write a tagline: (Base it on the root emotion and the high concept.)

© 2015 Jeff Lyons
Copying or distributing without written permission from the author is prohibited.

SHORT SYNOPSIS WORKSHEET (BLANK)

Anatomy of a Premise Line™:
Short Synopsis Worksheet

Storygeeks
Story Consulting ~ Training ~ Editorial

Premise Line Clauses & the Short Synopsis

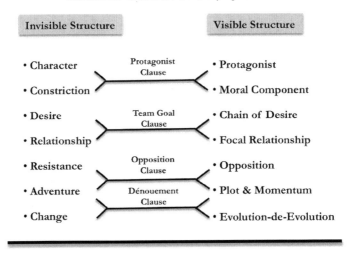

Invisible Structure		Visible Structure
• Character	Protagonist Clause	• Protagonist
• Constriction		• Moral Component
• Desire	Team Goal Clause	• Chain of Desire
• Relationship		• Focal Relationship
• Resistance	Opposition Clause	• Opposition
• Adventure	Dénouement Clause	• Plot & Momentum
• Change		• Evolution-de-Evolution

The synopsis should be an expanded version of your premise line, including each clause of the Anatomy of a Premise Line Template™ with each clause broken out into more detailed beats.

Write the "Protagonist" clause: (Character-Constriction:Protagonist-Moral Component))

Constricting Event: (moves them from life line to action line)

▪

Moral Blind Spot:

▪

Immoral Effect: (show in action)

▪

© 2015 Jeff Lyons
Copying or distributing without written permission from the author is prohibited.

Anatomy of a Premise Line™:
Short Synopsis Worksheet

Storygeeks

Story Consulting - Training - Editorial

Scenes:

Scene 1: Constricting Event (Call to Effect/Key Incident/Inciting Incident/Whatever):

-

Scene 2: Moral blind spot revealed (The moment we first see the blind spot appear.)

-

Scene 3: Immoral effect in action (in addition to the reveal in scene 2)

-

Write the "Team Goal" clause: (Desire-Relationship:Chain of Desire-Focal Relationship)

Chain of Desire: (Overall goal and smaller "link" goals supporting the overall goal, if you know them.)

- Overall desire:
- Link desire:
- Link desire:
- Link desire:

Focal Relationship or Teaming: (Who is spending the most time with the protagonist during the middle of the story?)

-

Scenes:

Scene 1: Overall Goal revealed

-

Scene 2: Focal Relationship established

-

Copying or distributing without written permission from the author is prohibited.

Write the "Opposition" clause: (Adventure-Resistance:Opposition-Plot & Momentum)

Who is the opponent/main antagonist?

-

What is at stake at the midpoint for everyone?

-

What is at stake for the protagonist at the midpoint?

-

What is the doom moment? (at about 3/4-way through the story)

-

Scenes:

Scene 1: Introduction of opponent/main antagonist

-

Scene 2: Midpoint Stakes (overall stakes rise)

-

Scene 3: Midpoint Stakes (protagonist's stakes rise)

-

Scene 4: Doom Moment

-

© 2015 Jeff Lyons

Copying or distributing without written permission from the author is prohibited.

Page 3 of 4

Write the "Dénouement" clause: (Adventure-Change:Plot & Momentum-Evolution-de-Evolution)

How does the protagonist change? (what does he/she learn about the belief driving their blind spot? How have they been wrong about themselves?)

-

Final resolution with main antagonist.

-

Protagonist's change in action (how is he/she going to act differently now?)

Scenes:

Scene 1: How the protagonist changes.

-

Scene 2: What does the final resolution look like?

-

Scene 3: How does the protagonist's change show itself in action in the end?

-

© 2015 Jeff Lyons

Copying or distributing without written permission from the author is prohibited.

PREMISE TESTING CHECKLIST (BLANK)

Anatomy of a Premise Line™:
Premise Testing Checklist

Storygeeks
Story Consulting - Training - Editorial

7-Step Premise Testing Process Checklist

Step 1: Is your premise soft or generic?

Questions	Yes	Needs Work
The idea feels well developed and complete.		
The premise is engaging and interesting when I hear it spoken out loud? (*You may not be the best judge of this.*)		
The premise has a sense of movement, forward or backward in time and space?		
The premise mostly plays out in the world, not inside someone's head?		

Step 2: Is your idea high-concept?

Questions	Yes	Needs Work
Is there a clear level of entertainment value?		
Is the idea original?		
Is the idea unique?		
Is the idea visual?		
Does the idea focus on a primal emotion?		
Is there a broader target market appeal to the idea, beyond friends and family?		
If you add "what if" to the beginning of the idea, does it lend itself to an exciting question?		

Step 3: Is your premise a story or a situation?

Questions	Yes	Needs Work
The true character driving this idea is revealed by unfolding events, more than by some problem is being solved.		
This idea requires subplots, twists, and complications to be properly told.		
This idea is about a human being on a journey leading to emotional change?		

Copyright © 2013 Storygeeks
Do not distribute or copy without author's written permission.

Anatomy of a Premise Line™:
Premise Testing Checklist
<Your Story Title Here>

Storygeeks
Story Consulting ~ Training ~ Editorial

	Yes	Needs Work
There is a strong moral component.		
Step 4: Does the tagline work?		
Questions	Yes	Needs Work
Is the tagline short and root emotion focused?		
Step 5: Does the log line work?		
Questions	Yes	Needs Work
Is the high-concept evident?		
Is the hook clear?		
Is the hook reflective of what originally excited you about the story? *(Does it bring you full circle?)*		
Is the visual image of the log line effective and memorable?		
Step 6: After Re-evaluating your premise line, are these questions true?		
Questions	Yes	Needs Work
Does the premise line align with the log line and tagline properly?		
Does the premise line tell the story you want to tell?		
Step 7: After unit testing your premise line, are these questions true?		
Questions	Yes	Needs Work
Was the response inside friends and family positive?		
Was the response outside friends and family positive?		
Totals:	18	6

© 2015 Jeff Lyons
Copying or distributing without written permission from the author is prohibited.

APPENDIX B

EXAMPLES

SHORT SYNOPSIS WORKSHEET EXAMPLE
(FILM: *GREEN GLOVES*)

Anatomy of a Premise Line™:
Short Synopsis Worksheet Example

Storygeeks
Story Consulting - Training - Editorial

Premise Line Clauses & the Short Synopsis

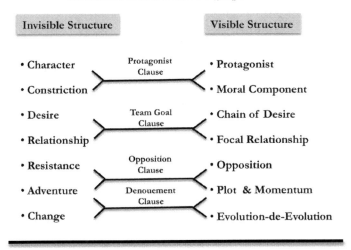

The synopsis should be an expanded version of your premise line, including each clause of the Anatomy of a Premise Line Template™ with each clause broken out into more detailed beats that correspond to their respective Visible Structure™ elements.

Project Title: "Green Gloves"
Project Type: Feature Film

Write the "Protagonist" clause: (Character-Constriction : Protagonist-Moral Component))

When Belfast heavyweight contender MICKEY KERRY, obsessed with becoming the Northern Ireland Area Heavyweight champ, is approached by reigning champ BARNEY WILSON for a title fight …

Constricting Event: (moves them from life line to action line)

- Mickey and Ben (Mickey's manager) are approached by the reigning area champ, Barney Wilson, for a title fight.

Moral Blind Spot:

- His blind spot is infidelity: the sin of lying and manipulating others as a result. He's also obsessed with winning the title. This fuels his tendency to lie.

© 2015 Jeff Lyons

Copying or distributing without written permission from the author is prohibited.

Belief Under the Blind Spot:

- "If people know the truth about me, I'll lose everything." This is a fear he has battled all his life, the fear of truly being seen. What will they see? Someone weak and unworthy of love.

Immoral Action: (show in action)

- Mickey lies to Jane about the Wilson fight, his job situation, and his terminal illness. Also, lies to Ben about his illness.

Scenes:

Scene 1: Constricting Event (Call to Action/Key Incident/Inciting Incident/Whatever):

- Mickey meets with his doctor who tells him he's got a few years to live if he stops boxing, a few months if he continues. Mickey tells the doctor he can't tell anyone, not even his wife; if the truth gets out he'll never be able to get a fight. So, he consciously keeps this secret for selfish reasons.

Scene 2: Moral blind spot revealed (The moment we first see the blind spot appear.)

- Ben and Mickey are approached by Barney Wilson's camp with an offer to fight a title bout. They are invited to a secret meeting with Wilson's inner circle to quietly plan the fight. First consequential reveal of his lying (i.e., keeping a secret) to Jane.

Scene 3: Immoral effect in action (in addition to the reveal in scene 2)

- Jane, who hates boxing, reminds Mickey that they have a deal: Ten years, if he didn't have the title after ten years he had agreed to give up the fight game and live a normal life. He lies to her and says he's working as a car dealer (having lost that job and not telling her) and has no plans on fighting and only wants to giver her the private business she's always wanted.

- Later, after the losing the Wilson fight, Ben discovers Mickey has lied to him all this time about being sick, and he feels betrayed and confronts Mickey.

Write the "Team Goal" clause: (Desire-Relationship : Chain of Desire-Focal Relationship)

Mickey joins with BEN, his manager, to secretly prepare for the fight of his life, hiding the truth of his terminal illness from everyone; while trying to set his wife JANE up in her own business so she and Mickey Jr. won't be homeless when he dies …

Chain of Desire: (Overall goal and smaller "link" goals supporting the overall goal, if you know them.)

Copying or distributing without written permission from the author is prohibited.

- Overall goal: To buy Jane her sandwich shop and make her secure for the future financially, when Mickey's dead and gone.
- Link goal: Beat Wilson and win the title and the huge purse; save the day.
- Link goal: Beat O'Reily and win the purse; save his family.
- Link goal: Convince Inis to marry Jane, if he dies in the ring.
- Link goal: Teach Mickey Jr. how to fight, so he can take care of himself when Mickey is gone.

Focal Relationship or Teaming: (Who's spending the most time with the protagonist during the middle of the story?)

- Jane and Ben (Mickey's Manager) alternate this role together throughout the middle of the story.

Scenes:

Scene 1: Overall Goal revealed

- After a successful fight and ensuing celebration, Mickey drives Jane past an available storefront in the local business district, seeing the store is still for sale, and Mickey leading her on that he intends on making Jane's dream of having her own business come true (for him and her).

Scene 2: Focal Relationship established

- Through back channels, Ben is approached about the Wilson fight and he tells Mickey. They both go to a secret meeting and strike a deal to do the fight. The partnership is sealed between Ben and Mickey.

- Jane opens the story already in relationship with Mickey.

Write the "Opposition" clause: (Adventure-Resistance : Opposition-Plot & Momentum)

… until Jane discovers Mickey's scheme and kicks him out, turning to a potential suitor, INIS, who is ready to step in and replace Mickey. When Mickey loses the Wilson fight, he is exposed as a liar …

Who is the opponent/main antagonist?

- Jane is the main antagonist/opponent. Other opponents are "outside" opponents: Wilson, Inis, O'Reily, Arnone, and Ben, with Ben being the central one of those.

What is at stake at the midpoint for everyone?

- If Wilson fight goes bad, or Mickey dies, everyone loses his or her dreams.

Copying or distributing without written permission from the author is prohibited.

Anatomy of a Premise Line™:
Log Line Worksheet

Storygeeks

Story Consulting - Training - Editorial

What is at stake for the protagonist at midpoint?

- Mickey could die, he could lose his marriage, he could lose the fight.

What is the doom moment? (at about 3/4-way through the story)

- Mickey loses the Wilson fight.

Scenes:

Scene 1: Introduction of opponent/main antagonist

- Opening scene with Mickey fighting Rufus Bigalow in the Belfast Hall. Jane is the only woman in an all-male audience, she later joins him after the fight in the locker room and we see the tension in the relationship, but also the love.

Scene 2: Midpoint Stakes (overall stakes rise)

- Wilson's manager, Ricky Smyth, meets with Mickey and Ben to seal the deal for the fight with Wilson; now all are committed to success or failure.

Scene 3: Midpoint Stakes (protagonist's stakes rise)

- Astringed from Jane, Mickey sees that Inis (the local cop) is getting very friendly with his wife and Jane is not discouraging him. Mickey realizes he's very close to losing her because of his decision on Wilson.

Scene 4: Doom Moment

- Mickey loses the Wilson fight and is nearly killed. Jane is closer to Inis than she is (publically) to Mickey, and Mickey has lost all hope of the title and saving his family's future. His lie about his health is also exposed to Ben for the first time, and this is another emotional blow to Mickey. He is truly alone.

Write the "Dénouement" clause: (Adventure-Change : Plot & Momentum-Evolution-de-Evolution)

… and in desperation arranges a winner-take-all bout with his worst nemesis, O'Reily, knowing it will lead to his death—he wins the fight, wins back Jane, and saves his family from ruin, after buying Jane her dream sandwich shop—only to succumb to his illness on Boxing Day, 1967, after spending the best Christmas of his life with his family.

How does the protagonist change? (what does he/she learn about the belief driving their blind spot? How have they been wrong about themselves?)

© 2015 Jeff Lyons

Page 4 of 5

Copying or distributing without written permission from the author is prohibited.

- Mickey finally stops lying and is exposed and vulnerable. He is no longer driven by ambition to win, but solely by a need to protect his family from ruin. He realizes he can be authentic and not lose anything.

Final resolution with main antagonist (and minor opposition)

- Mickey confronts O'Reily in the ring during the winner-take-all fight, and Jane comes to the stadium to confront him about his illness and to tell him it's more important he live than win and they fall back in love at ringside.

Protagonist's change in action (how is he/she going to act differently now?)

Scenes:

Scene 1: How the protagonist changes.

- Mickey decides to go see Inis and convince him to be with Jane during his winner-take-all with O'Reily. This is implicit permission from him to Inis to get ready to step into Mickey's place as her husband, because he doesn't expect to survive this fight. Until this point all his motives have been colored by ambition to achieve, but now its not about him, it's about something bigger than him.

Scene 2: What does the final resolution look like?

- Jane (main antagonist) comes to the stadium to confront him about his illness and to tell him it's more important he live than win.

Scene 3: How does the protagonist's change show itself in action in the end?

- Mickey tells Jane the truth, he's fighting for her now, not anything else, and that "sometimes dreams really do come true," meaning that his dream of having her safe and secure is all he cares about, and that's the real truth. They fall back in love at ringside.

Copying or distributing without written permission from the author is prohibited.

FULL SHORT SYNOPSIS EXAMPLE
(FILM: *GREEN GLOVES*)

Anatomy of a Premise Line™:
Full Short Synopsis Example
Green Gloves

Storygeeks
Story Consulting - Training - Editorial

LOGLINE:

A 1960s Irish heavyweight contender, with a terminal illness, fights one last bout to save his family from ruin, knowing the fight will kill him.

PREMISE LINE:

When Belfast heavyweight contender MICKEY KERRY, obsessed with becoming the Northern Ireland Area Heavyweight champ, is approached by reigning champ BARNEY WILSON for a title fight, Mickey joins with BEN, his manager, to secretly prepare for the fight of his life, hiding the truth of his terminal illness from everyone; while trying to set his wife JANE up in her own business so she and Mickey Jr. won't be homeless when he dies, until Jane discovers Mickey's scheme and kicks him out, turning to a potential suitor, INIS, who is ready to step in and replace Mickey. When Mickey loses the Wilson fight, he is exposed as a liar, and in desperation arranges a winner-take-all bout with his worst nemesis, knowing it will lead to his death—he wins the fight, wins back Jane, and saves his family from ruin after buying Jane her dream sandwich shop—only to succumb to his illness on Boxing Day, 1967, after spending the best Christmas of his life with his family.

Copying or distributing without written permission from the author is prohibited.

SYNOPSIS:

ANCIENT ARENA—A boxing match is underway in the style of the first Olympics: naked, brutal, bloody, to the death. MELANKEMOS, "The Untouched Boxer," fights a bloody, broken fighter. The broken boxer is unrecognizable. Melankemos benevolently looks down on the broken boxer, who now takes on a recognizable face, MICKEY KERRY. Mickey looks up to Melankemos in fear. He hears the crowd shouting for Melankemos to end it. Melankemos looks down to Mickey silently as if to ask, "Ready?" Mickey hesitates and then nods, yes. Melankemos smiles, but not malevolently; mercifully, as he raises his fist. The arena grows silent. Only the wind can be heard. Mickey closes his eyes. Melankemos's fist moves rapidly in to strike him.

BELFAST, IRELAND 1967—MICKEY KERRY comes to on the mat, waking from being knocked out. He's in a fight with RUFUS BIGALOW, a fight Mickey intends to win. Determined, he gets back up and makes short work of Bigalow, to the crowd's delight. Mickey's wife, JANE, finds it hard to be upbeat about the win; she's tired of the fight game and wants him to quit. During the post-fight party, Jane reminds him of their deal. If after ten years he was not world champ, he would hang up his gloves and they would live a normal life; well, ten years are up. Jane expects him to abide by their agreement.

After the party, Mickey drives Jane her dream location for a small sandwich shop she wants to open, and she gets very wistful about "dreams coming true." They both know the store is beyond their means to buy, but keeping this dream alive helps deflect Jane away from Mickey's fight ambitions, so he doesn't discourage her dreaming, in fact, he makes a strong suggestion she should expect a miracle.

Visiting his doctor, Mickey pees red into a cup. His doctor tells him he's got months to live if he keeps fighting; years if he quits and settles down. Mickey knows no one would fight him if they knew he was terminally ill with kidney disease, so he decides to hide the truth from everyone, including Jane and his manager, BEN. He's not sure what to do: fight or give up.

When Barney Wilson's team approaches Ben and Mickey about a possible title fight, all bets are off for Mickey; he makes his choice at last. With his weakening condition, he knows this is his last chance, not just for the title, but also to make enough money to save his family from the poor house. So, he consciously decides to lie to Jane about his job, his health, and the possibility of Wilson.

Mickey and Ben secretly begin lining up the players necessary to get a crack at the Northern Ireland Area Heavyweight Champion, Barney Wilson.

When Jane finds out Mickey lied about losing his job and his plans to fight, she puts two-and-two together and confronts him. He's been using the lure of buying a sandwich shop as a way of "bribing" her to not hold his feet to the fire (i.e., their agreement). She loves Mickey, but she's heartbroken at his betrayal. She can't take watching her husband fight for money; she just wants a normal life for her family and she has to think about Mickey Jr., who worships his dad. So, she kicks him out. Mickey moves in with Ben and hopes she'll come around.

Mickey and Ben meet with Wilson's manager, RICKY SMYTH, and a formal deal is struck with the Boxing Union of Ireland for Mickey and Wilson to fight. Mickey knows this will now go public and it will only make matters worse with Jane, but he needs the purse and he wants the title. It's now or never; everything is at stake for everybody—losing is not an option.

As Mickey comes close to the Wilson fight, Jane begins a flirtatious friendship with a local cop, INIS (to make Mickey jealous). Inis is two things Mickey isn't: stable and employed. And, he's interested. Jane's heart is with Mickey, but he just can't give her the normal life she craves. And she still has no idea he's dying.

Getting sicker, Mickey fights Wilson in Belfast's Ulster Hall. Inis and Jane listen to the fight together on the radio. Mickey is pummeled and nearly killed. It's the worst-case scenario. He loses his dream, and he doesn't make the money. The loss also makes Jane more hopeless Mickey will ever come around.

As Jane starts to grapple with the possibility that she might have to choose a new life without her husband, Mickey arranges for another fight with his arch nemesis, O'Reily. It will be a winner-take-all match; the purse being large enough to solve all of Mickey's problems. He's determined not to go out and leave Jane penniless.

Just before the O'Reily fight Mickey visits Inis to ask him to watch over his family and to be with them during the radio broadcast. He doesn't want Jane being alone if he should die in the ring. And he knows about Inis's interest. She could do worse than end up with a cop for a husband.

Jane listens to the O'Reily fight, along with Inis. It's bad. Mickey is going down for the count. She asks Inis to take her to the stadium, where she joins Mickey at ringside. The moment they share shows Inis he was always second fiddle. He leaves at peace with that. Jane's presence gives Mickey the second wind he needs. Mickey tells Jane the truth, he's fighting for her now, not anything else, and that "sometimes dreams really do come true," meaning that his dream of having her safe and secure is all he cares about, and that's the real truth. They fall back in love again, right at ringside, and Mickey goes on to pound O'Reily into the canvas.

STORE FRONT—CHRISTMAS MORNING 1967. Mickey, Ben, and the family are celebrating the Christmas he thought he'd only see from heaven. They all stand outside Jane's new sandwich shop admiring the big red ribbon on the front door.

KERRY HOUSE—BOXING DAY 1967. Mickey is bleeding in the sink, calls Ben and asks to go to the hospital. He, Jane, and Ben silently drive to hospital to try to save his life. Mickey watches Jane as he lays in her lap in the backseat. The love that fills the car is palpable. Suddenly he looks out the window to a growing white light.

ANCIENT ARENA—The ancient arena from the opening scene surrounds him. Melankemos hovers above the broken boxer. The crowd is cheering, but not for blood. The broken boxer looks up with his unrecognizable face. But now, Melankemos is Mickey! Rather than a final blow, Mickey offers his hand. A bloody hand reaches up and grabs his. Mickey smiles and pulls the other boxer up into an ever-brightening light.

© 2015 Jeff Lyons
Copying or distributing without written permission from the author is prohibited.

FULL SHORT SYNOPSIS EXAMPLE WITH NOTES
(FILM: *GREEN GLOVES*)

Anatomy of a Premise Line™:
Full Short Synopsis Example
—with Notes : Green Gloves

Storygeeks
Story Consulting - Training - Editorial

LOGLINE:

A 1960s Irish heavyweight contender, with a terminal illness, fights one last bout to save his family from ruin, knowing the fight will kill him.

PREMISE LINE:

When Belfast heavyweight contender MICKEY KERRY, obsessed with becoming the Northern Ireland Area Heavyweight champ, is approached by reigning champ BARNEY WILSON for a title fight, Mickey joins with BEN, his manager, to secretly prepare for the fight of his life, hiding the truth of his terminal illness from everyone, while trying to set his wife JANE up in her own business so she and Mickey Jr. won't be homeless when he dies, until Jane discovers Mickey's scheme and kicks him out, turning to a potential suitor, INIS, who is ready to step in and replace Mickey. When Mickey loses the Wilson fight, he is exposed as a liar, and in desperation arranges a winner-take-all bout with his worst nemesis, knowing it will lead to his death—he wins the fight, wins back Jane, and saves his family from ruin after buying Jane her dream sandwich shop—only to succumb to his illness on Boxing Day, 1967, after spending the best Christmas of his life with his family.

Comment: Visible Structure	
Protagonist	
Comment: Visible Structure	
Focal Relationship #2	
Comment: Visible Structure	
Moral Component (Blind Spot/Immoral Effect)	
Comment: Visible Structure	
Chaos of the middle / Adventure	
Comment: Visible Structure	
Main Antagonist / Focal Relationship #1	
Comment: Visible Structure	
Plot & Momentum / Protagonist Stakes Rise	
Overall stakes also rise when Mickey and Ben accept offer to fight Wilson.	
Comment: Visible Structure	
Doom Moment	
Comment: Visible Structure	
Plot & Momentum / Final Resolution	
Comment: Visible Structure	
Change / Mickey stops lying and does the right thing.	

© 2015 Jeff Lyons
Copying or distributing without written permission from the author is prohibited.

SYNOPSIS:

ANCIENT ARENA—A boxing match is underway in the style of the first Olympics: naked, brutal, bloody, to the death. MELANKEMOS, "The Untouched Boxer," fights a bloody, broken fighter. The broken boxer is unrecognizable. Melankemos benevolently looks down on the broken boxer, who now takes on a recognizable face, MICKEY KERRY. Mickey looks up to Melankemos in fear. He hears the crowd shouting for Melankemos to end it. Melankemos looks down to Mickey silently as if to ask, "Ready?" Mickey hesitates and then nods, yes. Melankemos smiles, but not malevolently; mercifully, as he raises his fist. The arena grows silent. Only the wind can be heard. Mickey closes his eyes. Melankemos's fist moves rapidly in to strike him.

BELFAST, IRELAND 1967—MICKEY KERRY comes to on the mat, waking from being knocked out. He's in a fight with RUFUS BIGALOW, a fight Mickey intends to win. Determined, he gets back up and makes short work of Bigalow, to the crowd's delight. Mickey's wife, JANE, finds it hard to be upbeat about the win; she's tired of the fight game and wants him to quit. During the post-fight party, Jane reminds him of their deal. If after ten years he was not world champ, he would hang up his gloves and they would live a normal life; well, ten years are up. Jane expects him to abide by their agreement.

> **Comment: TEAM CLAUSE**
> Focal Relationship (#1)
>
> **OPPOSITION CLAUSE**
> Main Antagonist

> **Comment: OPPOSITION CLAUSE**
> Scene #1

> **Comment: PROTAGONIST CLAUSE**
> Scene #3

After the party, Mickey drives Jane her dream location for a small sandwich shop she wants to open, and she gets very wistful about "dreams coming true." They both know the store is beyond their means to buy, but keeping this dream alive helps deflect Jane away from Mickey's fight ambitions, so he doesn't discourage her dreaming, in fact, he makes a strong suggestion she should expect a miracle.

> **Comment: TEAM GOAL CLAUSE**
> Scene #1

Visiting his doctor, Mickey pees red into a cup. His doctor tells him he's got months to live if he keeps fighting; years if he quits and settles down. Mickey knows no one would fight him if they knew he was terminally ill with kidney disease, so he decides to hide the truth from everyone, including Jane and his manager, BEN. He's not sure what to do: fight or give up.

> **Comment: PROTAGONIST CLAUSE**
> Scene #1

When Barney Wilson's team approaches Ben and Mickey about a possible title fight, all bets are off for Mickey; he makes his choice at last. With his weakening condition, he knows this is his last chance, not just for the title, but also to make enough money to save his family from the poor house. So, he consciously decides to lie to Jane about his job, his health, and the possibility of Wilson.

> **Comment: PROTAGONIST CLAUSE**
> Constricting Event
> This is also:
> **TEAM GOAL CLAUSE**
> Scene #2

> **Comment: PROTAGONIST CLAUSE**
> Scene #2

Mickey and Ben secretly begin lining up the players necessary to get a crack at the Northern Ireland Area Heavyweight Champion, Barney Wilson.

> **Comment: TEAM CLAUSE**
> Focal Relationship (#2)

When Jane finds out Mickey lied about losing his job and his plans to fight, she puts two-and-two together and confronts him. He's been using the lure of buying a sandwich shop as a way of "bribing" her to not hold his feet to the fire (i.e., their agreement). She loves Mickey, but she's heartbroken at his betrayal. She can't take watching her husband fight for money; she just wants a normal life for her family and she has to think about Mickey Jr., who worships his dad. So, she kicks him out. Mickey moves in with Ben and hopes she'll come around.

Mickey and Ben meet with Wilson's manager, RICKY SMYTH, and a formal deal is struck with the Boxing Union of Ireland for Mickey and Wilson to fight. Mickey knows this will now go public and it will only make matters worse with Jane, but he needs the purse and he wants the title. It's now or never; everything is at stake for everybody—losing is not an option.

> **Comment: OPPOSITION CLAUSE**
> Scene #2
> Midpoint Stakes—Overall Stakes Rise

As Mickey comes close to the Wilson fight, Jane begins a flirtatious friendship with a local cop, INIS (to make Mickey jealous). Inis is two things Mickey isn't: stable and employed. And, he's interested. Jane's heart is with Mickey, but he just can't give her the normal life she craves. And she still has no idea he's dying.

> **Comment: OPPOSITION CLAUSE**
> Scene #3
> Midpoint Stakes—Protagonist Stakes Rise

Getting sicker, Mickey fights Wilson in Belfast's Ulster Hall. Inis and Jane listen to the fight together on the radio. Mickey is pummeled and nearly killed. It's the worst-case scenario. He loses his dream, and he doesn't make the money. The loss also makes Jane more hopeless Mickey will ever come around.

> **Comment: OPPOSITION CLAUSE**
> Scene #4
> Doom Moment

© 2015 Jeff Lyons
Copying or distributing without written permission from the author is prohibited.

As Jane starts to grapple with the possibility that she might have to choose a new life without her husband, Mickey arranges for another fight with his arch nemesis, O'Reily. It will be a winner-take-all match; the purse being large enough to solve all of Mickey's problems. He's determined not to go out and leave Jane penniless.

Just before the O'Reily fight Mickey visits Inis to ask him to watch over his family and to be with them during the radio broadcast. He doesn't want Jane being alone if he should die in the ring. And he knows about Inis's interest. She could do worse than end up with a cop for a husband.

> **Comment: DENOUEMENT CLAUSE**
> Scene #1

Jane listens to the O'Reily fight, along with Inis. It's bad. Mickey is going down for the count. She asks Inis to take her to the stadium, where she joins Mickey at ringside. The moment they share shows Inis he was always second fiddle. He leaves at peace with that. Jane's presence gives Mickey the second wind he needs. Mickey tells Jane the truth, he's fighting for her now, not anything else, and that "sometimes dreams really do come true," meaning that his dream of having her safe and secure is all he cares about, and that's the real truth. They fall back in love again, right at ringside, and Mickey goes on to pound O'Reily into the canvas.

> **Comment: DENOUEMENT CLAUSE**
> Scene #2

> **Comment: DENOUEMENT CLAUSE**
> Scene #3

STORE FRONT—CHRISTMAS MORNING 1967. Mickey, Ben, and the family are celebrating the Christmas he thought he'd only see from heaven. They all stand outside Jane's new sandwich shop admiring the big red ribbon on the front door.

KERRY HOUSE—BOXING DAY 1967. Mickey is bleeding in the sink, calls Ben and asks to go to the hospital. He, Jane, and Ben silently drive to hospital to try to save his life. Mickey watches Jane as he lays in her lap in the backseat. The love that fills the car is palpable. Suddenly he looks out the window to a growing white light.

ANCIENT ARENA—The ancient arena from the opening scene surrounds him. Melankemos hovers above the broken boxer. The crowd is cheering, but not for blood. The broken boxer looks up with his unrecognizable face. But now, Melankemos is Mickey ! Rather than a final blow, Mickey offers his hand. A bloody hand reaches up and grabs his. Mickey smiles and pulls the other boxer up into an ever-brightening light.

PREMISE TESTING CHECKLIST EXAMPLE

Anatomy of a Premise Line™:
Premise Testing Checklist
<Your Story Title Here>

Storygeeks
Story Consulting - Training - Editorial

Step 1: *Is your premise soft or generic?*		
Questions	**Yes**	**Needs Work**
The idea feels well developed and complete.	X	
The premise is engaging and interesting when I hear it spoken out loud? (*You may not be the best judge of this.*)	X	
The premise has a sense of movement, forward or backward, in time and space?	X	
The premise mostly plays out in the world, not inside someone's head?		X
Step 2: Is your idea high concept?		
Questions	**Yes**	**Needs Work**
Is there a clear level of entertainment value?		X
Is the idea original?		X
Is the idea unique?		X
Is the idea visual?	X	
Does the idea focus on a primal emotion?	X	
Is there a broader target market appeal to the idea, beyond friends and family?	X	
If you add "what if" to the beginning of the idea, does it lend itself to an exciting question?	X	
Step 3: Is your premise a story or a situation?		
Questions	**Yes**	**Needs Work**
The true character driving this idea is revealed by unfolding events, more than by some problem being solved.	X	
This idea requires subplots, twits, and complications to be properly told.		X
This idea is about a human being on a journey leading to emotional change?	X	

© 2015 Jeff Lyons
Copying or distributing without written permission from the author is prohibited.

	Yes	Needs Work
There is a strong moral component.	X	
Step 4: Does the tagline work?		
Questions	**Yes**	**Needs Work**
Is the tagline short and root emotion focused?	X	
Step 5: Does the log line work?		
Questions	**Yes**	**Needs Work**
Is the high-concept evident?	X	
Is the hook clear?	X	
Is the hook reflective of what originally excited you about the story? *(Does it bring you full circle?)*	X	
Is the visual image of the log line effective and memorable?	X	
Step 6: After Re-evaluating your premise line, are these questions true?		
Questions	**Yes**	**Needs Work**
Does the premise line align with the log line and tagline properly?	X	
Does the premise line tell the story you want to tell?	X	
Step 7: After unit testing your premise line, are these questions true?		
Questions	**Yes**	**Needs Work**
Was the response inside friends and family positive?	X	
Was the response outside friends and family positive?		X
Totals:	18	6

© 2015 Jeff Lyons

Copying or distributing without written permission from the author is prohibited.

FULL SYNOPSIS EXAMPLE (NOVEL: *PICTURES OF YOU*)

Full Synopsis: Pictures of You (2013–Algonquin Books)
Type: Novel (*New York Times, USA Today* bestseller)
Author: Caroline Leavitt

(Note: SPOILERS—this synopsis does give away the story if you intend to read the book. Also, a novel synopsis almost always sounds unfinished or even sometimes cheesy, but that is because the real magic happens in the writing of the novel; the actual book is always more multi-layered than any synopsis.)

Pictures of You asks the question: How do we forgive the unforgivable?

The novel begins with Isabelle, a thirtyish, unhappily childless children's photographer, running from a cheating husband (a guy she ran off with when she was 16 only because her mother locked her out of the house) and an awful town, about to start a new life. The fog is covering everything, and she gets lost, and in the fog, she sees a car turned the wrong way, a woman in a red dress standing there as if she is waiting for something, and a boy running into the woods. She locks eyes with the boy. She can't stop, and the cars crash. Only Isabelle and the boy survive.

When cops come to tell Charlie Nash there's been an accident, he's decimated. He had argued with his wife April that morning, and in fact, although he adored her, he had snapped at her, "I wish you were just out of my sight." To compound his guilt and grief, the car was three hours away from his home. Charlie thinks April was running off with their very asthmatic son, Sam, leaving him. When Charlie tries to talk to Sam, though, Sam refuses to talk about any of it, and acts as if he is harboring a secret about what happened the day of the accident. Charlie looks for clues and finds a suitcase in the home is missing.

Isabelle, too, is wracked with guilt. Her car is totaled, and she's too phobic to drive. She stays in town to recuperate and she is found innocent (April's car was turned the wrong way). Wanting to make sure the father and son are okay, she begins to bike past their house, to watch them in the small town, and she becomes obsessed with the family she's torn asunder. Her therapist tells her to write a letter to Charlie asking forgiveness and not to mail it, but by mistake, she does.

Throughout the novel, two secrets about the crash are revealed. The first is Sam's version. His mother, trying to give him the things his asthma takes away, makes life as much of an adventure for him as she can. They pretend to be other people and drive everywhere. She fights for him when he is at the ER with asthma or in the hospital, right up until she annoys the nurses so much, they begin to dislike her and wonder if she is making Sam worse in order to drum up attention for herself. One day, Sam comes home and finds her car and an overnight bag. He thinks it's another surprise, so he hides under a blanket in the back and falls asleep. When he wakes, it's hours later, and the blanket makes him wheeze. April is stunned he's in the car. She tells him they are going on a great

adventure. Then the asthma attack turns terrible, she can't find a hospital, and they get lost in the fog. She calls 911, he thinks, and she tells him to stay in the car, the ambulance is coming. They both hear the car. He runs out, she runs to stop him, and he gets a huge gash across his arm, which will be a scar he carries all his life, but she is killed. At that moment, he looks at the other car and he sees Isabelle, surrounded with light, and he thinks she is an angel, like one of the pictures in his books. He convinces himself that she is there, like any angel, to give him a message and to help bring his mother back home.

Sam sees Isabelle around town and follows her, so he knows where she lives. He even shows up at her house one night when he doesn't have his key. She has to call Charlie, who is torn. The worst possible person is now the best possible person for his child in this instance, so he talks with Isabelle. Sam goes over there more and more. Isabelle teaches him about photography, which opens up a magical world for Sam.

Slowly, Charlie and Isabelle get to know one another, fall in love, first out of a common need. (They both shared the accident.) Then because of who they are. They keep it from Sam, who isn't ready to know there is another woman in his father's life. Charlie is also still wounded and not really ready for a new relationship because he hasn't made sense of the mystery of the old one. Isabelle falls in love with the child and all her long-buried maternal instincts come up. She starts to feel Sam and Charlie are hers. Her job, though, is becoming increasingly unsatisfying, and she's about to be laid off. She sees a pamphlet for a photography program in NYC, where you can study with real photographers and it doesn't matter that all you have is a GED, and she applies on a whim.

Isabelle finally starts to feel the possibility of forgiveness. Isabelle knows that Charlie loves her, but he is still haunted by his past. He doesn't tell Isabelle, but there are certain moments—at the diner where they used to go for donuts, at the soccer field, in the garden out back—where he senses April there, as if she's watching how he's raising their son. Isabelle is there every night, but she can't move in, which bothers her. One night, Isabelle can't figure out why. She's lying in bed with Charlie and she asks him what he talks about in therapy, and she realizes, in conversation, that he doesn't talk about her there at all. He talks about April and Sam.

Sam's photography allows him to finally be more popular at school and even make a friend, but it's a thuggy boy, Teddy. Teddy keeps asking about Isabelle, who she is, and Sam doesn't want to say he thinks she's an angel for fear of being made fun of, but when Teddy suggests they jimmy open Isabelle's apartment and see who she really is, Sam goes along with it, sure they will find angel stuff or maybe things about his mother.

They break in, see Isabelle's tortoise, see the bed unmade, and Sam is freaked because the room smells like his mother. He's sure now Isabelle is an angel and his mother is there. But then he sees a bottle of scent and a note. It's in his father's hand to Isabelle; Sam realizes that Isabelle isn't an angel and she isn't bringing his mother back but is taking his dad away from him. Teddy finds a condom on the floor. Sam drops the tortoise, and runs out into a storm.

Sam's missing. Charlie and Isabelle go to her apartment, and see it's been opened. They spot Sam's inhaler and figure out what happened. They both go to search for him.

Sam's arm is broken in the storm lightning, and so on. His asthma is a thousand times worse because of the emotional component: Sam now knows that not only is Isabelle not an angel, but she is a flawed human, and she's having sex with his father. He knows his mother is never coming back. Charlie fears Sam is going to die; he can't do anything but be there for his son, and he shuts Isabelle out. He wonders if he has brought in another woman who will bring harm to his son.

Isabelle's lowest point: She's not family so she can't find out how Sam is in the hospital, can't get in to see him. Charlie seems to be shutting her out because he's so worried about Sam. She goes home to find a letter: she's been accepted to a photography program in NYC. This is her shot. She can be someone. She can leave the Cape, a place she has always loathed. She wants Charlie and Sam to go with her.

Isabelle goes to see Charlie; he says he can't leave to move to NYC. He can't risk his son's life and health and can't trust that things will work out enough to do so. This is their home. He built the house. Plus, Sam can't live in a city with smog, and his doctors are all here. However, the real reason is he can't leave a place where he thinks April still is present. He can't let go until he figures out why she would leave with Sam. Sam is so angry, he can't hear her name without wheezing. He doesn't know how to handle any of this. Isabelle says she will give this opportunity up—she'll stay if she thinks they have a chance of a life together. She's not asking for marriage, just to be a part of their life. Charlie can't answer, which of course, is an answer.

Isabelle, heartbroken, leaves. She goes to the house in the early morning, to leave Sam her camera and a note, and then raps on his window. She tells him that even though he is acting mad, she knows he loves her—she knows he will forgive her. She'll write him; she'll keep in touch.

Isabelle in New York: loves the city, loves her classes, starts eating at a little café with a friendly chef. She calls Sam and he gets upset. Charlie wants to protect Sam, is angry with Isabelle for leaving, but Sam keeps the camera near him all the time, takes picture after picture of the road Isabelle left on. Charlie's moral choice—is Isabelle making his son worse? Is it better to make a clean break? He asks her not to call anymore, tells her Sam was in the hospital, and when she doesn't, Sam seems better, and he thinks this was the right call. When Isabelle writes Sam a letter, hating himself, Charlie opens it and never gives it to Sam.

Charlie then gets a letter addressed to April from someone named Bill that says only "I'm sorry." He leaves Sam with his parents and goes to find out the truth about April. Shocked, he realizes everything he thought was wrong. He learns that April was going to Boston every week just to feel like she was slipping into another life. While there, she met Bill. She had begun a relationship with Bill, who was also married and going to leave his wife, and they had planned to run away together, but she had never told the man she had a child. He was shocked

to hear it from Charlie and appalled that she would leave her child. In any case, he had decided not to go with her, to stay with his wife, so he hadn't shown up that day of the accident when he was supposed to meet April and they would fly to California. When he hadn't heard from April, he assumed she hadn't shown up either or that she had called it off. Bill also tells Charlie that April had told him that she never felt loved by Charlie and always suspected he would leave her. She falls for Bill because he is all over her, emotionally and physically. Stunned, Charlie doubts his ability to really know a woman. He remembers how she used to ask him if he loved her. Why hadn't she known?

Knowing the truth about why April left, Charlie steps up to the plate. He tells Sam how he's been feeling that April leaving was his fault and Sam reveals that he thought it was his fault and Charlie says now they know it was neither one of their faults, that it was an accident. Charlie has kept April's ashes, unable to do anything with them, and now Charlie and Sam set the ashes free in the garden April loved. Charlie lets her go. He realizes that you cannot forgive someone for their actions but you can still love them, and that week, for the first time, he doesn't feel her anywhere anymore. She's really gone.

Charlie misses Isabelle and decides to go see her even after all this silence. He vows not to do what he did with April, which was to hide his feelings and assume she knew them, but to risk himself. When he finally goes to see her, she is happy to see him. She tells him she started seeing the chef. She's getting married. He's shocked; he keeps probing, and she finally tells him. She's pregnant. This is a big deal. She was told she could never have kids. She won't leave her fiancé, won't let this child have anything but two parents. On the way home, they are really quiet. Charlie kisses her. She tells him she's five months pregnant and the child hasn't kicked yet, which worries her. Then she kisses him, and they end up sleeping together, but it's the last time. After he leaves, Isabelle cries in the middle of NYC for what might have been, but she goes home to her fiancé, and we see he's a good man, he loves her, he's kind. There isn't the passion she felt for Charlie, but there is something stable and good here. That night, she wakes in the middle of the night, and her baby kicks for the first time. She has what she needs—not Charlie or Sam, but work she loves, a man who loves her, a baby.

Charlie gets Sam, comes home, and doesn't tell him where he's been. Sam seems happy, has had a great time with his grandparents, etc. Charlie doesn't have April or Isabelle, but he has his son, and he tells him, "I love you," a thousand times a day.

Flash forward twenty years. Sam is in his late 30s, saying goodbye to the woman he loves, Lisa, whom he doesn't live with, and going to see Isabelle, who has become a famous photographer. In scenes, we find out that Sam's asthma miraculously disappeared when he was 15, and he has become a doctor: an obstetrician because it's the most hopeful kind of doctor of all to be. He brings babies into the world, makes sure they are safe. He hasn't had a real relationship (obviously he can't trust women since both April and Isabelle left him) but he is beloved by his women patients. He and Lisa argue because she wants to know where their relationship is going, why can't they live together, or have more of a commitment.

We find out Charlie keeps busy, loves his son, dates a woman. Sam goes to see Isabelle after all these years—she's got two kids, and he sees how Frank is a doting, terrific husband. Isabelle is happy. He finally asks her: why did you leave? How could you do that to me? And she's stunned. She tells him that is not what happened. Reveals the truth, that Charlie asked her not to contact him, that he kept getting terrible, dangerous asthma attacks from the stress and the emotion. She tells him she felt he was hers, that she was going to adopt him—things he didn't know. Sam is stunned. Isabelle feels horrible, she thought he knew—but Sam is elated because he realizes he didn't drive Isabelle away. Isabelle didn't really leave him—his father had stopped her from contacting him—and his father did it to protect him.

Sam thinks about all that has happened, about how you can never really know some things about a person. He thinks about Isabelle being happy with a man who is so good to her. He thinks about his father, who never found anyone—not for want of trying now—and then he drives home, and he stops at a diner and calls Lisa. He says, "Let's," his heart pounding because he is scared. And she says, "Let's what?" And he says, "Let's get married," and then he holds his breath, and we don't hear her answer.

(Note: The published novel departed from this synopsis, but the author used this as her guide to write the first draft.)

APPENDIX C

E-RESOURCES/COMPANION WEBSITE

Focal Press has established a companion website where you can access proprietary resources that accompany this book. All the examples and worksheets listed in Appendices A and B are available for download from this website. It is a lot easier to use them if you download the files from the Internet, but, for those who do not wish to do this, the forms and samples can be copied from Appendix A and Appendix B.

It is very possible that I will add new resources to the companion website over time, so there is an added benefit to using this resource, as it will give you access to new and updated materials as I add them to the site. There is no site registration or login required.

Go to this URL to download content from the *Anatomy of a Premise Line* e-Resources/Companion website page: *www.focalpress.com/cw/lyons/*

APPENDIX D

WRITER RESOURCES

(Note: The Internet addresses and locations below may change over time, so these links may not last. If the links are broken or changed, all these resources are worth searching for using your web browser.)

Every writing how-to book I know lists various resources in the appendix to help the writer with advice, more tools, references, etc. The lists tend to be long and include the usual suspects: all the flavor-of-the-month gurus or hipster story consultants active at the time the list is published. I really did not want to saddle you with another generic list of "writer resources." You have Google and a web browser—you don't need me to recommend a story consultant. But, since consulting is one of the things I do (I actually make my living as a writer!), I thought you'd like to know who I respect in the business—trust me, the list is short. As time passes, of course, some of these companies and individuals may fold or decide to go sell aluminum siding, but most have had some serious longevity, so I suspect they will be around for quite some time. None of the intro blurbs I give are meant to provide a comprehensive review of services or skills. I just want to introduce them to you, and you can contact them for more.

Chris Soth (Mini-Movie Method)

Chris Soth is a screenwriter with studio credits who has developed a beat sheet/sequencing process called the "Mini-Movie Method." It is a great tool designed specifically for filmmakers and screenplay writing. This is a no-nonsense and practical process designed to generate productivity and deliverables. I like no-nonsense.

Website: www.milliondollarscreenwriting.com
Email: milliondollarscreenwriting@gmail.com
Facebook: www.facebook.com/chrissoth

Writer's Boot Camp (WBC)

Founded by producer Jeffrey Gordon, WBC is one of the best "put your butt in a chair and get it done" programs out there. For more than two decades, WBC has been providing some of the best screenwriting classes and industry networking events available anywhere. Many of their alumni have gone on to write for major film studios and television/cable networks or have significant independent film projects produced.

> *Address*: 2525 Michigan Avenue, Building I, Santa Monica, CA 90404
> *Phone*: 310.998.1199 or 800.800.1733
> *Website*: www.writersbootcamp.com
> *Email*: support@writersbootcamp.com
> *Twitter*: @writersbootcamp
> *Facebook*: www.facebook.com/WritersBootCamp

Christopher Vogler

Christopher Vogler is the author of *The Writer's Journey: Mythic Structure for Writers*, based on the work *The Hero with a Thousand Faces* by Joseph Campbell, one of the world's foremost mythologists (sadly deceased). Chris teaches excellent workshops based on *The Writer's Journey* material and is especially popular in the screenwriting community.

> *Phone*: 800.814.0544
> *Website*: www.christophervogler.com
> *Email*: derek@tvfilmseminars.com
> *Facebook*: www.facebook.com/chris.vogler.568

Tawnya Bhattacharya ("Script Anatomy")

"Script Anatomy," founded in 2010 by writer Tawnya Bhattacharya, is a writing program developed and taught by a working TV writer. Its unique curriculum is designed to give emerging professionals practical development, writing, and rewriting tools to help advance their craft. "Script Anatomy" clients have won spots in all major TV writing fellowships, have staffed on or sold pilots to both cable and network channels.

> *Website*: www.scriptanatomy.com
> *Twitter*: @ScriptAnatomy
> *Facebook*: www.facebook.com/tawnya.b

Jenna Avery (The Writer's Circle)

Jenna Avery is a sci-fi screenwriter, columnist, blogger, writing-habit coach, and the founder of "The Writer's Circle," an online coaching program that helps

writers build professional writing habits. This is another "put your butt in a chair and get it done" program, but geared more around writing practice, not writing craft. The program relies on a system of guilt-free support, powerful small group coaching, and daily accountability. It's designed for procrastinators, writing newbies, and writers under a deadline.

For Information/Registration: www.justdothewriting.com

John Truby

John Truby (Truby's Writers Studio) has been teaching story structure and screenplay development for more than two decades. He's one of the few "gurus" who actually has professional screenwriting experience working both in features and television. He is the author of an important book called *Anatomy of Story: 21 Steps to Becoming a Master Storyteller*. He is internationally recognized and sells tons of great products. His work with genre structures is especially wonderful.

Phone: 310.573.9630
Website: www.truby.com
Email: trubystudio@truby.com
Twitter: @johntruby
Facebook: www.facebook.com/trubyswritersstudio

John August

John has one of the most popular and respected screenwriting/entertainment industry-related bogs on the Internet. He is a screenwriter (*Big Fish, Charlie and the Chocolate Factory, Corpse Bride*, among others), novelist, playwright, and director. His no-nonsense take on the screen trade is refreshing and incredibly informative.

Blog: www.johnaugust.com
Email: ask@johnaugust.com
Twitter: @johnaugust
Facebook: www.facebook.com/johnaugust.fb

Go Into the Story (Scott Myers)

Go Into the Story is another popular and useful screenwriting blog. Scott is an accomplished screenwriter, having worked for major studios and broadcast networks. He is a popular screenwriting teacher through the UCLA Extension Writer's Program, and is a great resource for any screenwriter, regardless of level of experience. He also writes the "official screenwriting blog" for the Blacklist (blcklst.com).

Blog: http://gointothestory.blcklst.com/
Email: gitsblog@gmail.com
Twitter: @gointothestory
Facebook: www.facebook.com/pages/Go-Into-The-Story/147927418335

The Bitter Script Reader

One of the best blogs on script reading by a professional story analyst (anonymous) who has worked for Oscar-winning production companies and one of the "big" agencies. This person's wit and insight are incredibly fun and educational. He/she is one of the gatekeepers you are trying to win over in your writing efforts. Read this blog and learn. And have lots of fun.

Blog: www.thebitterscriptreader.blogspot.com
Email: zuulthereader@gmail.com
Facebook: www.facebook.com/pages/Bitter-Script-Reader/154427441425

Julie Gray

Based out of Tel Aviv, Israel, Julie is an experienced writer, story analyst, writing coach, editor, and advocate for artists and storytellers across the globe. The author of *Just Effing Entertain Me: A Screenwriter's Atlas*, Julie has taught story at Warner Bros. Studios, The Great American PitchFest, The London Screenwriters' Festival, Oxford University, and many others. She is a great font of wisdom, experience—and darn good advice.

Website: www.jgwriters.com
Email: storieswb@gmail.com
Blog: www.jgwriters.com/#!blog/c1dy4
Twitter: @julie_gray
Facebook: www.facebook.com/rswriters.juliegray

Disclaimer: None of the resources listed above have read this book prior to publication, or publicly endorse, support, recommend, or subscribe to anything I say in this book. Their presence here is in no way an endorsement of me or my writing. I make this disclaimer for their benefit, but also to make it clear these recommendations are in no way a *quid pro quo*. They're here because they're the real deal and I like them.

INDEX

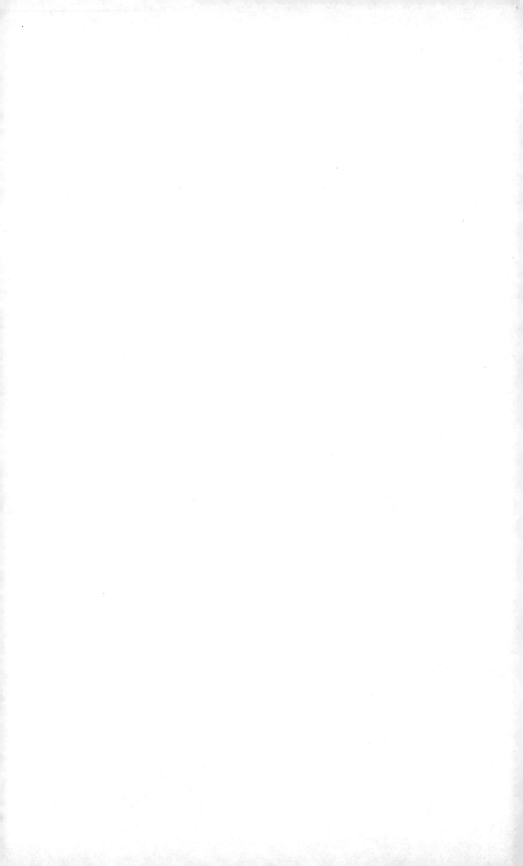

65357594R00113

Made in the USA
Middletown, DE
02 September 2019